100 Years of
Railways
Twentieth Century in Pictures

100 Years of
Railways
Twentieth Century in Pictures

AMMONITE
PRESS

PRESS
ASSOCIATION
Images

First Published 2010 by
Ammonite Press
an imprint of AE Publications Ltd,
166 High Street, Lewes, East Sussex BN7 1XU

Text copyright Ammonite Press
Images copyright Press Association Images
Copyright in the work Ammonite Press

ISBN 978-1-906672-52-2

British Cataloguing in Publication Data. A catalogue
record of this book is available from the British Library.

Editor: Richard Wiles
Picture research: Press Association Images
Design: Gravemaker + Scott

Colour reproduction by GMC Reprographics
Printed by Hung Hing Printing Co. Ltd.

Page 2: A sea of hats and glum expressions from stranded passengers on a crowded platform at Paddington station, London during the rail strike of 1924.
31st January, 1924

Page 5: The *Golden Fleece,* an ex-LNER A4 Class streamlined 4-6-2 steam locomotive, hauls *The Elizabethan* express from London King's Cross station to travel the 393 miles to Edinburgh in 6½ hours – at the time the fastest ever non-stop journey between the two cities, with an average speed of 60 miles per hour, and the world's longest non-stop run.
28th June, 1954

Page 6: The refurbished Barlow train shed of St Pancras International station includes a split-level section, with Rendezvous on the upper platform level concourse where Eurostar departs, and the Arcade below, formed of the undercroft and set beneath Victorian brick arches.
20th September, 2008

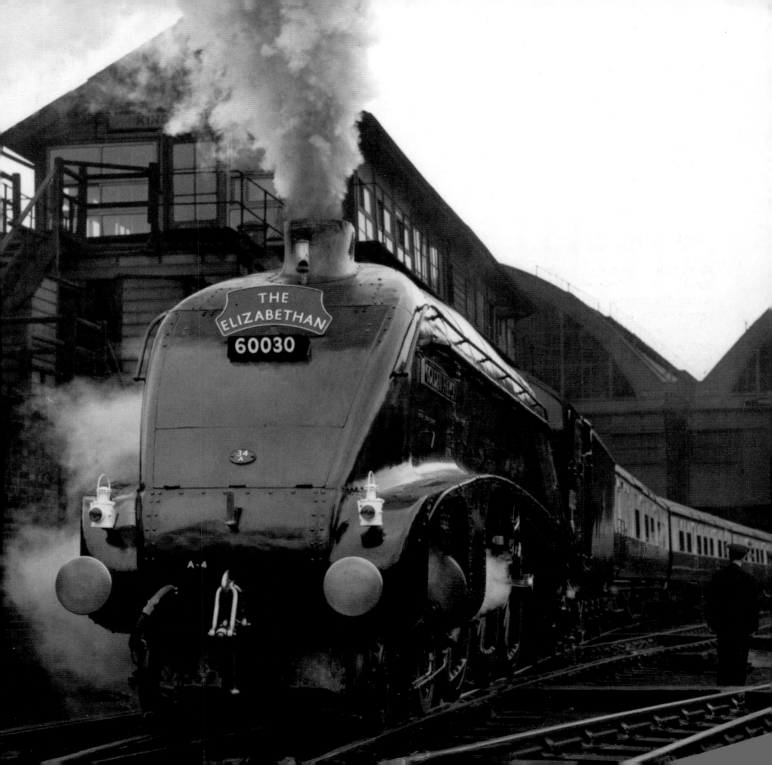

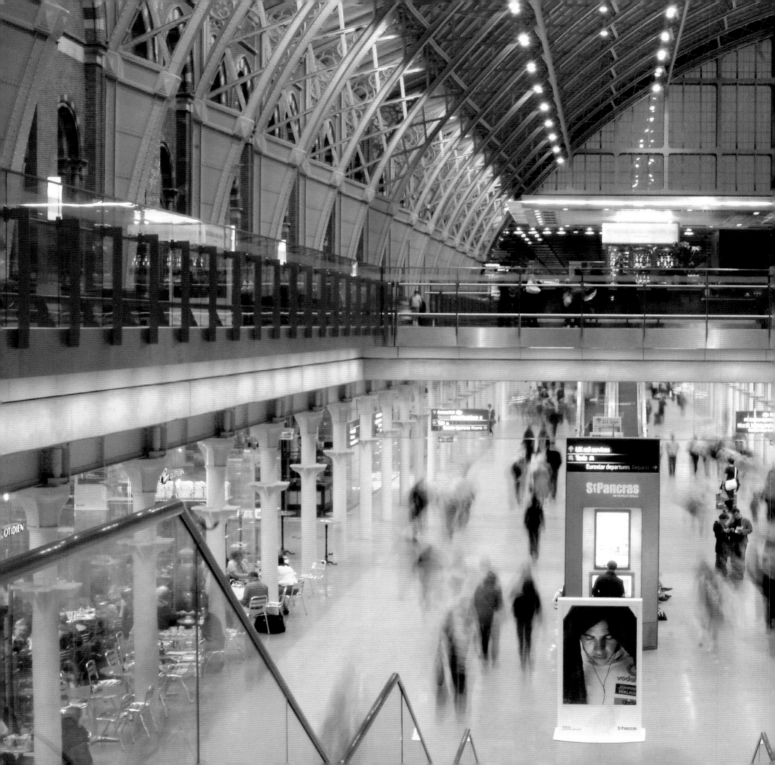

Introduction

Britain's railway system is the oldest in the world, established in 1825 with the opening of the first locomotive hauled public railway. By the end of the 20th century the network boasted more than 10,000 miles of track. Britain pioneered the development of the steam engine and the production of iron, and later steel, rails; her engineers were pivotal in the worldwide adoption of railways. 'Railway Mania' erupted with a collection of privately operated local lines, which, during the 20th century, were bought out or amalgamated. Railway corporations spread their influence into hotel chains, bus and road haulage, shipping lines and air services, and London opened the world's first underground railway system.

The railways were brought under government control during the First World War, emerging in 1923 as the 'Big Four' joint-stock public companies. Before air travel was commonplace, railways were the crucial link to the coastal ports and the Continent, the USA and the world. Royalty, politicians and celebrities were to be seen at London Victoria station boarding luxurious boat trains such as the *Golden Arrow*. Competition from road transport during the 1920s and 1930s reduced revenue for the railways, and in 1948 the Big Four were nationalized as British Railways. In the 1950s steam traction was phased out in favour of dieselization and electrification. Despite regeneration of track and stations, losses mounted and the network became unprofitable. A major contraction occurred in the mid-1960s when Dr Richard Beeching's *The Reshaping of British Railways* resulted in 4,000 route miles being slashed, freight depots closed and transport for heavy industry transferred to road haulage.

The Inter-City 125 High Speed Trains of the 1970s rejuvenated rail travel, but by 1997 operations had been privatized, with ownership of track and infrastructure passing to Railtrack, passenger operations franchised to the private sector, and freight services sold. A spate of accidents tarnished the image of rail travel and Railtrack's nationwide track replacement programme spiralled in cost, bringing about the collapse of the company and its replacement by state-owned Network Rail. The opening of the Channel Tunnel in 1994 gave Britain a direct rail link to Continental Europe, and in the new millennium the first high-speed line offered connections to over 100 destinations across France, Belgium, Germany and the Netherlands.

For many people the abiding image of Britain's railways may be the bygone age of steam, a romantic view of locomotives hauling trains through picturesque countryside. For others it represents the drudgery of the city commute, late trains, cramped compartments – and the seasonal curse of leaves on the line. This book examines the many faces of Britain's railways over 100 years, reflected in the unique photographs of the Press Association.

Facing page: Sheffield's main railway station during a bitter coal strike, when hundreds of Gordon Highlanders in full accoutrement were drafted in to protect what coal supplies remained in the depots.
January, 1911

The original Bank underground station near Mansion House, London. The first station opened on the 25th of February, 1900 when the City & South London Railway (now part of the Northern Line) opened an extension from Borough to Moorgate.
1st August, 1901

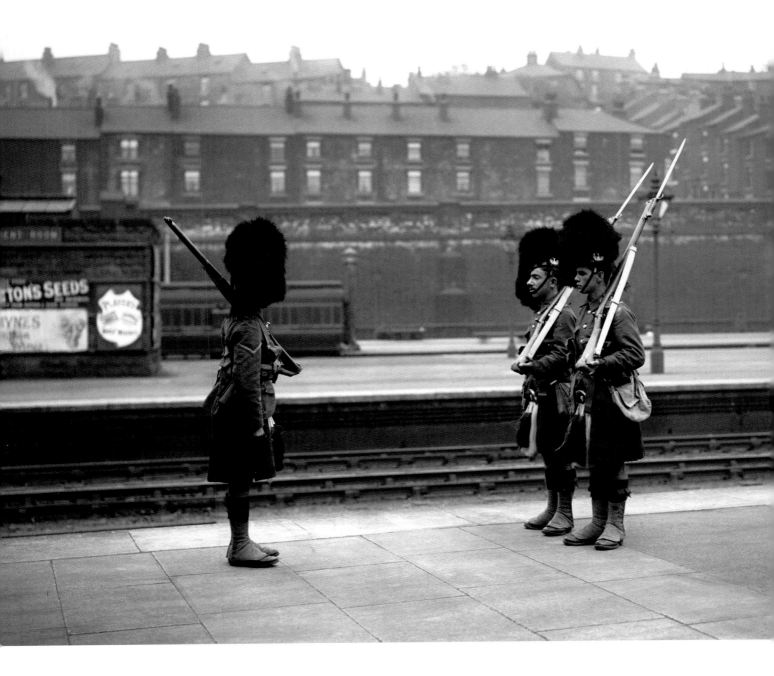

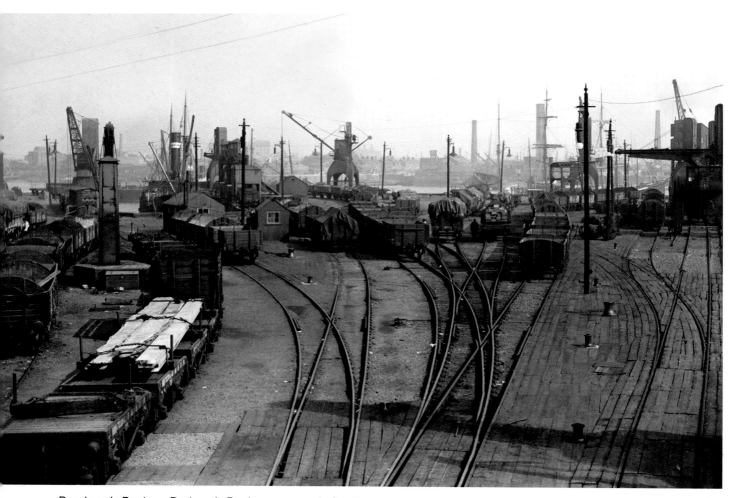

Deadman's Dock, or Dodman's Dock, was named after the shipbuilders Dudman & Company, who operated on the site at the end of the 18th century. Bought from them by the Brighton & South Coast Railway Company in 1850, it was later owned by Southern Railway and eventually British Rail after nationalization, until it closed in 1970. It is now the site of the Surrey Quays shopping centre on the Isle of Dogs.

January, 1911

A hopeful passenger arrives at Snow Hill railway station in Holborn, London to find it closed due to a coal strike, while a dour-faced newspaper vendor finds the morning trade poor. Miners were striking for the establishment of a minimum wage.
5th March, 1912

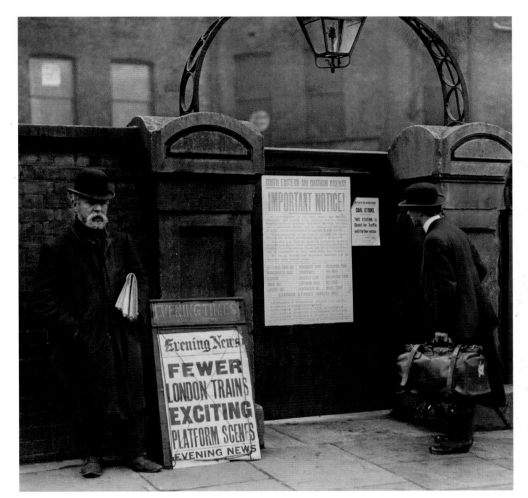

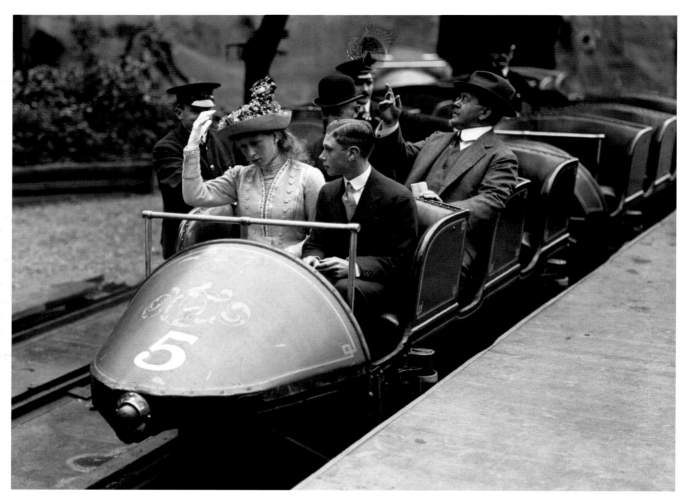

Prince Albert and Princess
Mary, children of King
George V and Queen Mary,
on the scenic railway at
Earls Court, London.
1st February, 1913

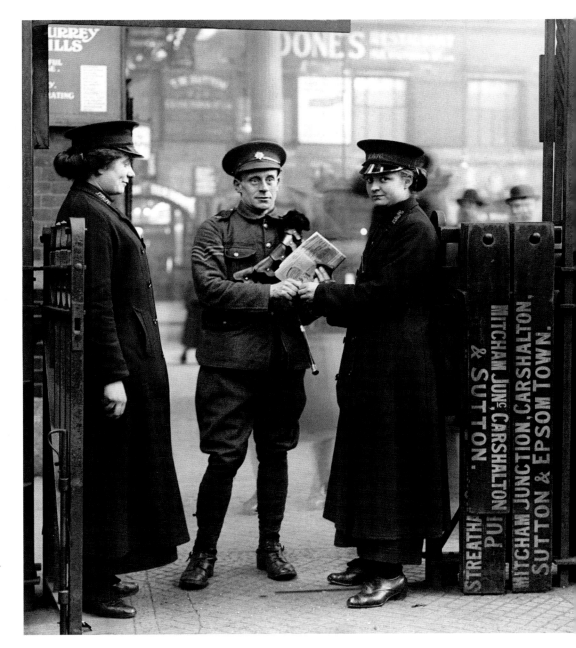

As increasing numbers of men left their jobs to join the armed forces, they were replaced by women. Here, female ticket collectors check the ticket of a British soldier at Victoria station, London during the early months of the First World War.
4th September, 1914

Female engine cleaners at work on the South Western Railway during the First World War.
January, 1917

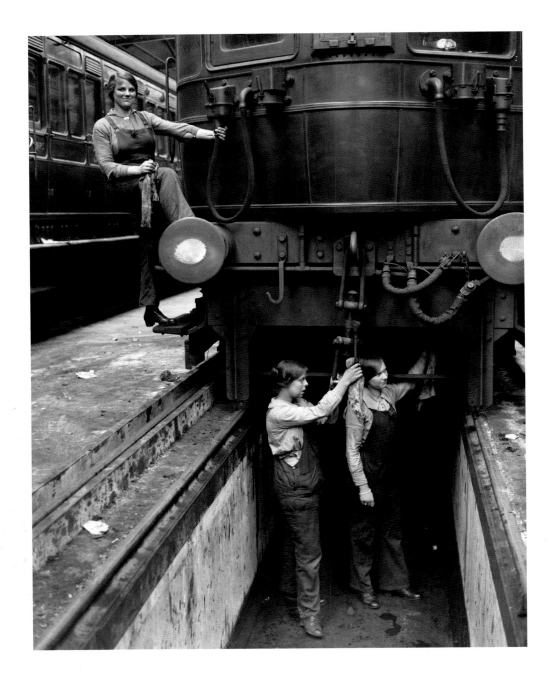

During a national rail strike, rail unions accused the government of applying a wartime pay agreement, allowing wage cuts to be made for some grades due to the fall in the cost of living to which the agreement was linked. Although the action was one of the most successful ever undertaken by the rail unions, volunteers attempted to keep the trains running. Here, an electric train leaves London Bridge station.
27th September, 1919

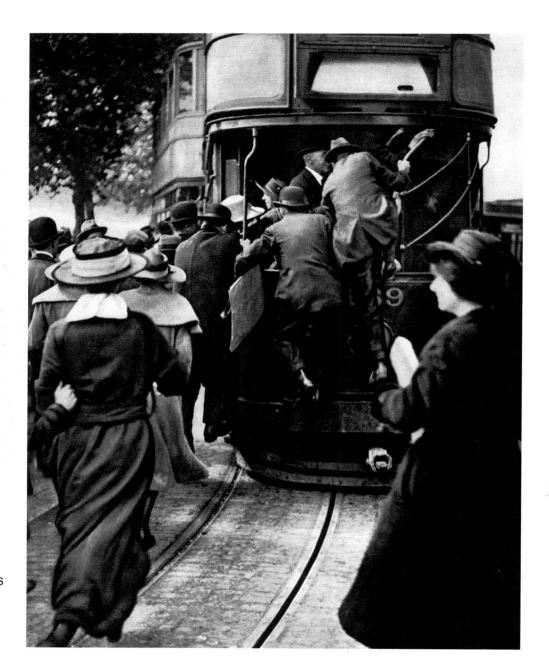

An unseemly rush for trams ensued on the Victoria Embankment, London during the rail strike.
4th October, 1919

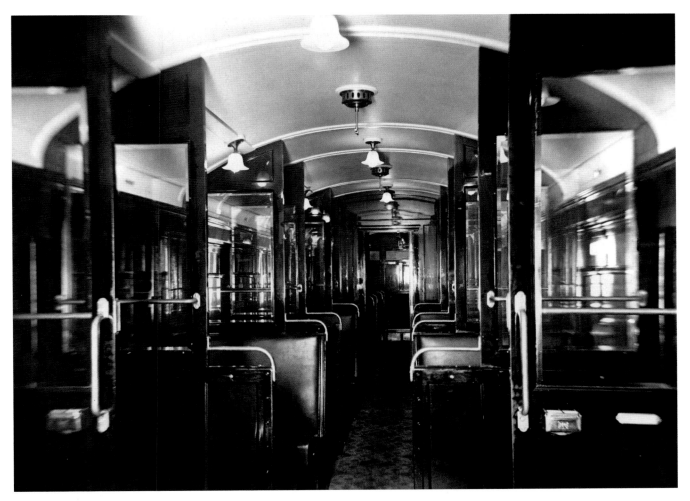

An interior view of one
of the carriages of a new
electric train constructed for
the Metropolitan Railway,
London's first underground
railway, which later became
the Circle Line.
18th December, 1919

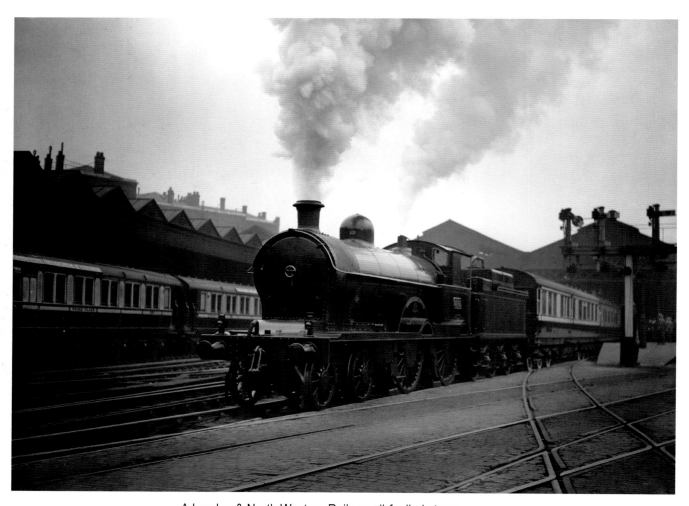

A London & North Western Railway oil-fuelled steam locomotive in 'blackberry black' livery pulls a passenger train out of Euston station, London. The LNWR existed between 1846 and 1922; during the late 19th century, it was the largest joint stock company in the world. It became a constituent part of the London, Midland & Scottish (LMS) railway in 1923.

1st September, 1920

British monarch King George V (second L) and his sisters, Queen Maud of Norway (L) and Princess Victoria (second R) were present at King's Cross station, London to greet Maud's husband King Haakon VII of Norway (C) and their son Prince Olaf (R) on their arrival from Oslo. **20th December, 1921**

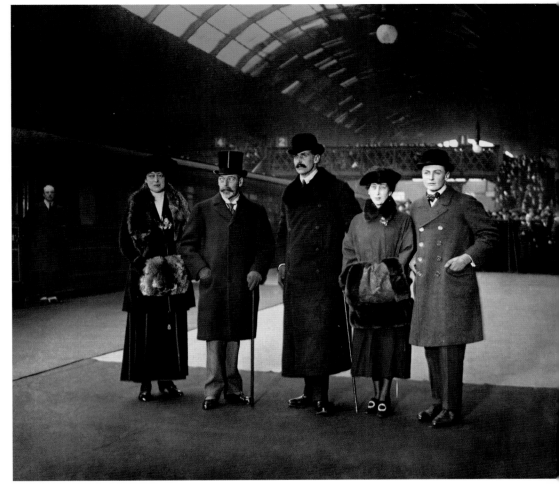

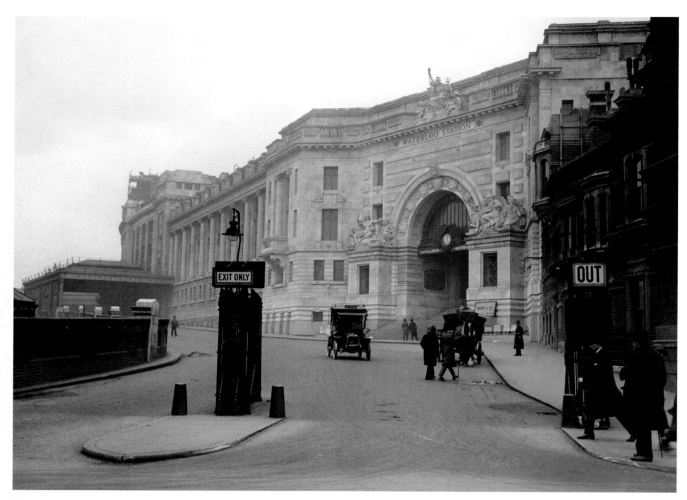

The main pedestrian entrance to London Waterloo station, the Victory Arch, was built as a memorial to company staff who died during the First World War. It opened onto an 880ft long concourse, which had 21 platforms after extensive reconstruction between 1900 and 1922.

25th April, 1922

Facing page: After extensive rebuilding, London Waterloo station was reopened on the 21st of March, 1922, rationalizing the station's notoriously confusing layout, which had earned it scorn from music hall comics and writers such as Jerome K Jerome, who wrote about the difficulty in finding a platform, departure time or destination in *Three Men in a Boat*.

1925

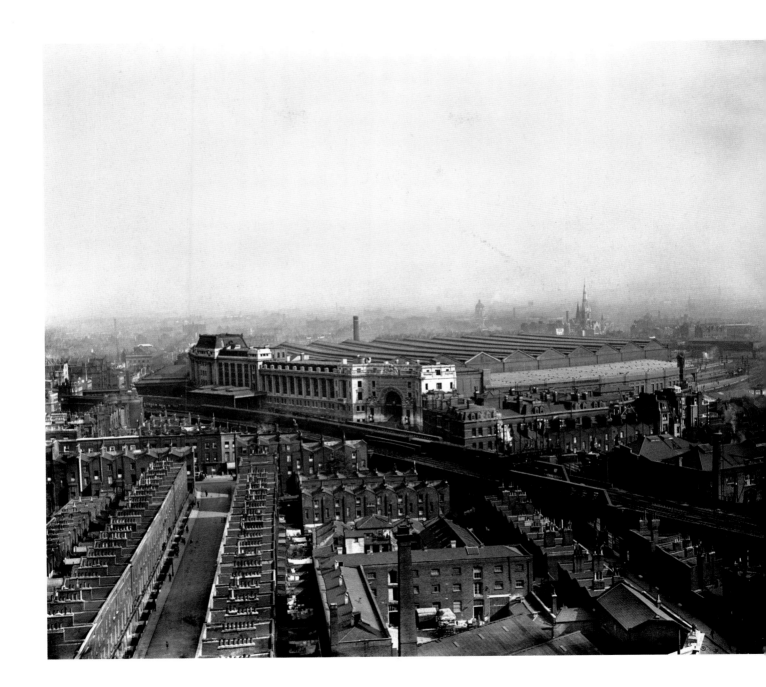

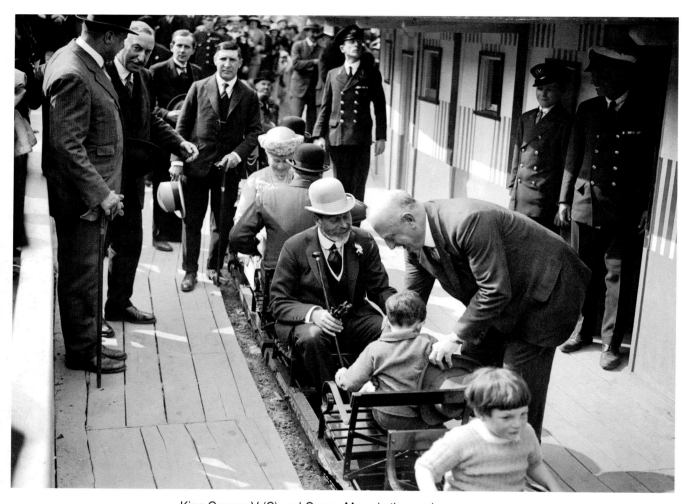

King George V (C) and Queen Mary, in the carriage
behind, ready to start a journey on the miniature railway
that ran around the British Empire Exhibition, Wembley,
Middlesex. The king, a railway enthusiast, visited the Palace
of Engineering where the now famous locomotive No 4472
Flying Scotsman, built in 1923, was on display.
14th May, 1925

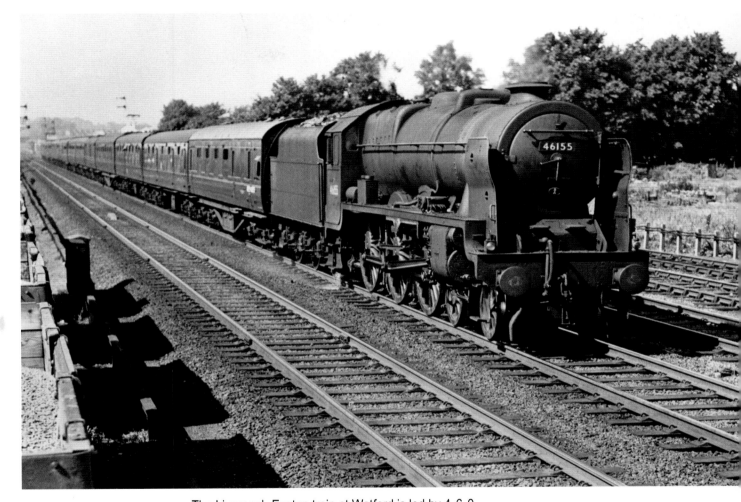

The Liverpool–Euston train at Watford is led by 4-6-0
locomotive No 46155 *The Lancer*, rebuilt by the North British
Locomotive Company as a Royal Scot class locomotive
in an effort to give the LMS railway an engine capable
of hauling the heaviest express trains.
1st May, 1926

Lord Ashfield (L), Chairman of the Underground Electric
Railways Company of London Ltd, hands over a silver
key to Colonel John Moore-Brabazon, pioneering aviator,
Conservative junior minister and later Minister of Transport in
Churchill's wartime government, during the opening of the new
underground railway with the world's longest tunnel, which ran
from East Finchley to Morden on the Northern line, London.
13th September, 1926

Facing page: Escalators being built at Piccadilly
Circus underground station, London as part of a
major renovation by John Mowlem & Co, which
had begun in 1925. Eleven escalators were
installed in two flights for access to the two lines
that served the station.
1st September, 1928

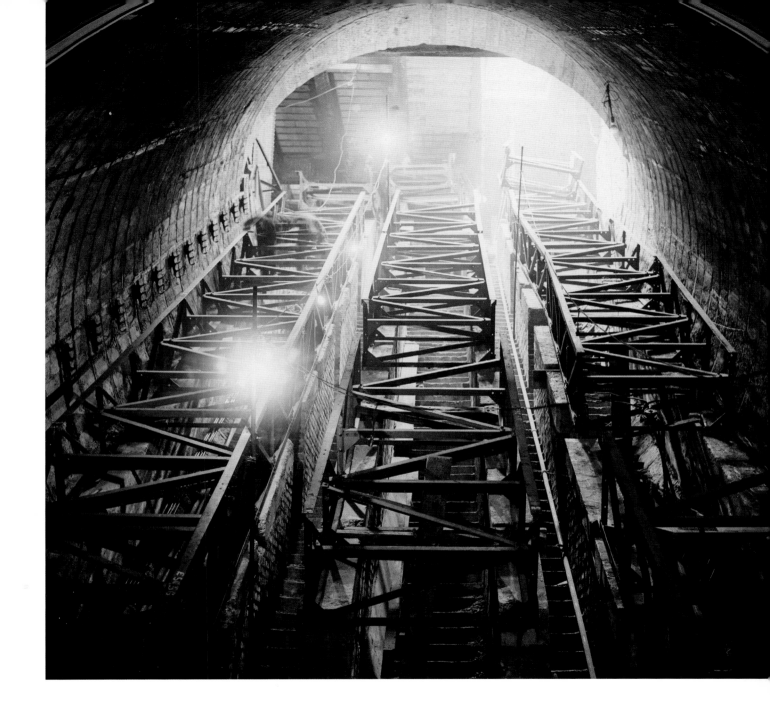

The upgrading work at Piccadilly Circus underground
station involved constructing a sub-surface booking hall and
circulating area, and pedestrian subways, directly beneath
Piccadilly Circus itself.

1st September, 1928

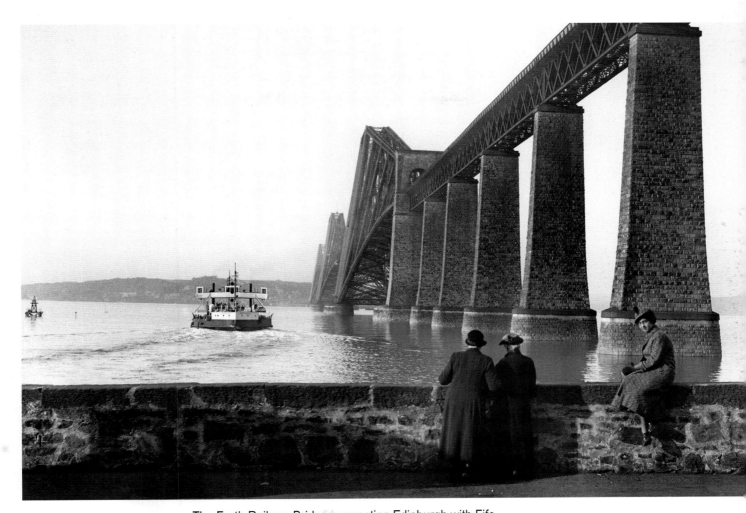

The Forth Railway Bridge connecting Edinburgh with Fife,
Scotland, the first cantilever bridge in the UK to be built
entirely in steel, was constructed between 1883 and 1890.
Designed by Sir John Fowler and Sir Benjamin Baker it was
built by Sir William Arrol's company.
1930

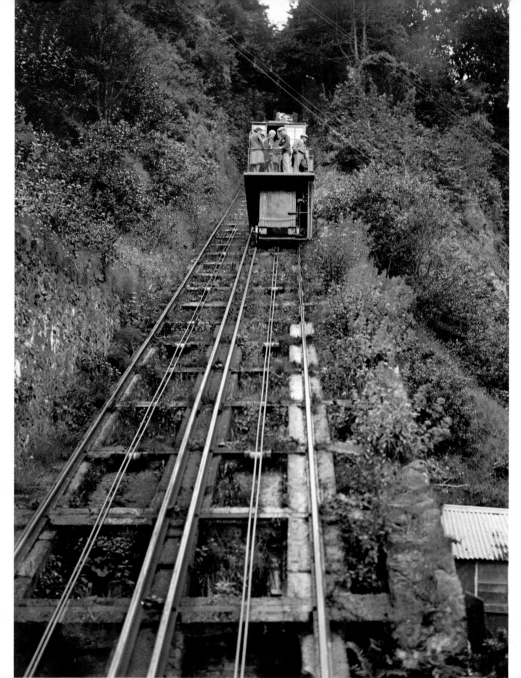

The Lynton & Lynmouth Cliff
Railway is a water-powered
funicular railway connecting
the twin towns of Lynton and
Lynmouth on the rugged
coast of North Devon. Until
the railway was built the cliffs
separating the towns were
an obstacle to economic
and tourism development.
Opened in 1890 it has been
in continuous use ever since.
Each of the two cars can
transport 40 passengers
or cabins can be replaced
with flat load beds for
haulage of freight.
4th August, 1931

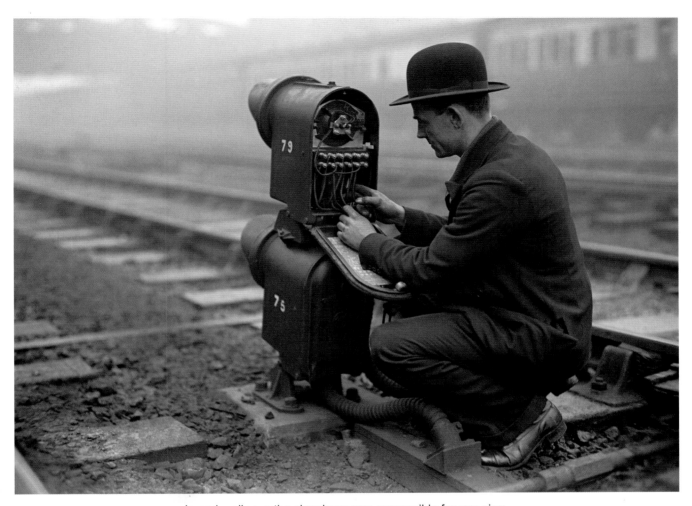

In early railways the signalman was responsible for ensuring that points were correctly set before allowing a train to proceed, and human error could lead to accidents. Interlocking, a British innovation, prevented points, signals and other appliances being operated unsafely. A new electrical relay interlocking is installed at Westbourne Bridge, a skewed girder bridge crossing the main railway tracks into Paddington station, London.
1932

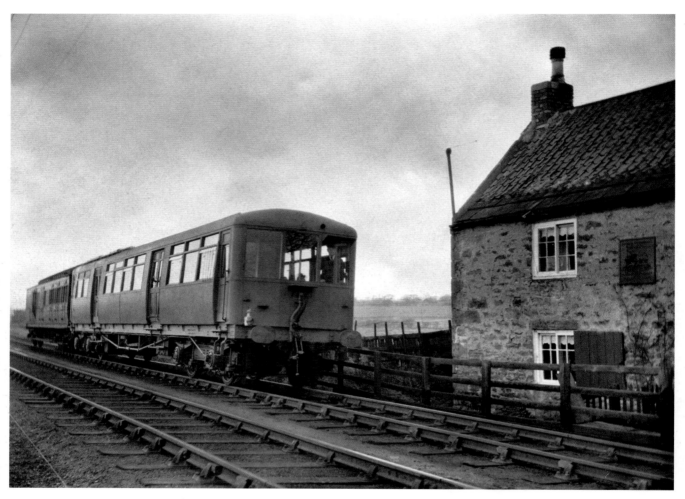

One of three diesel-electric railcars built by Armstrong-Whitworth Ltd, the *Northumbrian* was put in regular service on the North Wylam line near Newcastle-upon-Tyne. The self-propelled train, which could carry 60 passengers and luggage at 65mph, is seen passing the Wylam cottage where railway pioneer George Stephenson was born in 1781.
19th February, 1932

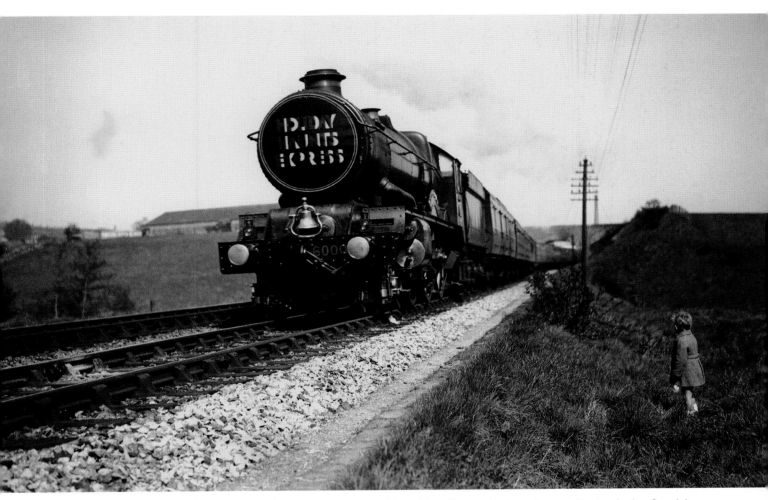

Great Western Railway's 6000 Class *King George V* steam locomotive hauls the *Cornish Riviera Express* through Somerset as a young boy looks on. The smoke box door bears a legend referring to the company's annual *Holiday Haunts* publication listing attractions at West Country resorts served by GWR lines. The bell was presented during the locomotive's tour of the United States in 1927 to commemorate the Baltimore & Ohio Railroad's centenary.

6th May, 1933

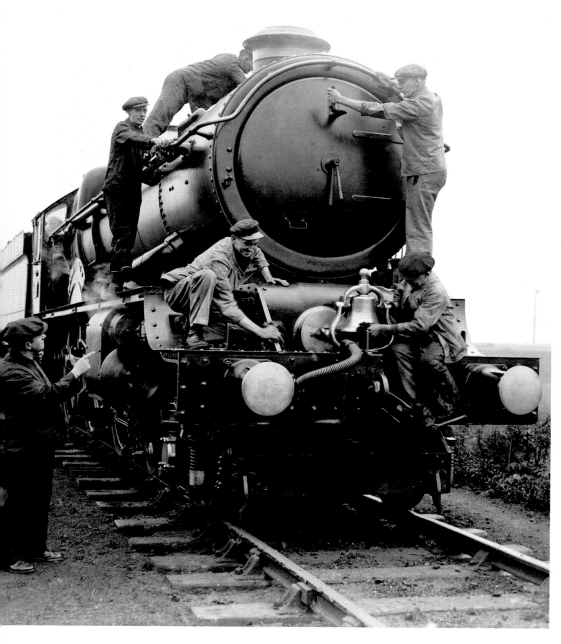

Men set to work to get
the *King George V*
GWR locomotive spotless
and shiny in time for the
honeymoon trip of Prince
George, Duke of Kent, after
his forthcoming marriage
to Princess Marina of
Greece and Denmark.
6th November, 1934

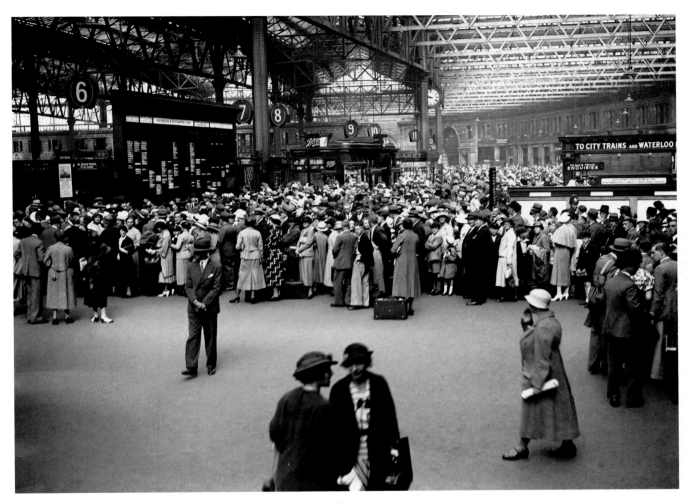

Crowds of holidaymakers wait
for trains at London Waterloo
station during the busy summer
holiday season.
23rd July, 1935

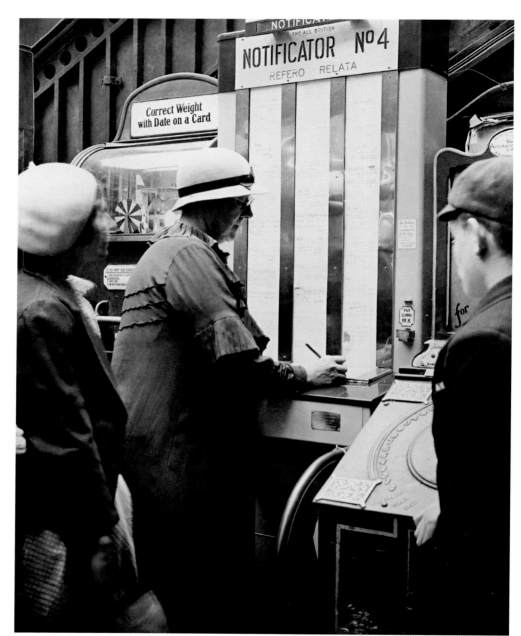

A queue forms to use the Notificator 'robot messenger' at Liverpool Street station. On receipt of a coin in the slot a brief message to friends or relations, written on a continuous strip of paper, passes behind a glass panel where it remains in public view for two hours.
21st August, 1935

Young holidaymakers and
their parents enjoy the
miniature railway train hauled
by a real steam locomotive
on the beach at Southsea,
near Portsmouth.
22nd August, 1935

Onlookers line the railway embankment to pay their last respects to King George V, who died of influenza on the 20th of January. After lying in state at Westminster his body was transported to Windsor for burial in the funeral train hauled by GWR locomotive No 4082 *Windsor Castle*.
28th January, 1936

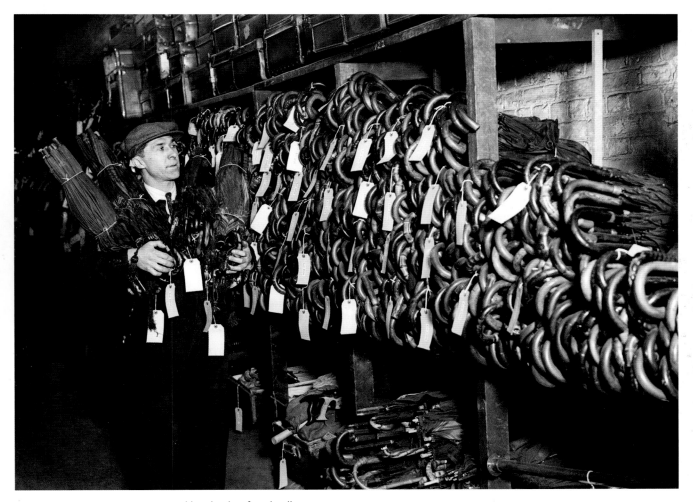

Hundreds of umbrellas
in the lost property
department at Waterloo
station, south London.
1st April, 1936

A fine collection of pith helmets at the Waterloo station lost property office, no doubt left on trains by forgetful travellers returning from the colonies.

1st April, 1936

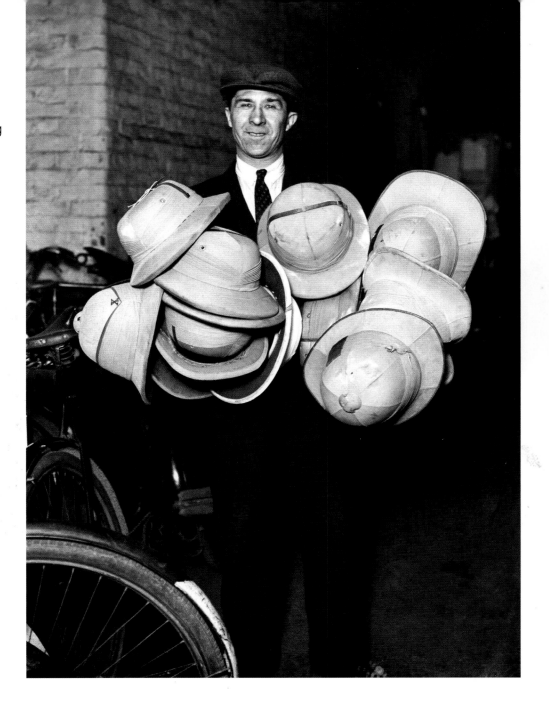

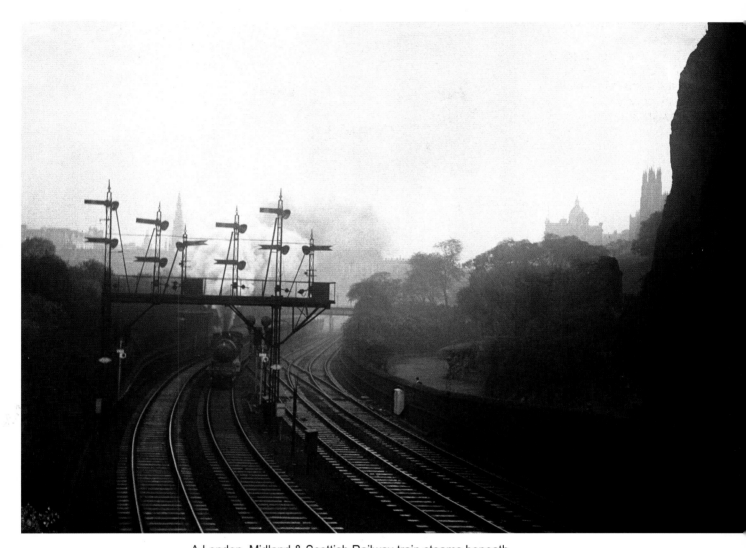

A London, Midland & Scottish Railway train steams beneath
a signal gantry in the shadow of Edinburgh Castle.
19th October, 1936

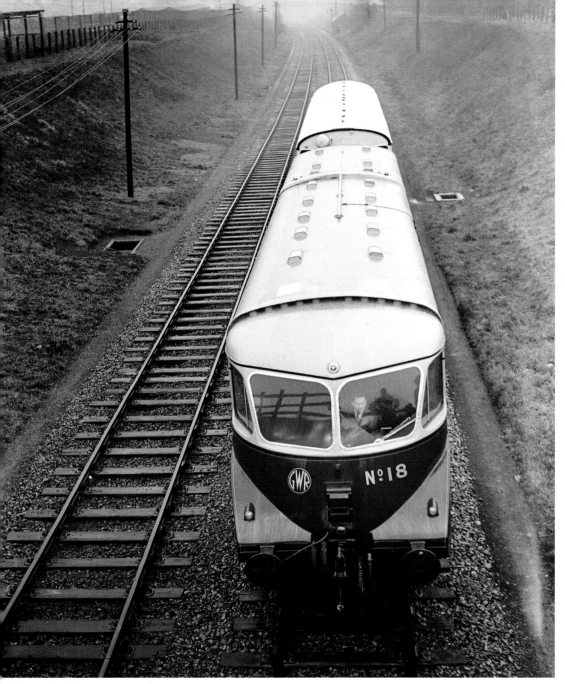

Facing page: The *Dominion of Canada*, LNER A4 Class steam locomotive No 4489, designed by Sir Nigel Gresley, featured a streamlined design to improve aerodynamics and speed capabilities, and to create updraught to lift smoke away from the driver's vision. On her maiden voyage she sported a garter blue livery.
24th May, 1937

The Great Western Railway introduced the first of a series of diesel railcars in 1933 that were still in use in the 1960s. With buffers and draw gear for hauling a trailing coach, prototype No 18 featured 'air smoothed' bodywork, earning it the nickname 'flying banana'.
2nd February, 1937

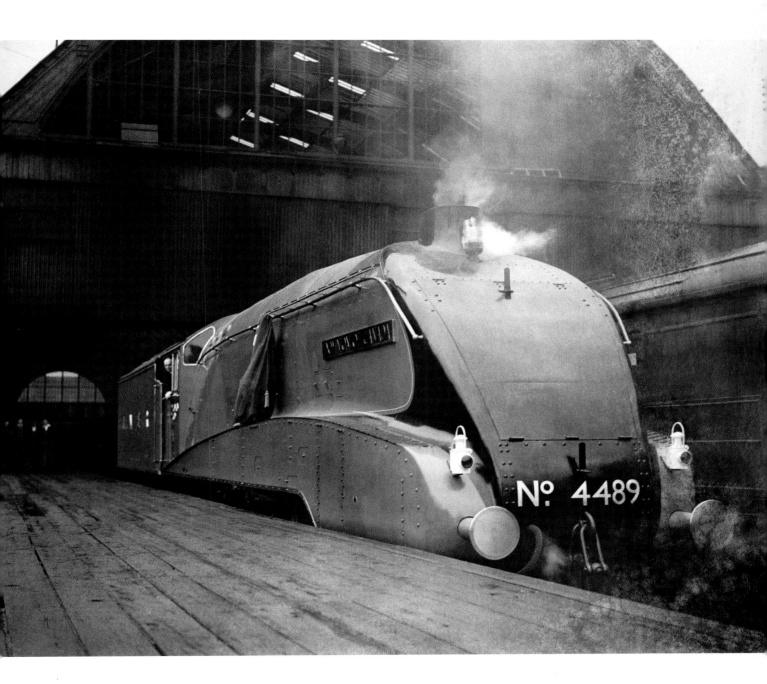

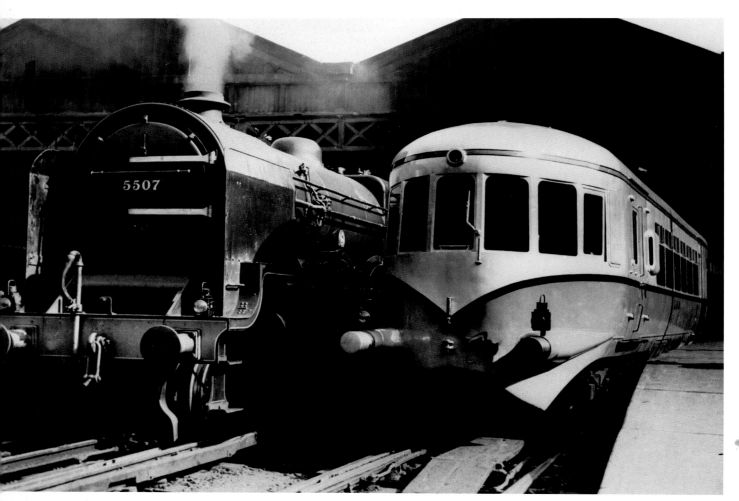

The London, Midland &
Scottish *Royal Tank Corps*
No 5507, one of 52 Patriot
Class passenger steam
locomotives, stands
alongside a streamlined LMS
articulated diesel railcar.
26th October, 1937

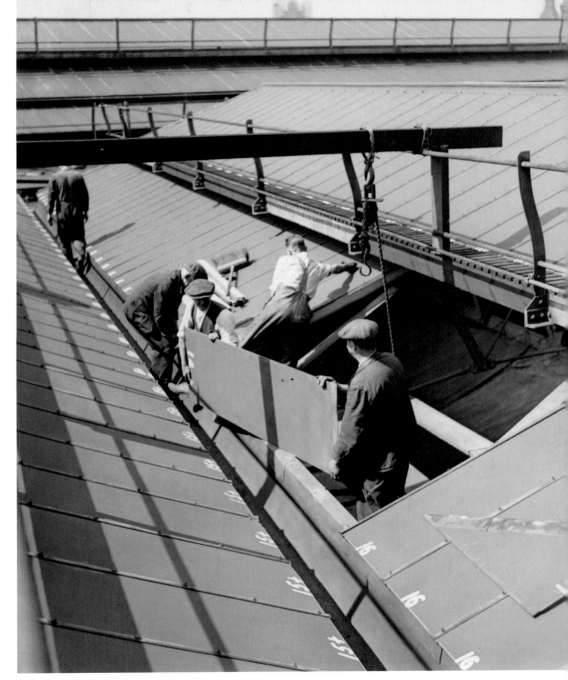

The fear of the bombing that was to follow during the London Blitz led to glass on the roof of Waterloo station being replaced by asbestos sheets.
January, 1939

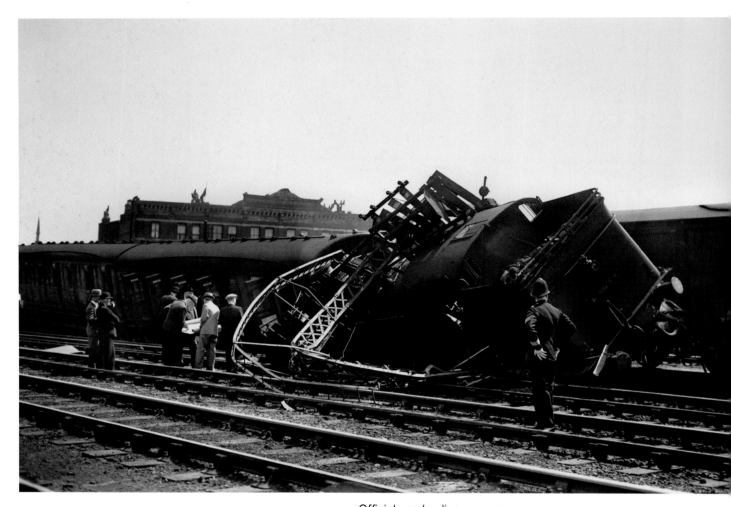

Officials and police assess
the damage to a steam
locomotive and its train after
a crash at Caledonian Road,
north London.
1st May, 1939

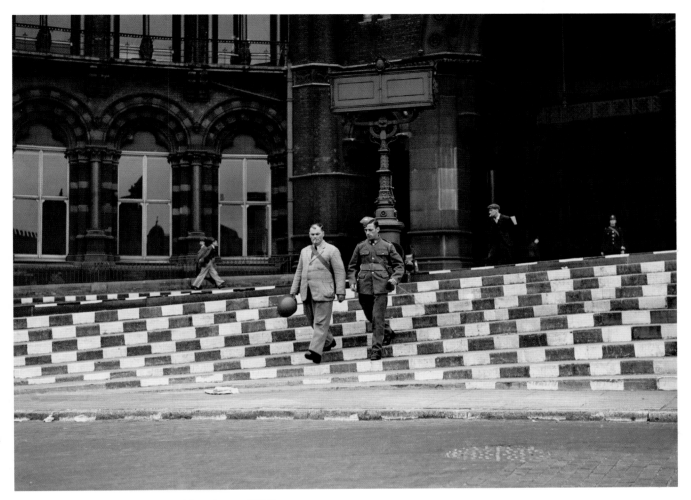

The steps of St Pancras station were painted black and white so that they could be easily seen during the wartime blackout.
1st August, 1939

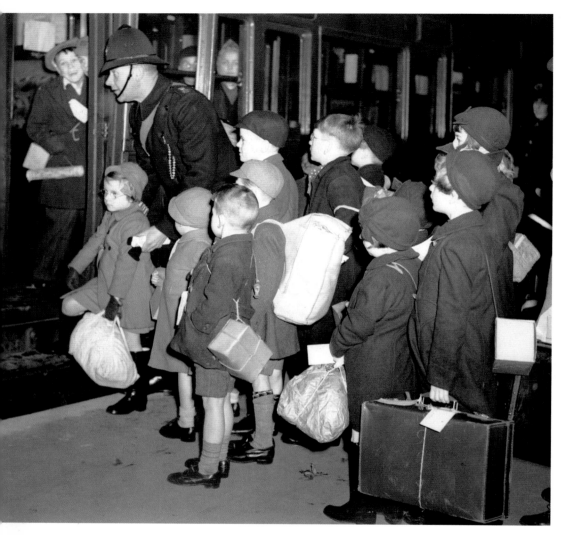

London schoolchildren with their luggage and gas masks in cardboard boxes are ushered onto trains for evacuation to the relative safety of Devon in the West Country. Around three million people, the majority of them children, were moved from urban areas at risk from bombing during Operation Pied Piper.

1st September, 1939

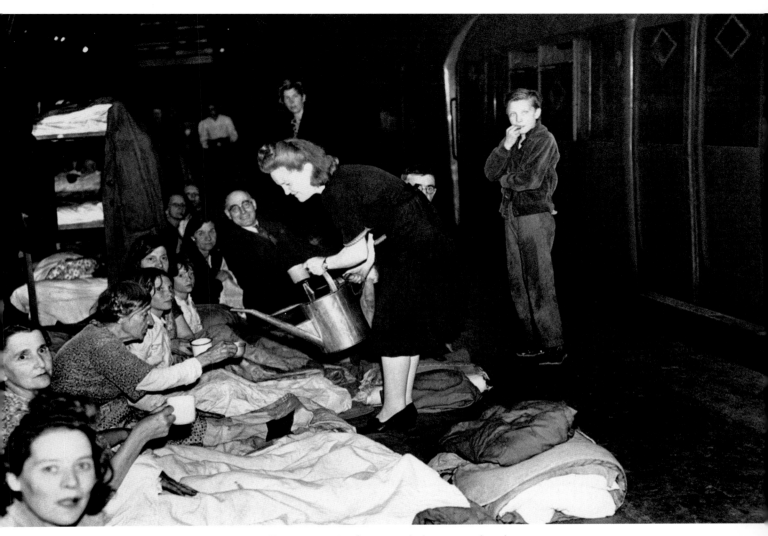

A woman dispenses water from a watering can as Londoners take shelter on the platforms of the London Underground during the Blitz.
10th October, 1940

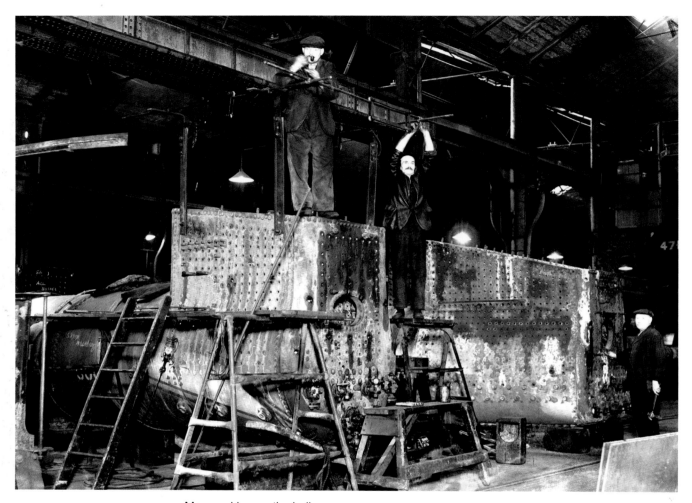

Men working on the boiler
of a steam locomotive,
one of many new engines
being made to keep up with
the demands of the armed
forces during the war effort.
15th December, 1941

A female worker uses
a flame-cutting tool
to cut metal plate for
a new locomotive.
15th December, 1941

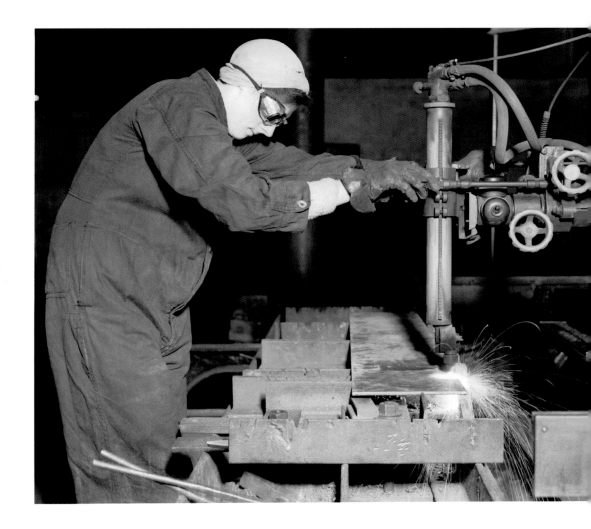

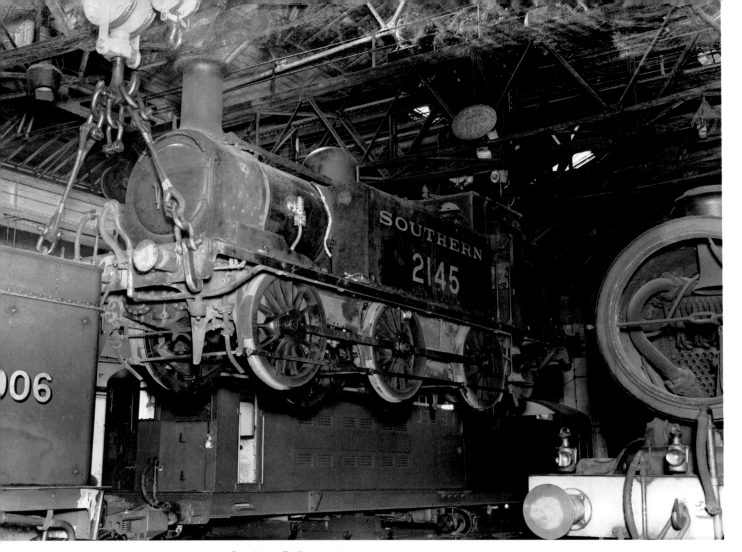

Southern Railways steam
locomotive No 2145 is
hoisted aloft during repairs.
15th December, 1941

The manufacture and repair
of locomotives during the
Second World War was an
ongoing task, as shown
by these engineers, who
are boring the cylinder of
a steam engine.
16th December, 1941

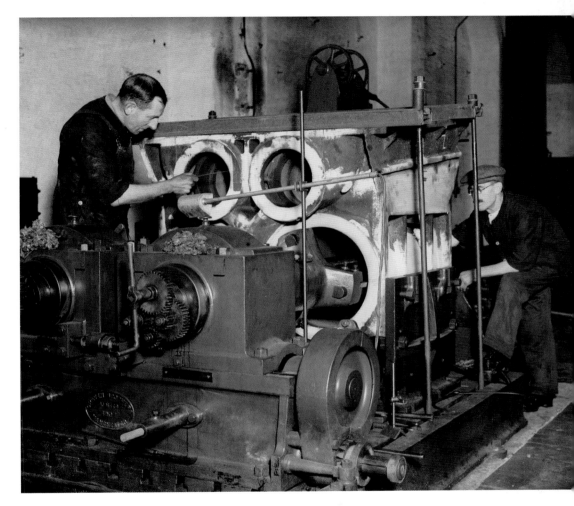

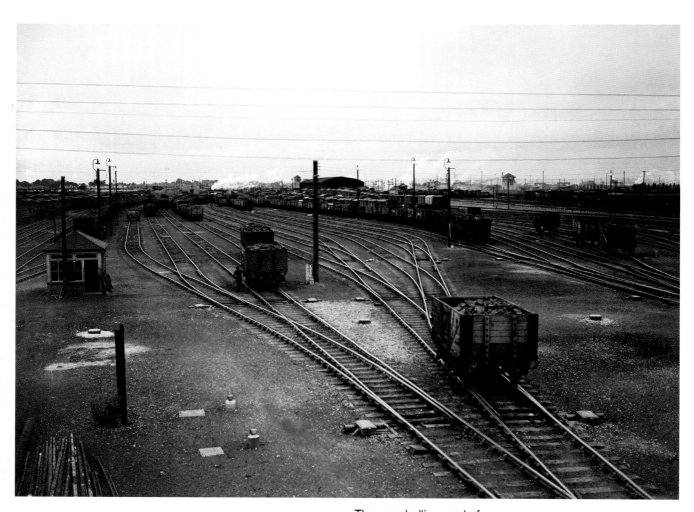

The marshalling yard of
an LNER freight station,
where laden trucks are
separated onto several
sidings for sorting and
assembly into long trains.
1st December, 1942

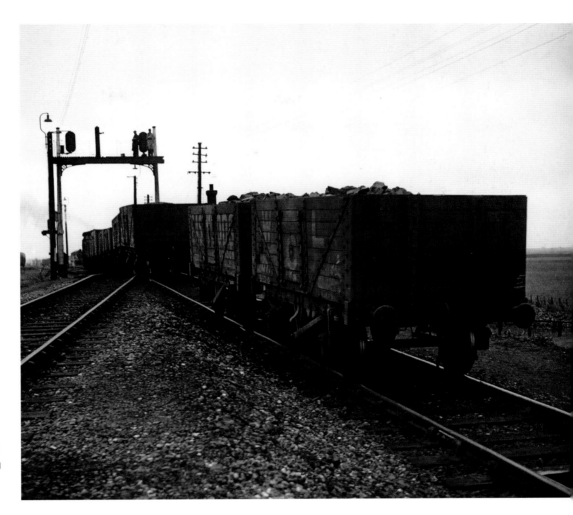

Freight trains are shunted into the marshalling yard along a lead track by the locomotive, passing through various points to guide them onto specific sidings.
1st December, 1942

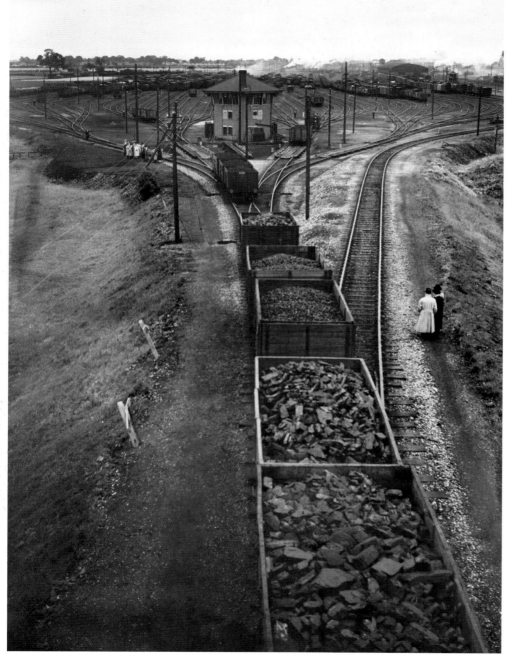

In some marshalling yards the lead track was laid on an artificially built hill called the 'hump'. Single trucks, or groups of trucks, were uncoupled just before or on the crest of the hump to roll by gravity to their assigned sidings.
1st December, 1942

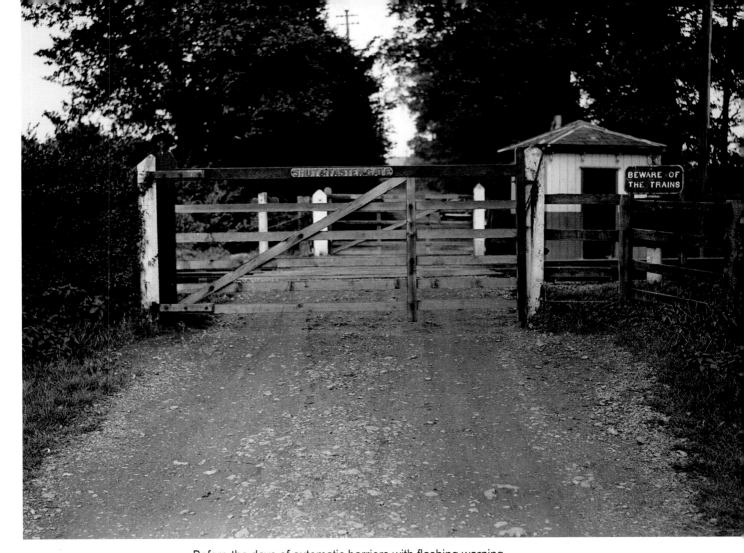

Before the days of automatic barriers with flashing warning lights, level crossings over railway lines, such as this example near Virginia Water, Berkshire, consisted of nothing more than a pair of gates bearing the signs 'Shut & Fasten Gate' and 'Beware of the Trains'.

1st May, 1945

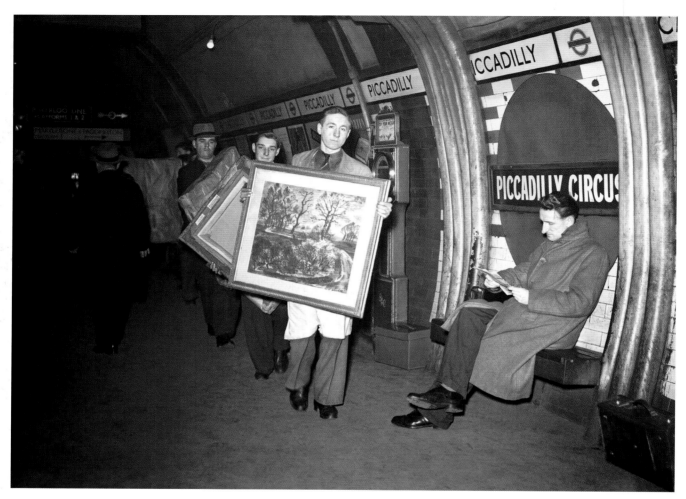

Eighty feet below the surface of Piccadilly Circus, in part of the underground station known as Aladdin's Cave, national art treasures from the Tate Gallery and the London Museum, stored at the outbreak of the Second World War, are retrieved under police guard at the end of the conflict.
4th February, 1946

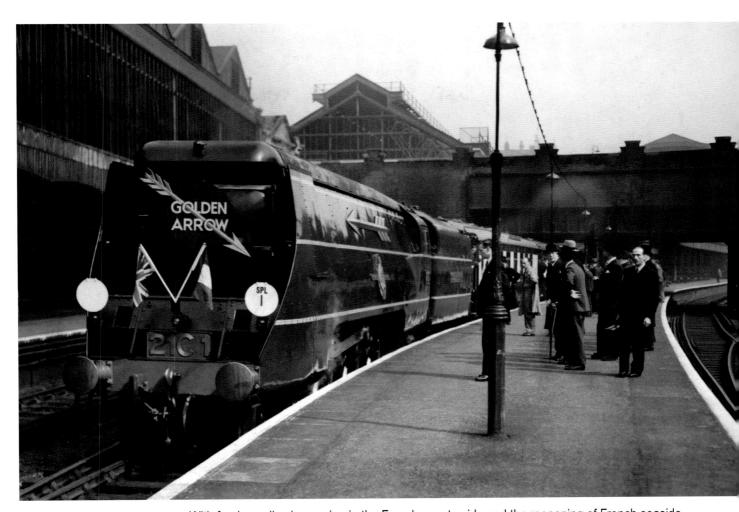

With food supplies increasing in the French countryside and the reopening of French seaside resorts, the prospects for British holidaymakers improved. SR's luxury *Golden Arrow* boat train service, hauled by the Merchant Navy Class 21C1 *Channel Packet* air-smoothed 4-6-2 Pacific steam locomotive, ran from London Victoria to Dover, where passengers took the ferry to Calais to join the *Flèche d'Or* of the Chemin de Fer du Nord for Paris.

13th April, 1946

Manchester Central station, which opened in 1880, saw continuous service until its closure on the 5th of May, 1969, when remaining services were switched to Manchester Piccadilly station. After years of neglect it was to be refurbished in the 1980s to become the Greater Manchester Exhibition and Conference Centre (G-Mex), later being renamed Manchester Central in honour of its railway history.
11th July, 1946

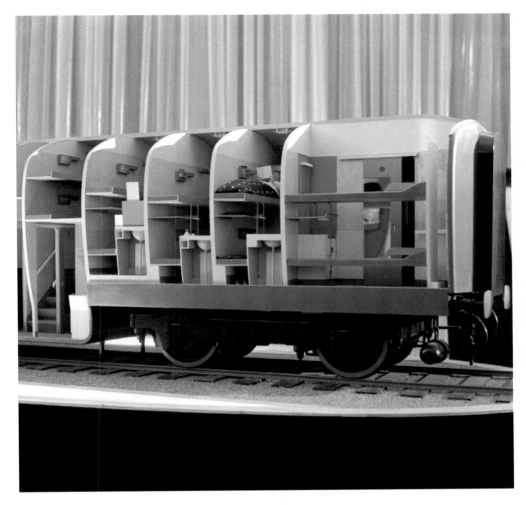

A scale model of a third class railway sleeper carriage was unveiled in the morale-boosting *Britain Can Make It Exhibition* held at the Victoria and Albert Museum, London. The exhibition, aimed at enhancing Britain's postwar export trade, was organized by the newly formed Council of Industrial Design, later to become the influential Design Council.

23rd September, 1946

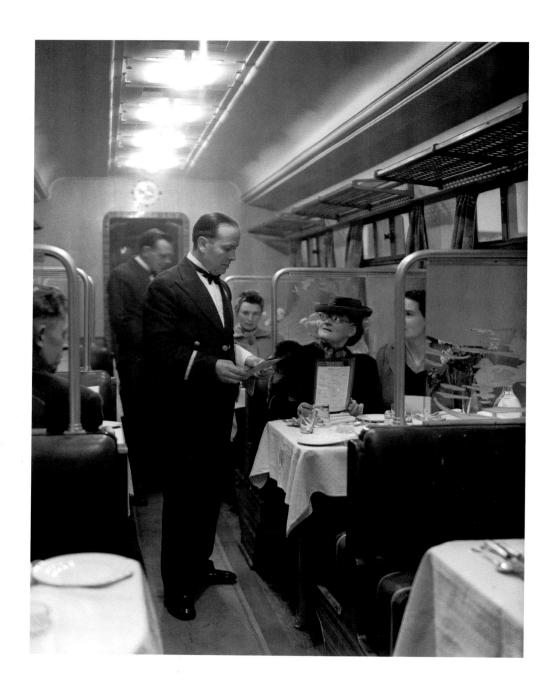

Table service in the new
Great Western Railway
third-class dining saloon.
5th November, 1946

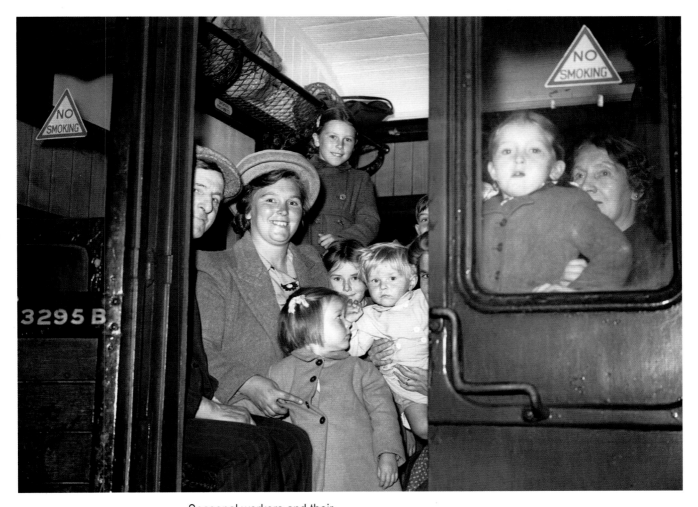

Seasonal workers and their
families crowd into a railway
carriage at Waterloo station
to wait for the train's departure
for Kent and the hop fields
where they will work.
15th August, 1947

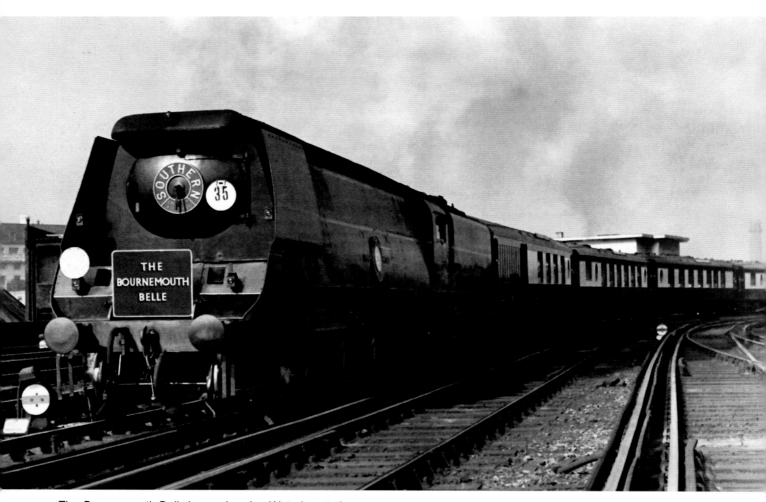

The *Bournemouth Belle* leaves London Waterloo station,
hauled by a Merchant Navy Class Pacific locomotive,
on its first postwar run after Southern Railway introduced
more and faster trains on the inauguration of their winter
timetables. A civic reception was held in Bournemouth
to mark the train's arrival 2hr and 10min after its departure.
7th October, 1947

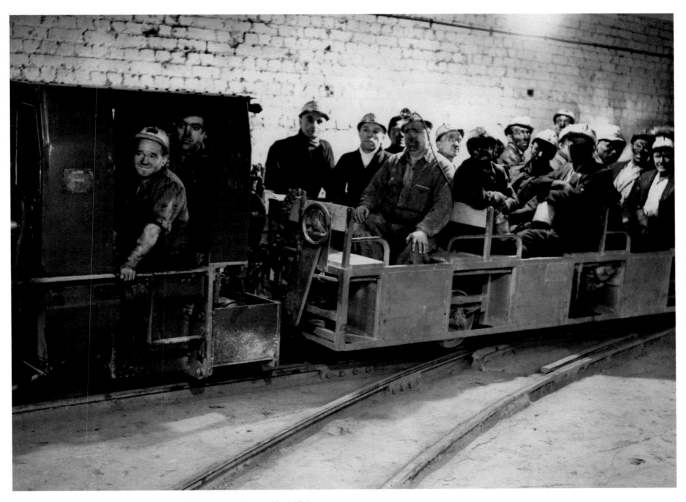

Miners coming off shift by
way of the newly installed
diesel railway at Nook
Colliery, Astley, Lancashire.
2nd April, 1948

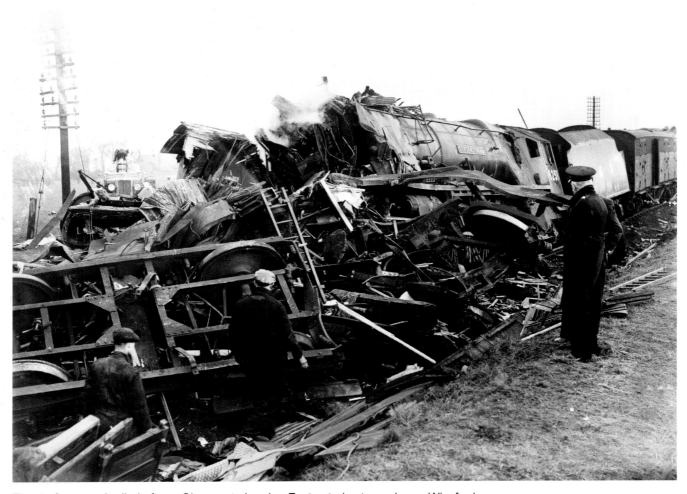

Twenty-four people died after a Glasgow to London Euston train stopped near Winsford, Cheshire, when the communication cord was pulled by a passenger, a soldier on leave seen to depart the train after it had stopped. A following postal express hauled by LMS Coronation Class 4-6-2 No 6251 *City of Nottingham* ran into the train, leaving only five of the ten passenger coaches and eight of the 13 postal coaches intact. The signalman at Winsford Station had erroneously reported the passenger train clear before accepting the postal train.
17th April, 1948

Before intercoms and lights were introduced to trains, railway guards were equipped with coloured flags and lamps to indicate to the engine driver. Green was generally the signal to 'go', while red meant 'danger'.

21st September, 1948

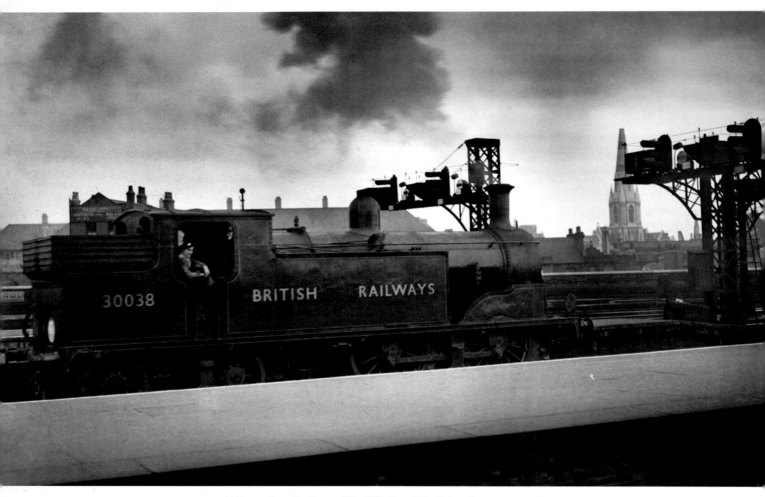

With nationalization of the 'Big Four' British railway companies on the 1st of January, 1948, locomotives such as SR's M7 Class steam tank locomotive No 30038 – shown holding at a railway signal for the 'all clear' – were repainted in British Railways livery. The tank locomotive, which carried its own water and fuel rather than pulling them on a tender, was a reliable suburban passenger engine until the early 1960s.

21st September, 1948

The engine driver of the Pullman Boat Train receives last minute instructions from the supervisor at London Waterloo station, before setting off on his foggy journey to Southampton Docks to connect with RMS *Queen Mary* for the transatlantic service to New York, USA.

30th November, 1948

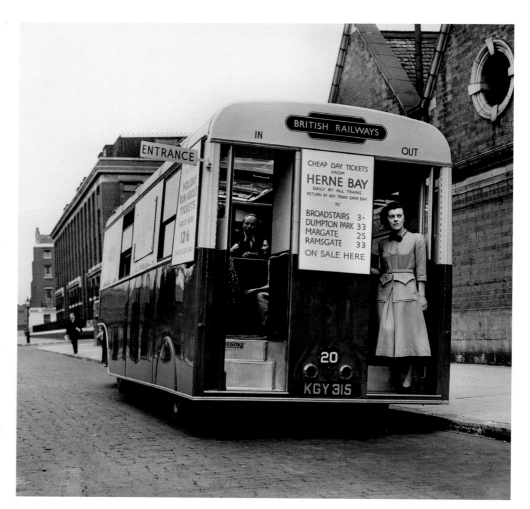

A British Railways mobile booking office at Herne Bay, Kent offers cheap day tickets and third-class only 'Holiday Run-about' tickets to other popular coastal resorts.
11th August, 1949

An underground 'tube' train pulls into Cockfosters station, the terminus of the northbound Piccadilly Line.
25th February, 1950

Passengers wait for a train
on a platform at Piccadilly
Circus underground station.
25th May, 1950

A railway level crossing
at Grays in Essex.
21st September, 1950

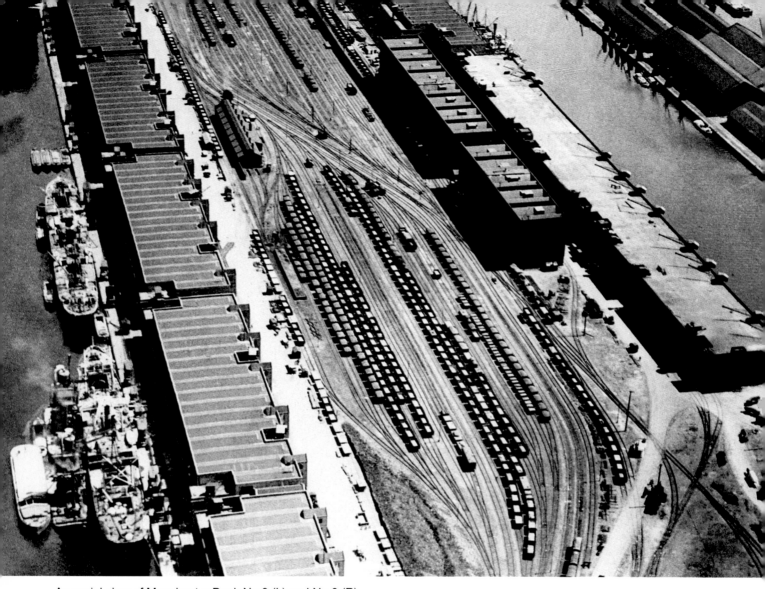

An aerial view of Manchester Dock No 9 (L) and No 8 (R),
40 miles inland on the upper reaches of the Manchester Ship
Canal. The docks were served by a network of railway lines.
January, 1951

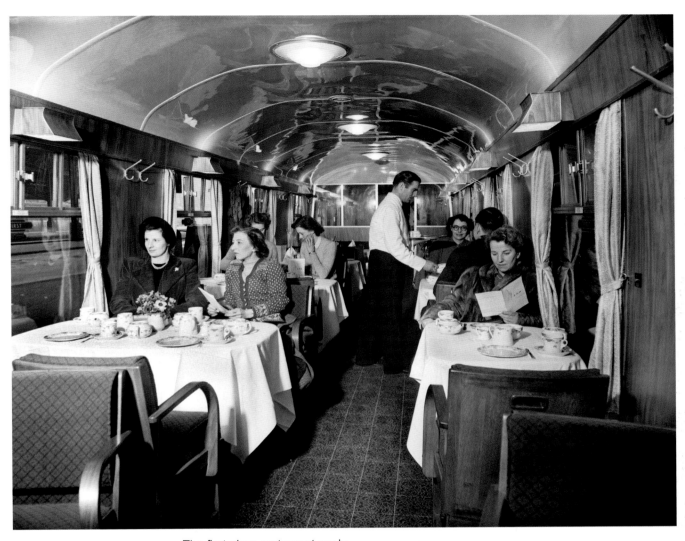

The first-class restaurant car in
one of the new standard Mark 1
carriages for British Rail.
12th March, 1951

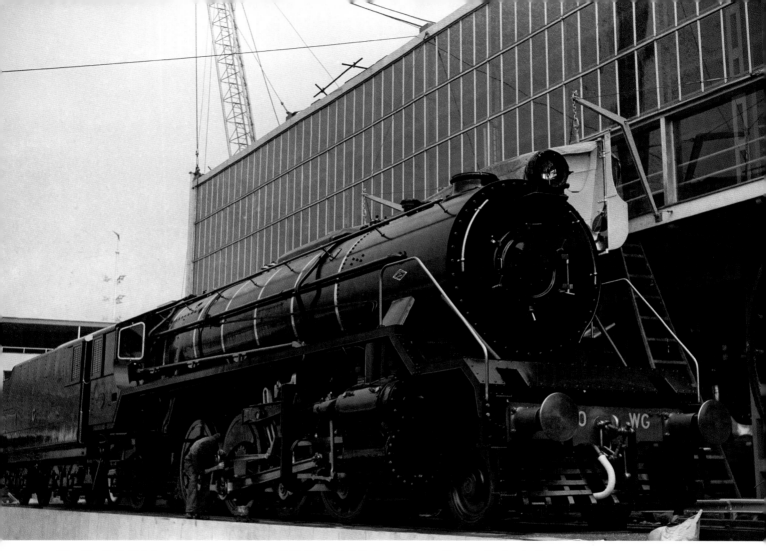

The North British Locomotive Company's WG Class 2-8-2 steam locomotive on display in the Transport section of the Festival of Britain. NBL, formed in 1903 through the amalgamation of three Glasgow companies – Sharp Stewart, Neilson Reid and Dübs & Co – became the largest locomotive building company in Europe, capable of producing 600 engines per year, which were exported to Australia, Malaysia and New Zealand.

30th April, 1951

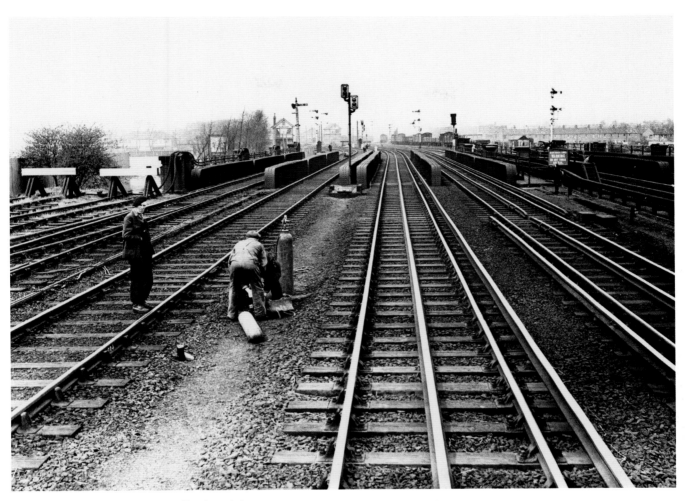

Track maintenance men
working on an electrified
railway track crossing a
bridge, while a lookout
keeps a wary eye out for
approaching trains.
2nd May, 1951

Cartoonist and constructor of whimsical kinetic sculpture Rowland Emett stands beside *Neptune*, one of the 4-6-2 configuration locomotives of the Far Tottering to Oyster Creek Railway. Set in Battersea Park, the pleasure railway was a standard 15in gauge set-up built for the Festival of Britain; the locomotives, rolling stock and stations were derived from Emett's cartoons in *Punch*.

5th May, 1951

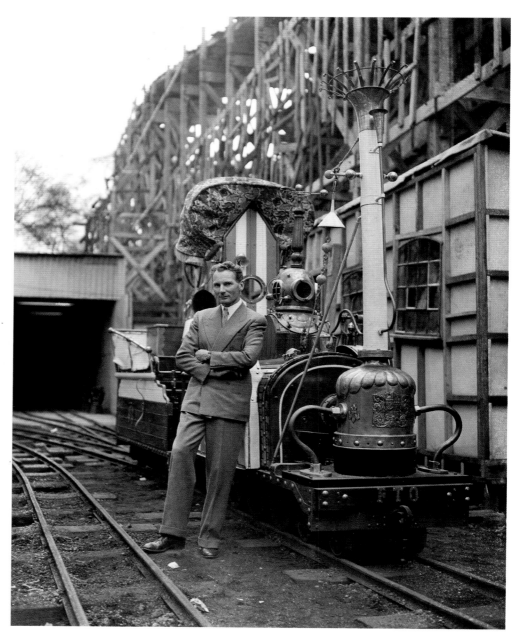

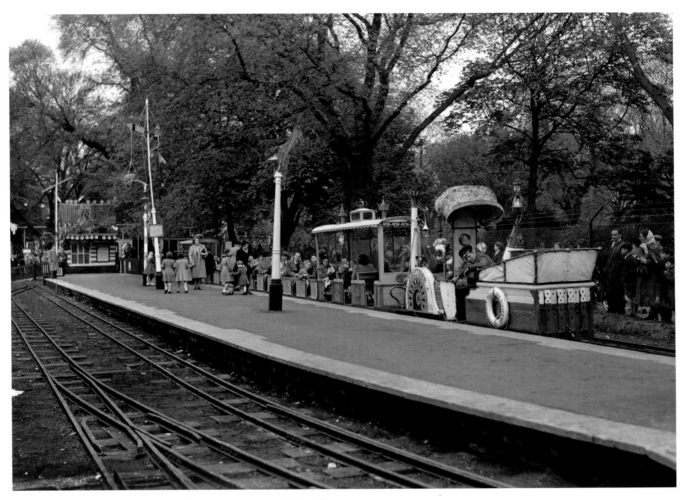

Neptune prepares to trundle
a trainload of passengers
along the Far Tottering to
Oyster Creek Railway at the
Festival of Britain fun fair in
Battersea Park.
28th May, 1951

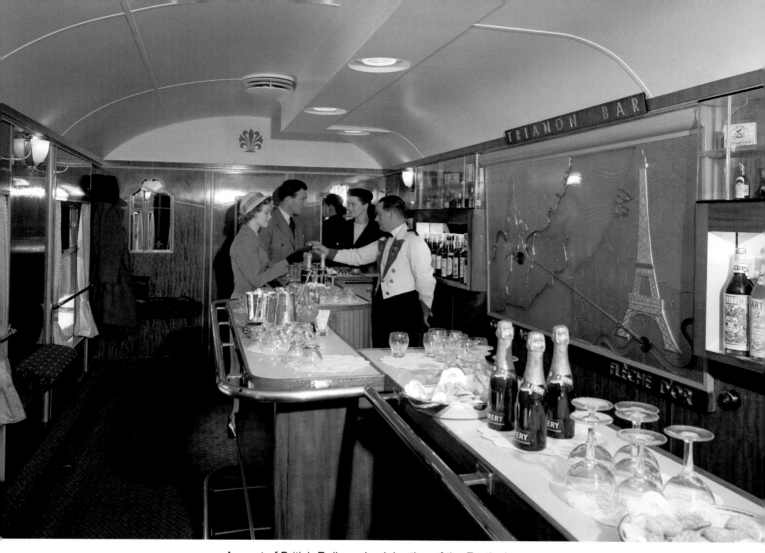

As part of British Railways' celebration of the Festival of Britain, a new set of Pullman carriages was built for the London to Dover section of the *Golden Arrow* luxury boat train. Passengers en route to Paris could partake in refreshment in the 'Trianon Bar' located in the first-class parlour and bar car *Pegasus*.

5th June, 1951

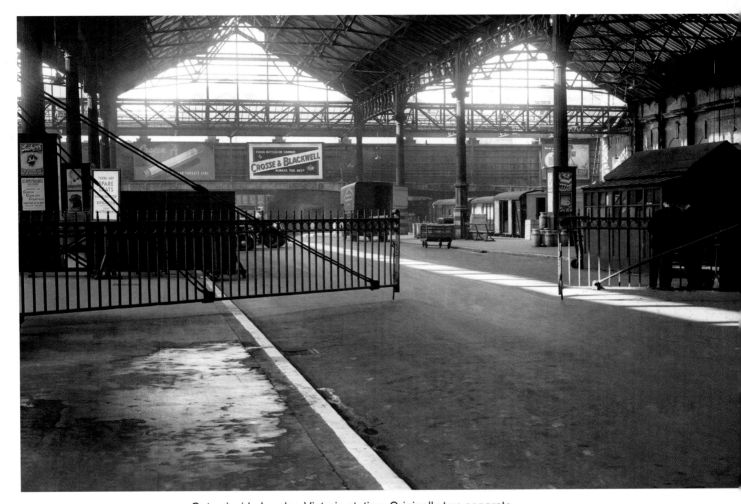

Gates inside London Victoria station. Originally two separate stations – the Eastern (Chatham) side was the terminus for services to Kent; the Western (Brighton) side the terminus for services to Surrey and Sussex – they were connected in 1924 and the interior redeveloped in the 1980s with the addition of shops on the concourse, and the Victoria Place shopping centre above the western platforms.

4th April, 1952

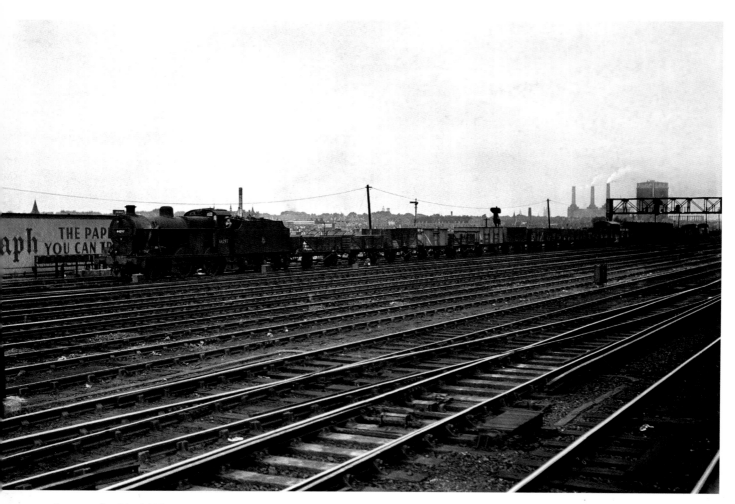

Locomotive No 44297, originally built in Derby for the Somerset & Dorset Joint Railway in 1927 and taken into LMSR stock in 1930, hauls a goods train on the approach to Clapham Junction, south London. Battersea Power Station and nearby water tower are visible (R).

28th July, 1952

Facing page: The vast roof of Cannon Street station in central London was damaged by incendiary devices during the Second World War, and although its glazing had been removed prior to the conflict, the factory in which it was stored was bombed. During the 1950s property boom it was proposed to construct a multi-storey office building above the station. All that remains of the original architecture are the twin towers on the river frontage, and their low flanking walls.

5th August, 1952

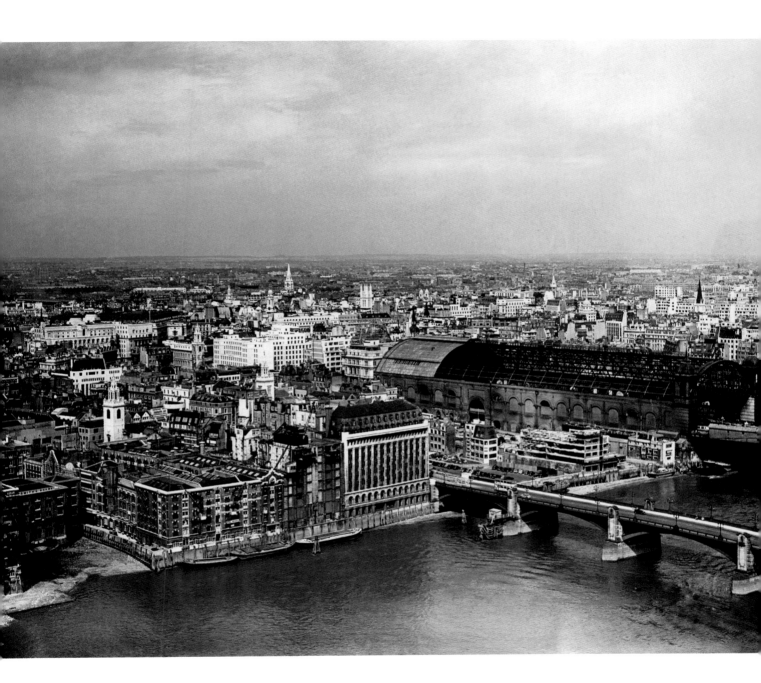

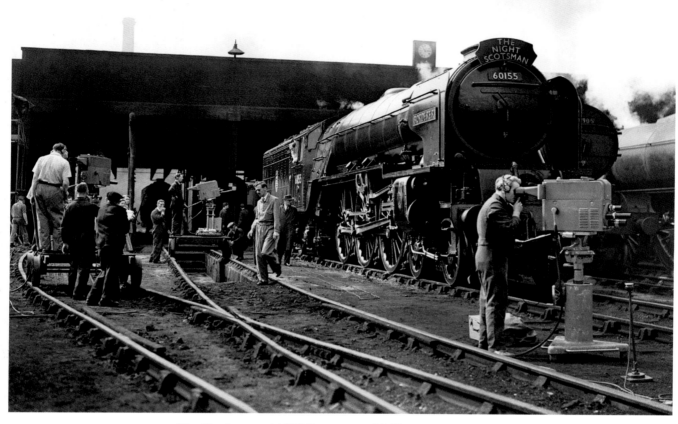

The *Borderer*, an LNER Peppercorn A1 Class steam locomotive that hauled the *Night Scotsman* train from King's Cross, London to Edinburgh, is filmed for a BBC television documentary on the delivery of the night mail.

28th August, 1952

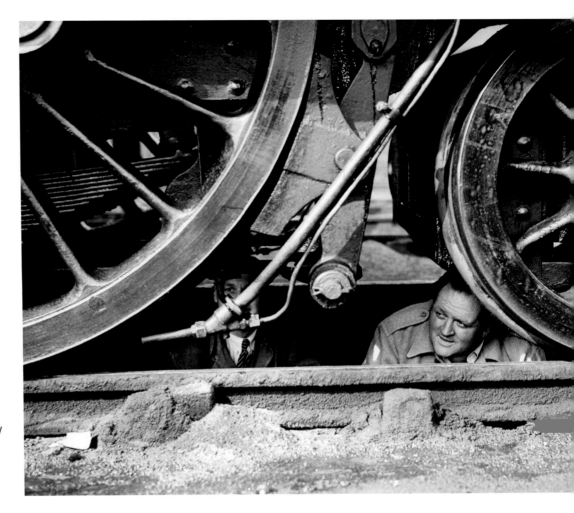

During the televising of the preparation of the *Night Scotsman's* locomotive, presenter Richard Dimbleby watches a sand jet being used on the engine's massive wheels.

29th August, 1952

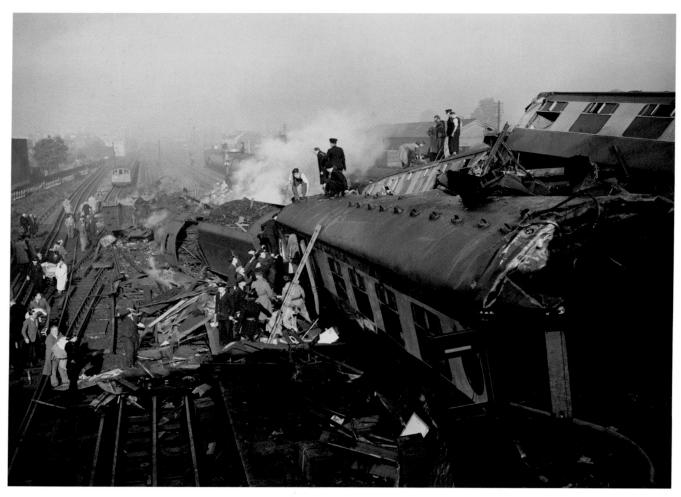

The scene of destruction following a triple train crash at Harrow and Wealdstone station, 11 miles from central London. An express sleeper train from Perth, Scotland struck a local train standing in the station at more than 50mph and then, seconds later, a double-headed express from London Euston to Liverpool ploughed into the derailed coaches. One hundred and twelve people died and 340 were injured in the accident.

8th October, 1952

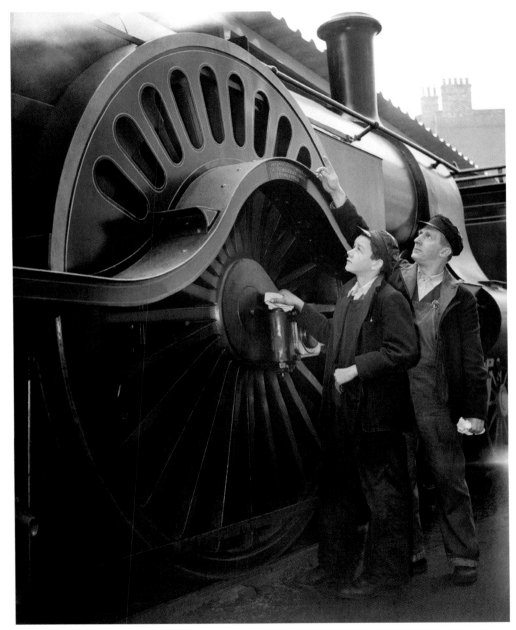

During the Great Northern Railway Centenary Exhibition at King's Cross station a driver and young fireman study one of the 8ft 1in diameter driving wheels of the Stirling 4-2-2 No 1 steam locomotive, designed by Patrick Stirling and built in 1870. The elegant curves of the locomotive are a prime example of 'form' over 'function', although it achieved high speeds when hauling a lightly loaded train. The 'eight-footer' is preserved at the National Railway Museum, York.

10th October, 1952

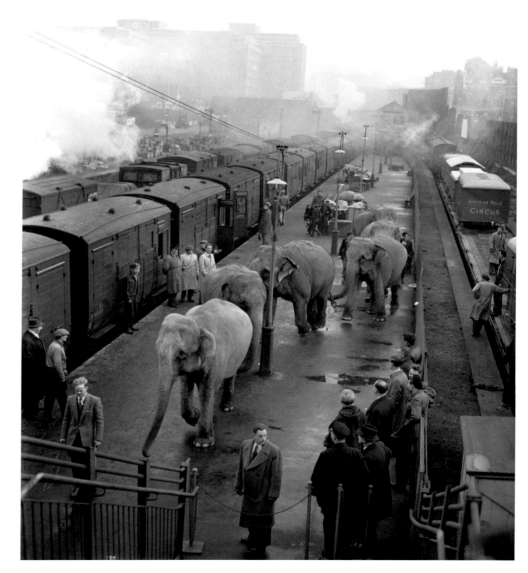

Having disembarked from their own train, a team of elephants lumbers down the platform at London Olympia station watched by amazed travellers, as the Bertram Mills Circus comes to town for its annual Christmas season at the exhibition centre.
10th December, 1952

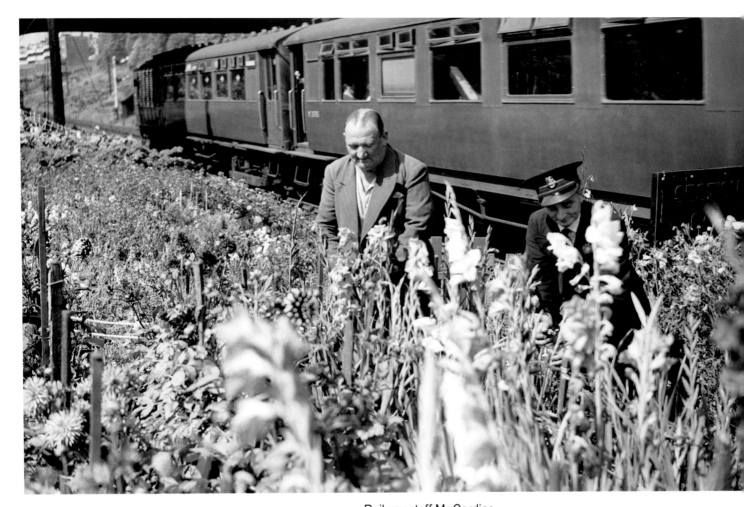

Railway staff Mr Cordine
and Mr Simpson tend to their
flowers in the garden beside
Parliament Hill railway
station, London.
11th August, 1953

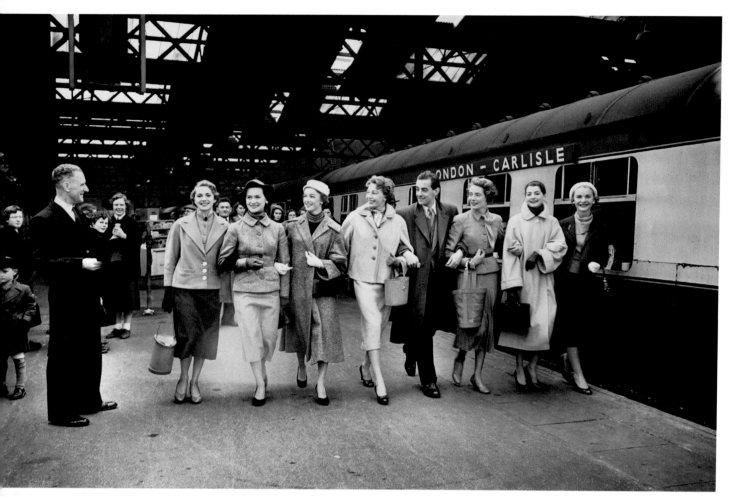

The stationmaster
at London Euston station
politely doffs his hat to
a group of mannequins
as they leave for a TV
fashion show extolling
the virtues of Rayon.
29th April, 1954

Driver S Tappin of Islington, London looking out of the cab of the *Golden Fleece*, the engine at the head of *The Elizabethan* express train as it leaves King's Cross station to make the fastest ever non-stop journey between London and Edinburgh.

28th June, 1954

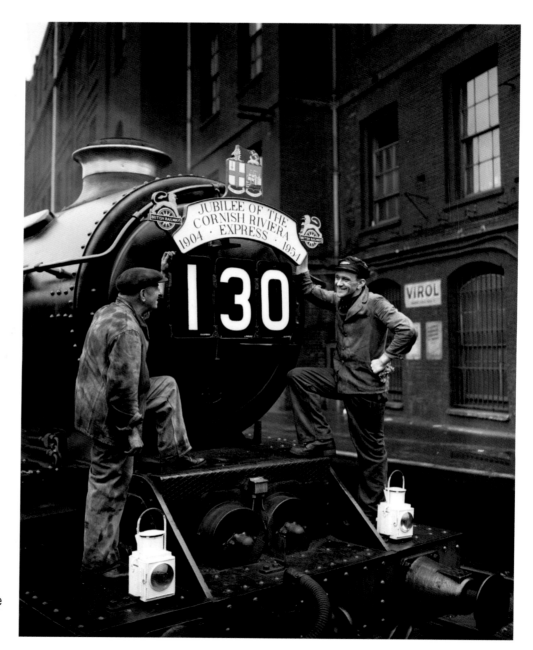

A special headboard on locomotive No 130 commemorates the 50th anniversary of the *Cornish Riviera Express*, Western Region's crack train, at Paddington station, London before beginning its 246 mile run to Penzance, Cornwall.
1st July, 1954

Railway worker Mr Robert Watts poses for a photograph with one of the tools of his trade after winning a suggestions competition run by his employer, British Railways.
24th June, 1955

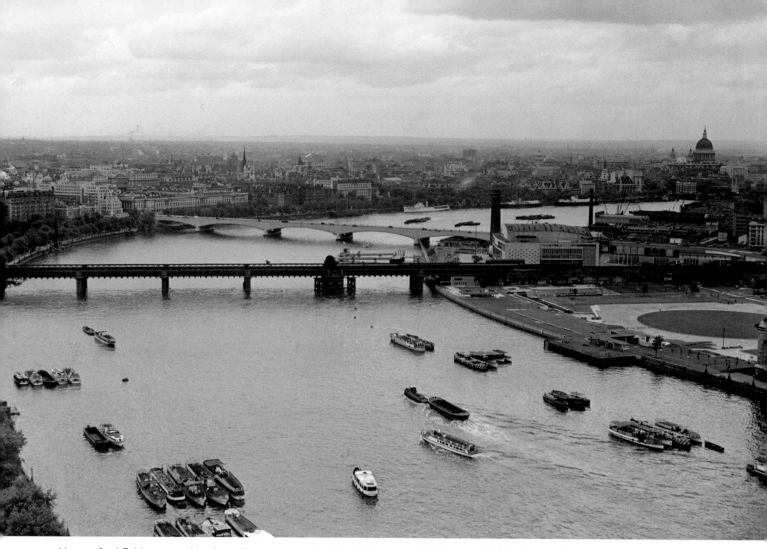

Hungerford Bridge, carrying the railway across the River Thames, with Waterloo Bridge beyond, viewed from the clock tower of the Palace of Westminster. Brunel's original suspension bridge, which opened in 1845, was replaced in 1864 by the nine-span wrought iron lattice girder bridge when the South Eastern Railway extended its tracks into the newly built Charing Cross station. Walkways on each side were replaced in 2002 by two cable-stayed pedestrian bridges.
30th June, 1955

Prince Charles and Princess Anne, followed by their grandmother, Princess Andrew of Greece and Denmark, and accompanied by Vice-Admiral Sir Conolly Abel Smith, Flag Officer, Royal Yachts (R), and stationmaster Mr T Fryer (L), walk from the train on arrival at Portsmouth from London to embark in the Royal Yacht *Britannia*. There they would join their parents, the Queen and the Duke of Edinburgh, on an eight-day cruise to Wales, the Isle of Man and Scotland.

5th August, 1955

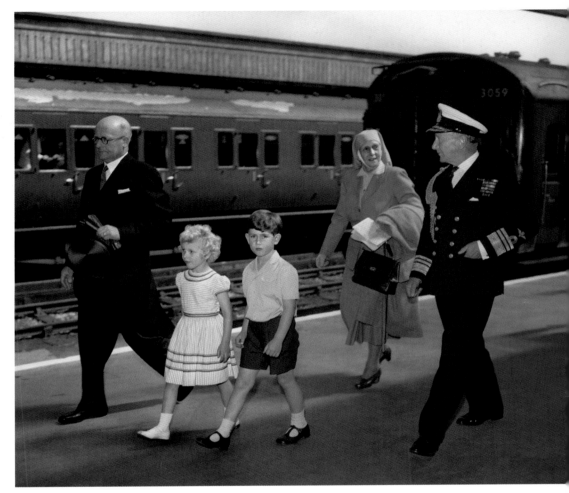

Mr W D Syzling (L), the new
stationmaster at St Pancras
station, discusses the
workings of the station
with Mr G W Morrison.
16th August, 1955

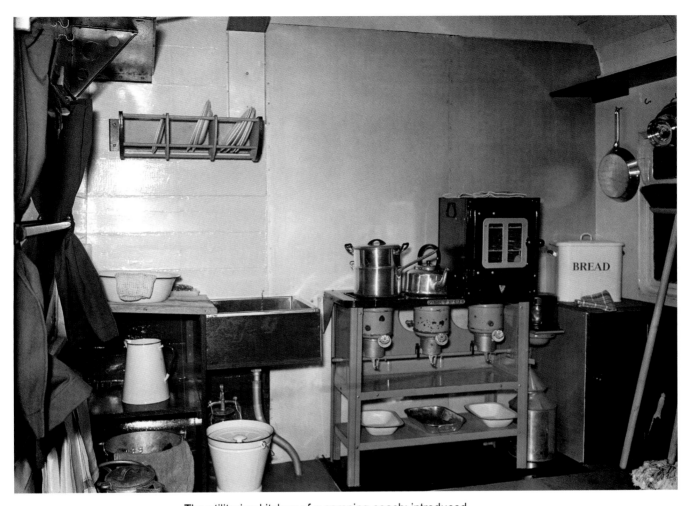

The utilitarian kitchen of a camping coach: introduced by LNER in 1933 this popular accommodation for holidaymakers was revived by British Rail after the war. Retired passenger carriages, converted into basic sleeping, living and cooking space, were parked at locations in rural or coastal areas.
9th January, 1956

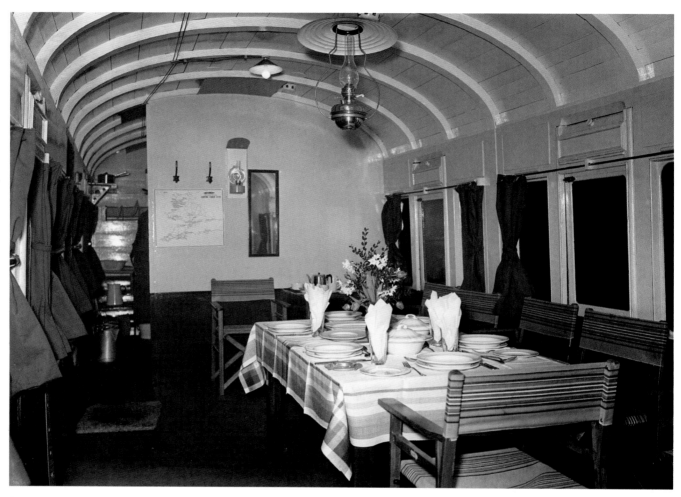

The living space of a camping coach contained a large dining table with ample space for holidaymaking groups of friends and family, who were required to travel by train to the station where the coach was located, and encouraged to use the railways on their holiday jaunts in the locale.

9th January, 1956

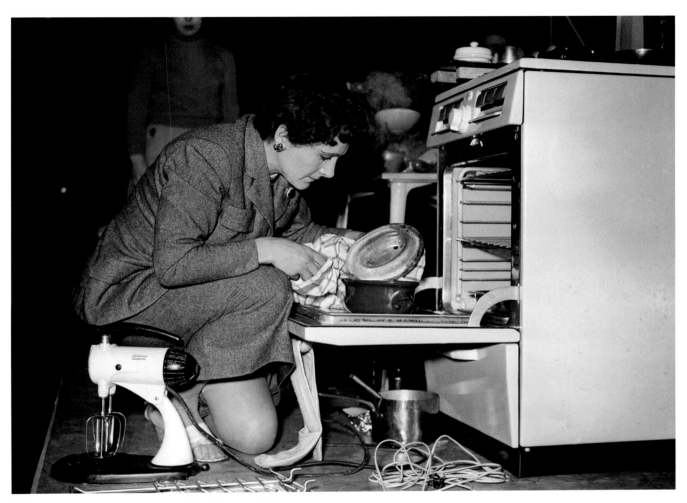

Television cook Fanny Craddock checks the efficiency of the electric cooker on board the latest camping coach to be introduced by British Rail.
9th January, 1956

The first Inter-City Class 126 DMU (diesel multiple unit) train built for working on British Railways mainline tracks pulls into Swindon station in Wiltshire. The train was painted in BR Green with distinctive 'speed whiskers' at the front of the full width cab.

27th July, 1956

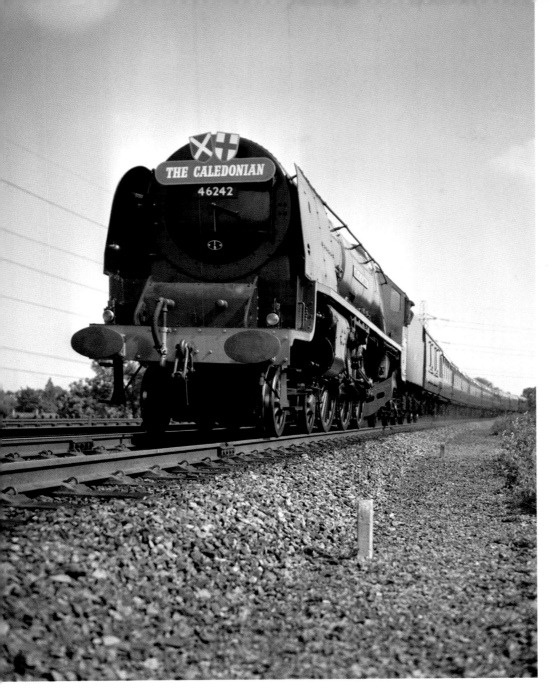

Britain's newest express train, *The Caledonian*, hauled by the Coronation (also known as Duchess) Class locomotive *City of Glasgow* No 46242 thunders through Watford on the long haul to Glasgow on her inaugural run. The train was scheduled to cover the 401 miles from London Euston station in 400 minutes at an average speed of more than 60 miles an hour. The southbound express covered the trip in 398 minutes, a new postwar record.

17th June, 1957

Scottish actor Sean Connery and American actress Lana Turner, who appear together in the film *Another Time Another Place*, arriving at London King's Cross station.
29th September, 1957

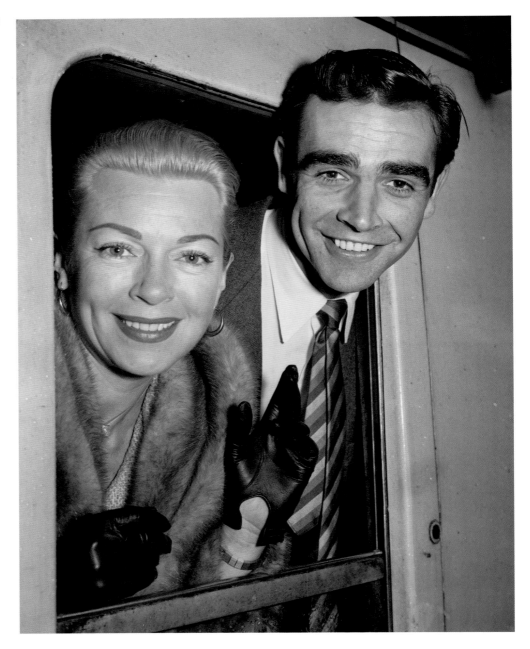

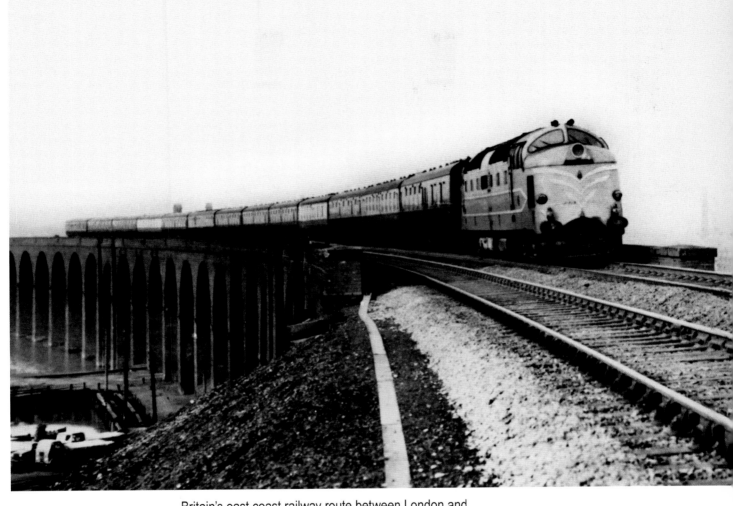

Britain's east coast railway route between London and Edinburgh was to be served by a fleet of the most powerful diesel-electric locomotives in the world. The British Transport Commission announced that an order for 22 of the 3,300hp Deltic locomotives would be placed with the English Electric Company. The locomotive shown is hauling an express train near Widnes on the London to Liverpool line.

31st March, 1958

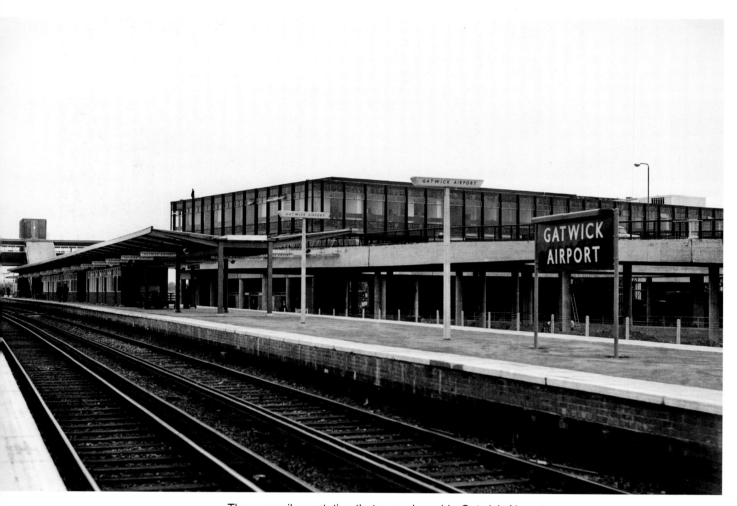

The new railway station that runs alongside Gatwick Airport after the terminal's £7.8m redevelopment between 1956 and 1958. Gatwick was the first airport in the world with a direct railway link, which provided rapid access to London.
29th May, 1958

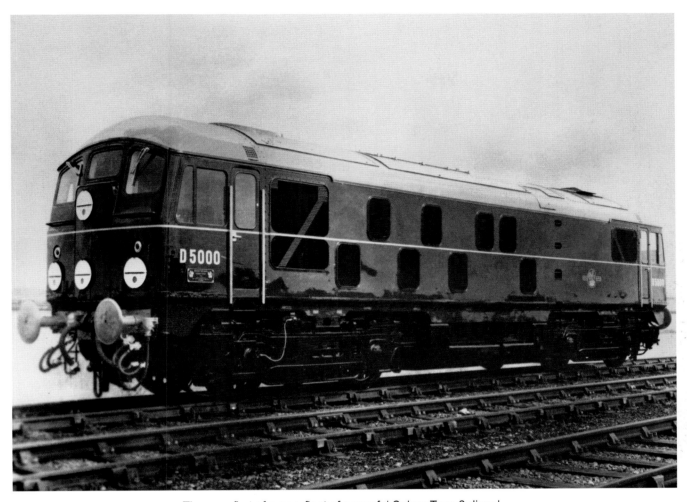

The very first of a new fleet of powerful Sulzer Type 2 diesel locomotives, No D5000 was constructed by British Rail at its Derby Works. Rejected by the National Railway Museum, the locomotive ended its days at Swindon Works, where it was scrapped in 1977 after having been taken out of service in 1976.

24th July, 1958

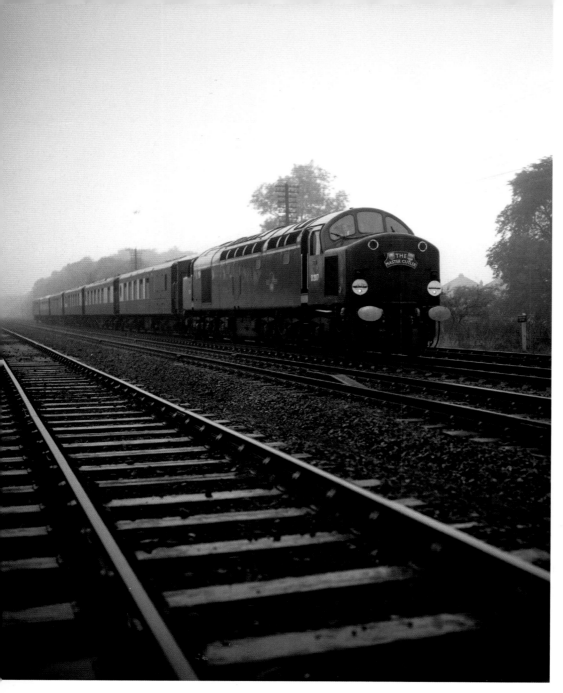

Britain's first diesel hauled Pullman express train, *The Master Cutler*, speeds through Brookman Park Station, Hertfordshire, on its first run from Sheffield to London. It was scheduled to complete the 161 mile journey in 165 minutes, stopping only at Retford on the way.

15th September, 1958

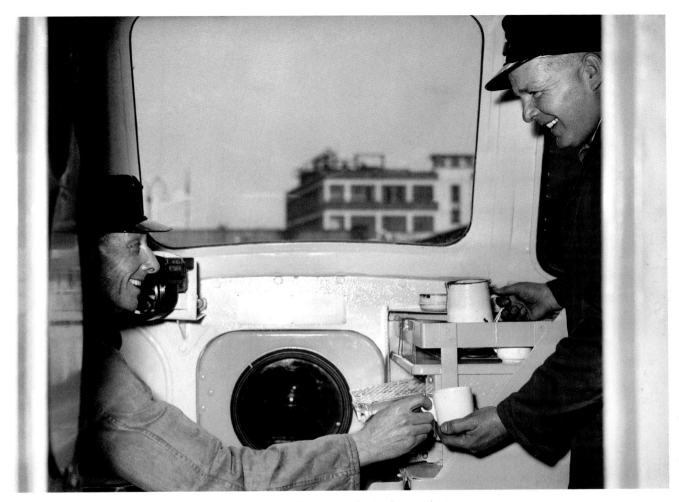

The two drivers, Jack Hill and Leslie Jordan, make tea
on the cooker of the first mainline diesel-electric locomotive.
23rd April, 1959

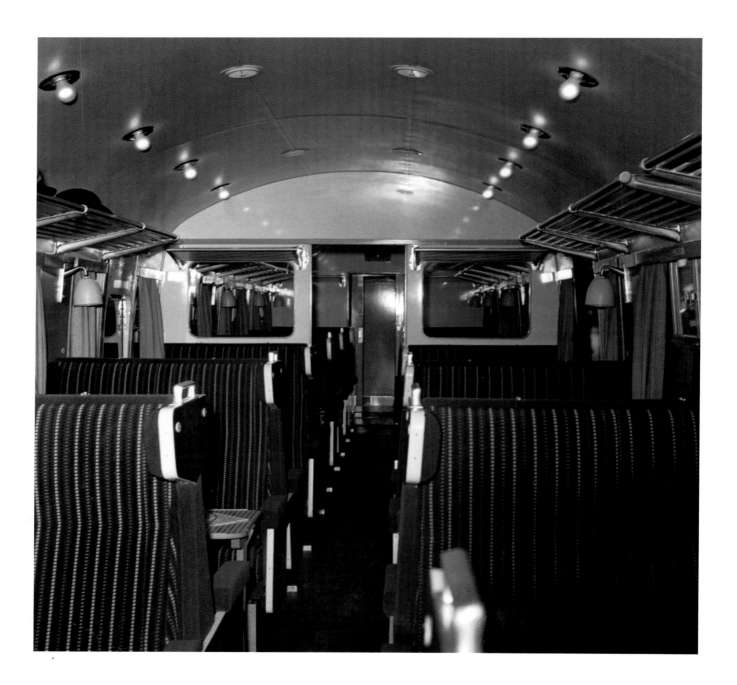

Facing page: The interior of one of the carriages on the newly electrified Kent Coast Express Line.
9th June, 1959

After a derailment at St Pancras station, the breakdown gang brings in a huge crane to lift locomotive No 40030 back on the rails. The LMS Fowler 2-6-2T, built at Derby Works in 1931, was, like others in its series, withdrawn from service between 1959 and 1962. None was preserved.
29th July, 1959

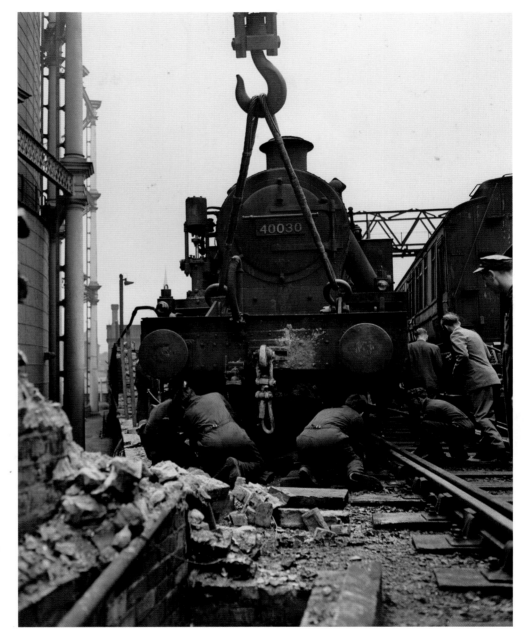

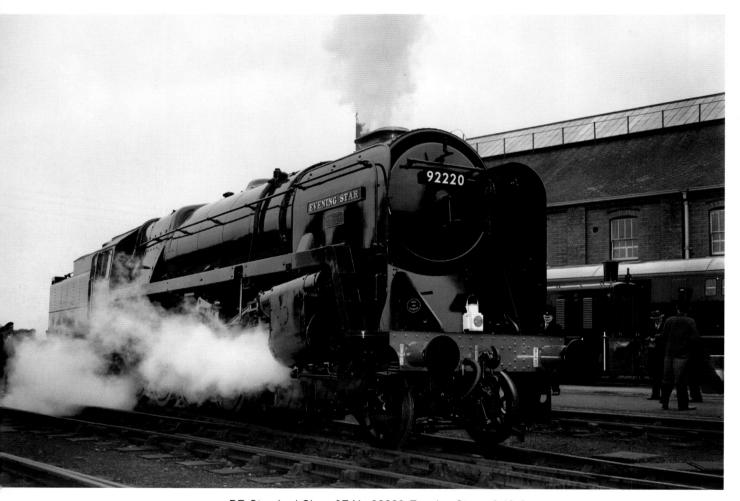

BR Standard Class 9F No 92220 *Evening Star*, a 2-10-0 locomotive, steams slowly out of Swindon Works after her naming ceremony. The last steam locomotive to be built by British Railways as a result of their dieselization and electrification policy, the engine is now preserved at the National Railway Museum, York.
18th March, 1960

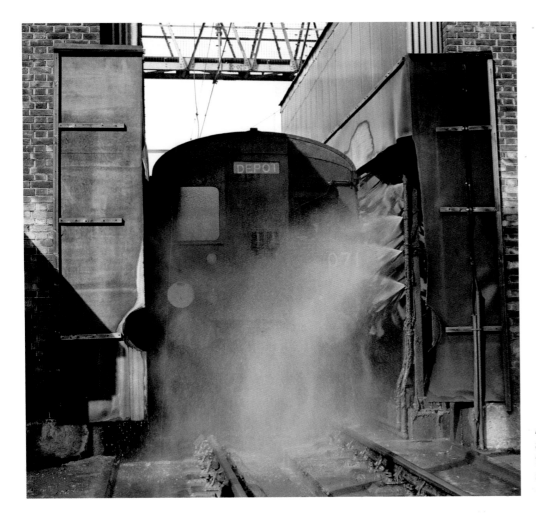

As the waterspray activates, a train passes slowly through the cleaning shed at Ilford, Essex.
16th August, 1960

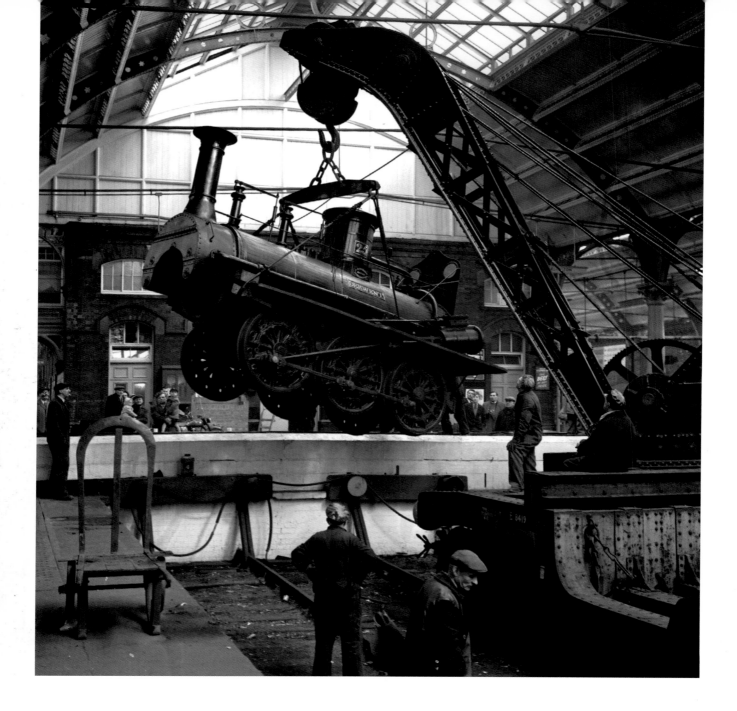

Facing page: The 115-year-old locomotive *Derwent* is lifted by a powerful crane at Darlington Bank Top station on its way to be renovated and later preserved in the Darlington Railway Centre and Museum. Built by William and Alfred Kitching, the 0-6-0 steam locomotive worked the Stockton & Darlington Railway, the world's first permanent steam locomotive hauled public railway.
20th March, 1961

From a railway carriage window the Queen Mother bids farewell to her daughter, Princess Margaret, and Mr Anthony Armstrong Jones before leaving London Victoria station for Portsmouth and the Royal Yacht *Britannia* for a cruise to Tunisia.
17th April, 1961

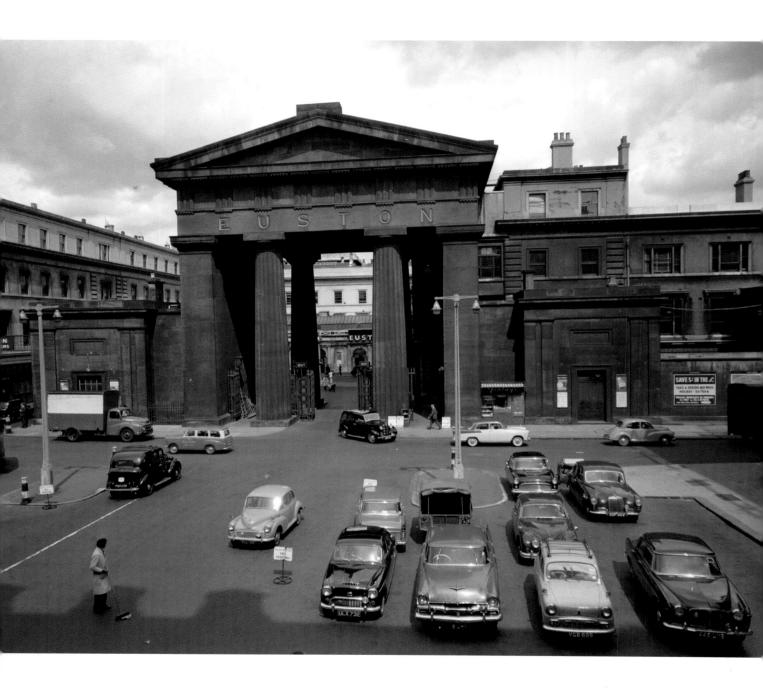

Facing page: The imposing arch at London Euston station was a Doric-columned structure built as the original entrance to the station in 1837. The arch, along with the original station buildings, was demolished in December 1961. The station was rebuilt without the arch.
27th September, 1961

Fourteen-year-old schoolboy Christopher Hughes of Ponders End, Middlesex, takes an oil can around his 15-ton railway engine. The engine, built in 1896 by Avelin & Porter, is to be presented by Christopher to the Enfield and District Veteran Vehicle Society, of which he is a member.
24th August, 1962

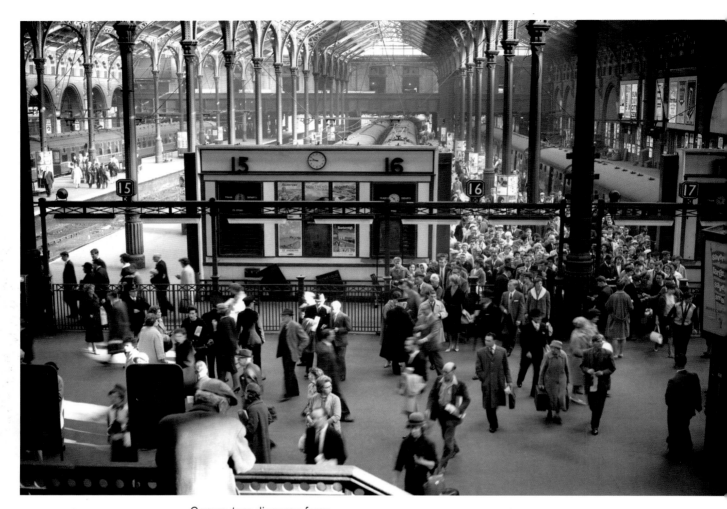

Commuters disgorge from
platforms 16 and 17 at
Victoria station, London.
2nd October, 1962

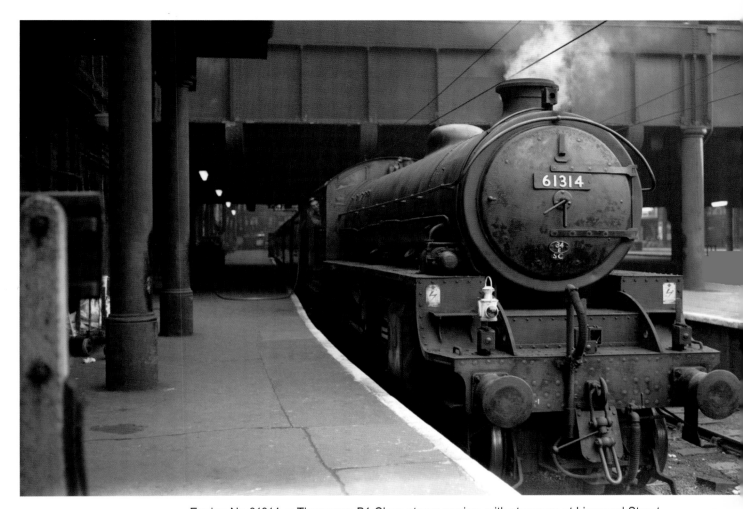

Engine No 61314, a Thompson B1 Class steam engine, with steam up at Liverpool Street station. Known as *Bongos*, after the breed of antelope, B1s were used for Departmental work, hauling engineers' trains, marshalling stock, and in this case providing heating for the sleeper compartments of a stationary train used by officials of Liverpool Street and Fenchurch Street stations, while they work around the clock to provide a skeleton rail service during a strike.
3rd October, 1962

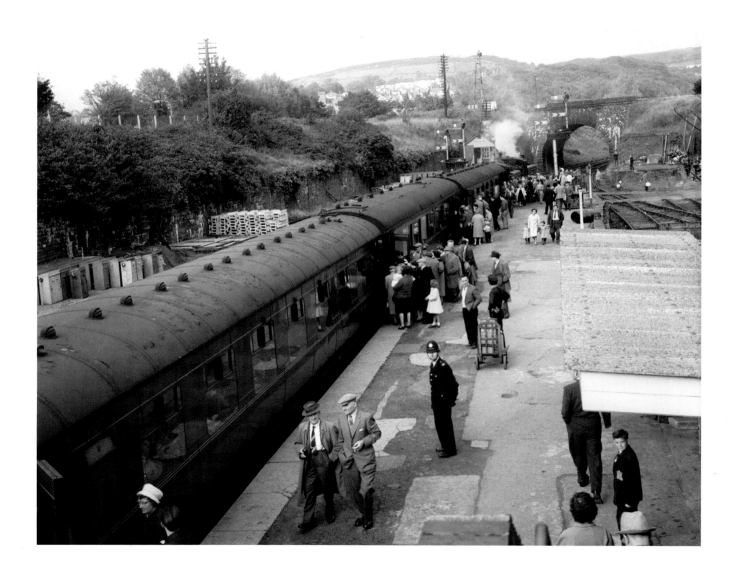

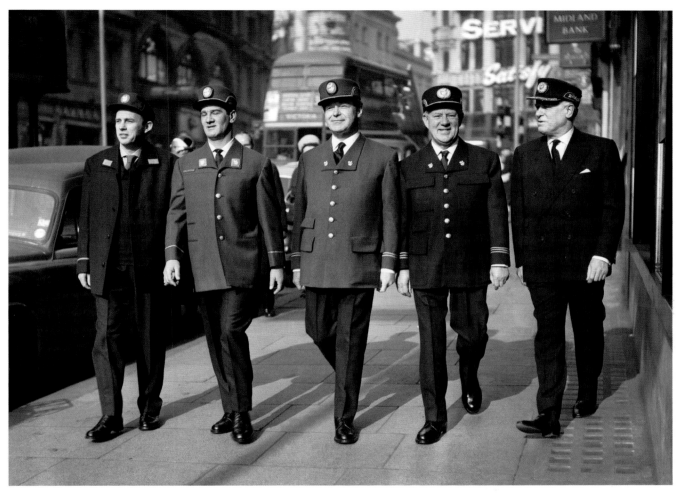

Facing page: A 'double-header' of two steam locomotives was needed to haul the last passenger train from Neath to Brecon, Wales. The Neath & Brecon Railway had provided rail access to Swansea via 'running rights' on the Swansea Vale Railway. After passenger services were withdrawn, only freight services remained, serving local quarries.
14th October, 1962

Railway ticket collectors model the somewhat shapeless new uniforms that have been introduced to present a smart, efficient image for British Rail.
26 February, 1963

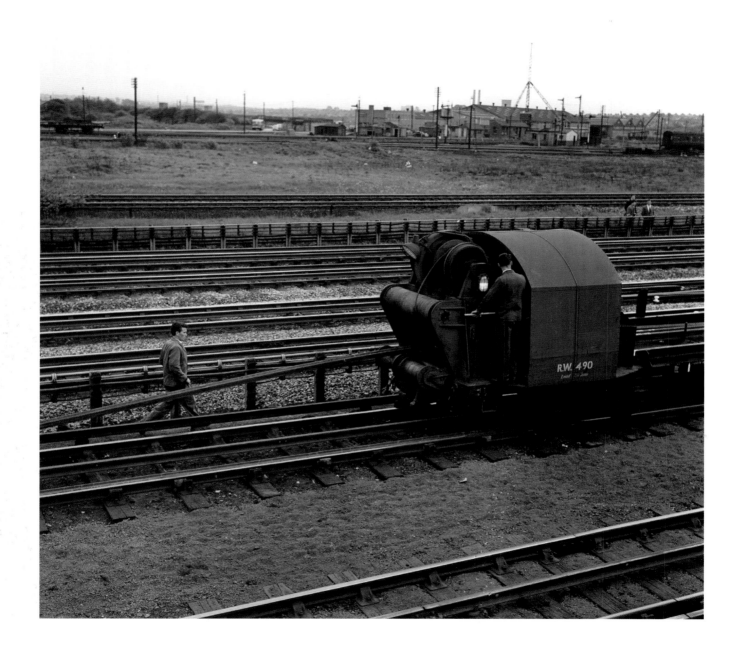

Facing page: A heavy rail is lifted and drawn by winch as part of a demonstration at Neasden, London during the centenary parade of rolling stock to commemorate 'Metro-land', the suburban areas built to the north west of London in the early 20th century, and served by the Metropolitan Railway.
23rd May, 1963

Locomotive No 23, a Metropolitan A Class engine built at Manchester in 1866, heads the special train at Neasden as part of a grand parade of past and present rolling stock to commemorate the 100th anniversary of London's underground.
23rd May, 1963

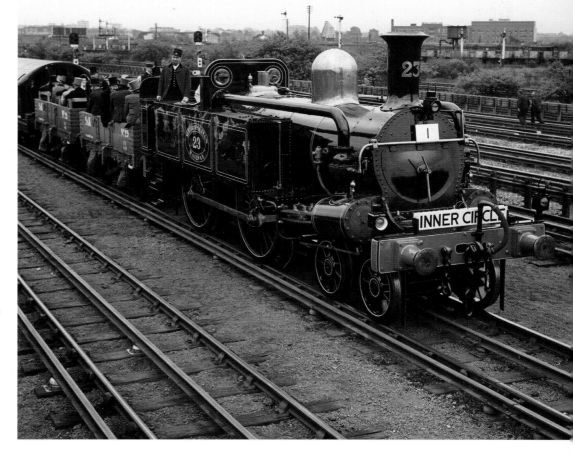

Glass scattered on the floor of one of two vans which, with the English Electric Class 40 diesel locomotive D326, were uncoupled from an overnight Glasgow–Euston mail train and robbed at Bridego Bridge near Mentmore, Buckinghamshire, the incident that became known as The Great Train Robbery. The 15-strong gang of robbers got away with £2.6m.
8th August, 1963

Facing page: The coaches of the train involved in The Great Train Robbery, under police guard at Cheddington station.
10th August, 1963

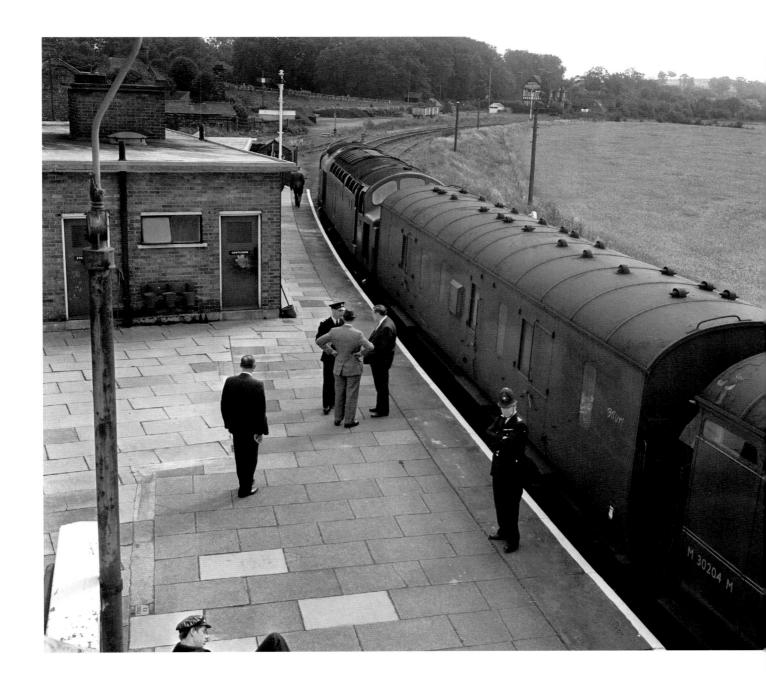

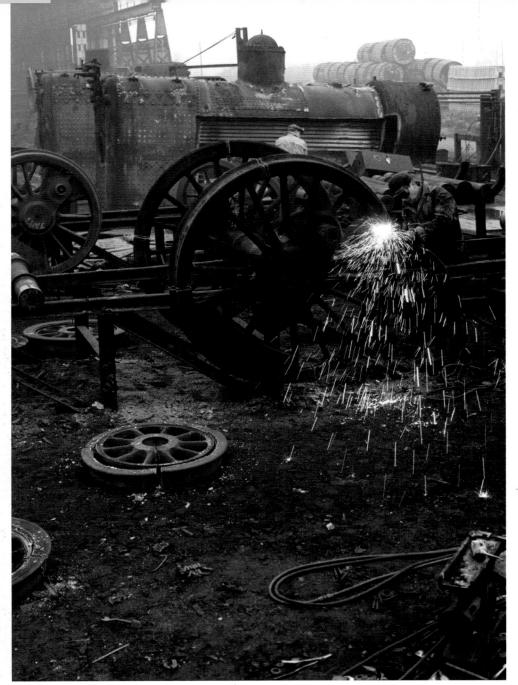

Facing page: The epitome of the steam age and one of the greatest icons of the 19th and 20th centuries, a steam locomotive is cut up at the scrap yard at Swindon.
12th August, 1963

Their rail galloping days over, the wheels of an 'iron horse' meet a sad end under the flames of a cutter's torch in the scrap yard at Swindon, birthplace of the Great Western Railway locomotives.
12th August, 1963

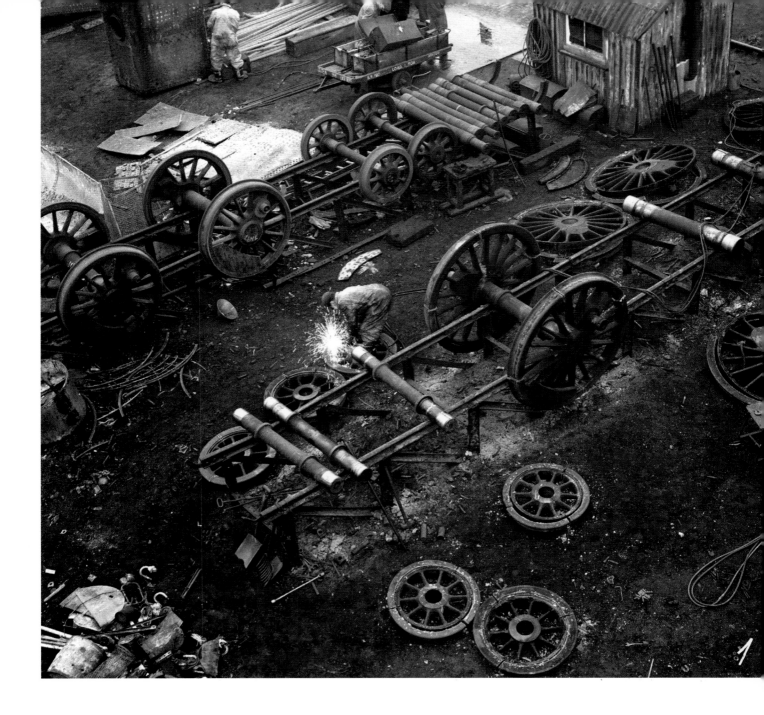

The London Midland &
Scottish Railway locomotive
works at Derby, birthplace
of hundreds of steam
locomotives, said goodbye to
the 'iron horse' forever when
No 75042, a Standard Class
4 4-6-0 engine, left the
works under its own power.
The locomotive received
a civic send-off with the
unhappy distinction of being
the last steam locomotive to
receive a general repair at
the British Railway Works.
20th September, 1963

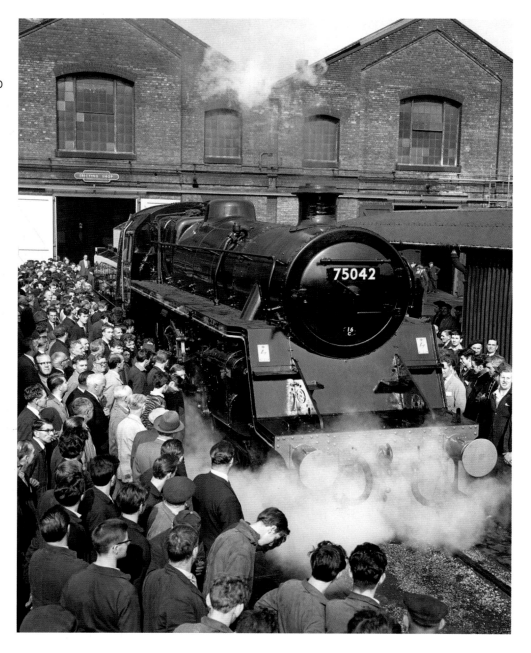

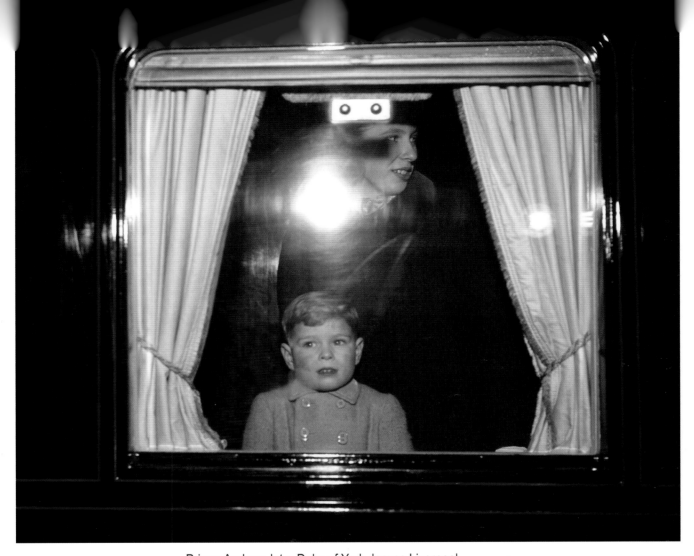

Prince Andrew, later Duke of York, leaves Liverpool
Street station, London, with his sister Princess Anne for
Sandringham where they will spend Christmas with other
members of the Royal family.
21st December, 1963

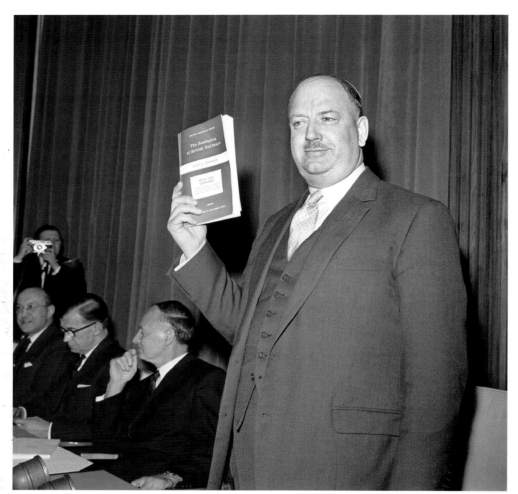

Dr Richard Beeching holds aloft a copy of *The Reshaping of British Railways*. The 'Beeching Axe' fell as the plan to reduce the cost of running the nationalized British Railways system resulted in the wholesale closure of more than 4,000 miles of what were considered little-used and unprofitable, mainly rural branch and cross country lines, and 3,000 stations.
27th March, 1963

Schoolboy Christopher Lockyear, 12, (R) and Senior Driver George Barlow (L) push out *Green Goddess*, the miniature 4-6-2 Pacific locomotive that is part of the Romney, Hythe & Dymchurch Railway in Kent, then the world's smallest public railway in terms of its 15in track gauge. Apart from being a tourist attraction, the railway also runs a public service between the small towns and villages between Hythe and Dungeness.

11th March, 1964

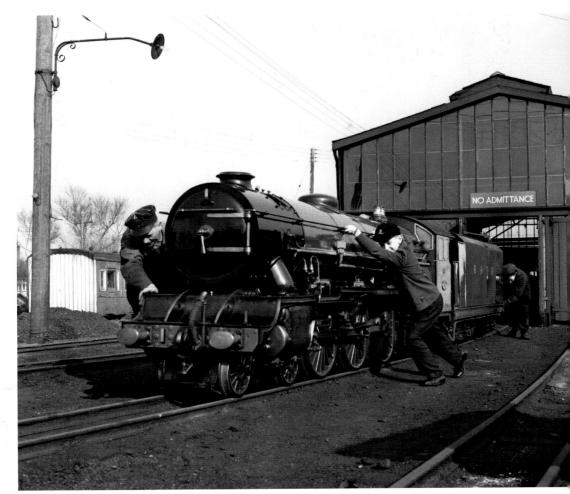

As part of the British Transport Commission's aim to remove steam locomotives from British Rail by 1968, Project XP64, a Class 47 diesel-electric locomotive No D1733 developed by Brush Traction, stands with its train at Marylebone station, London. Carriages and engine are painted in 'Rail Blue', the new livery of turquoise blue and pale grey, with brown underframe, and feature the new British Rail logo of two fused arrows.

28th May, 1964

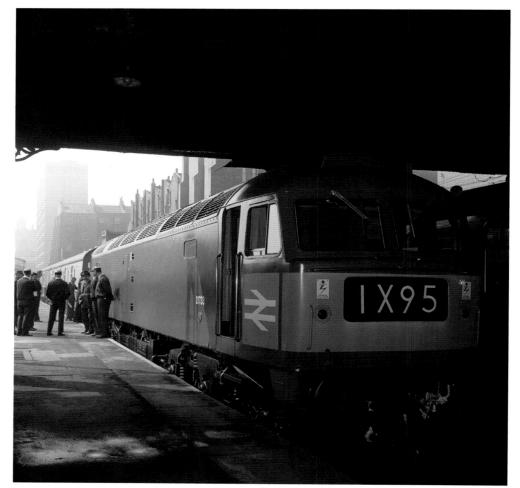

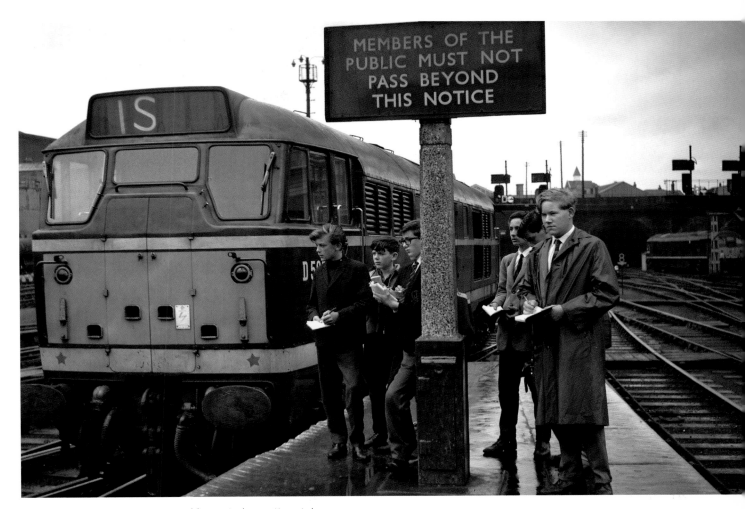

Young train spotters take
down locomotive numbers at
London King's Cross station.
1st July, 1964

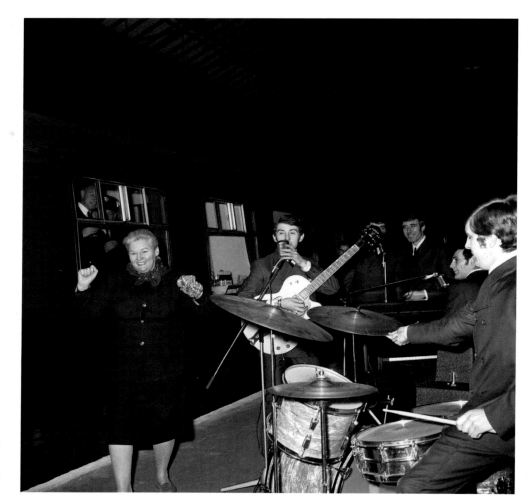

British Rail porter Alice Eades steps out of the way as *The Moody Blues* give travellers using Holborn Viaduct station a sample of their music before the group boards a special train for a round trip to Victoria station.
11th November, 1964

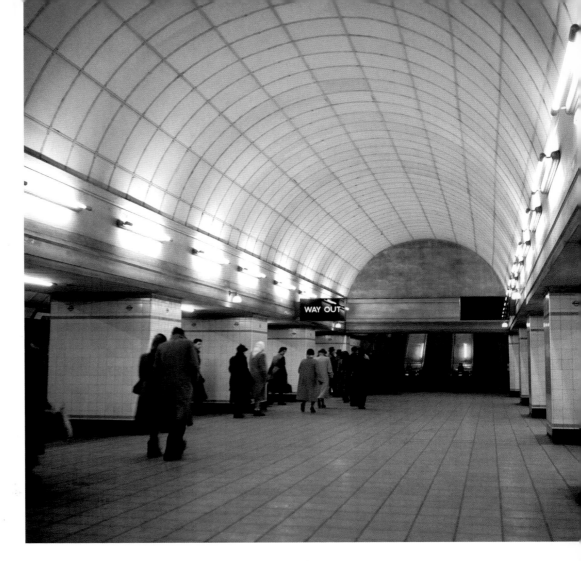

Passengers head for the escalators to take them to street level in a London underground station on the Central Line.
January, 1965

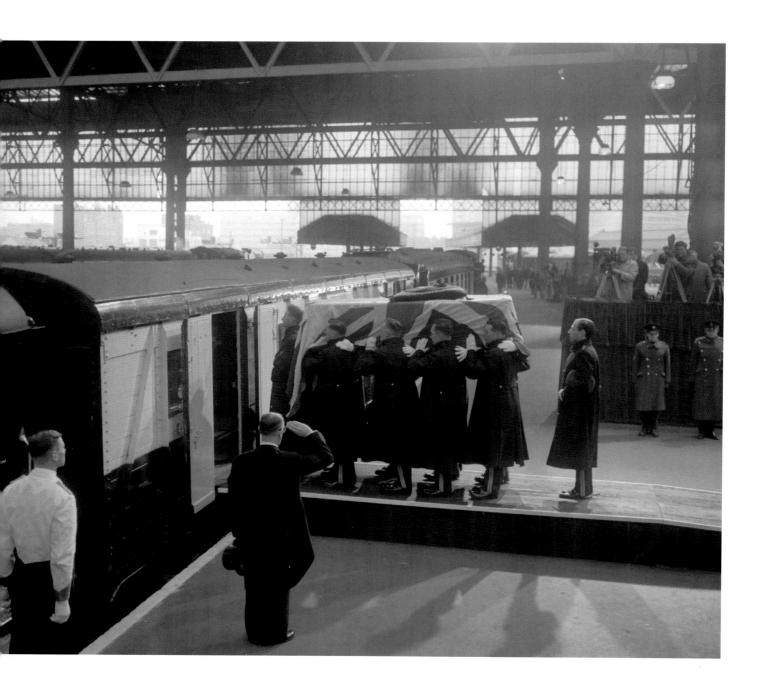

Facing page: A bearer party from the Queen's Royal Irish Hussars, Sir Winston Churchill's old regiment, places the statesman's coffin in Southern Railway van S2464S, part of a specially prepared funeral train, at Waterloo station, London. The interment was to take place at Bladon, not far from Churchill's birthplace at Blenheim Palace, Oxfordshire. The funeral train of Pullman coaches was hauled by Bulleid Pacific steam locomotive No 34051 *Winston Churchill*.
30th January, 1965

A damsel in distress: actress Diana Rigg, on location for a new series of *The Avengers*, is tied to the rails of a miniature railway on Lord Gretton's Stapleford Park Estate near Melton Mowbray, Leicestershire in an episode entitled 'The Gravediggers'.
4th April, 1965

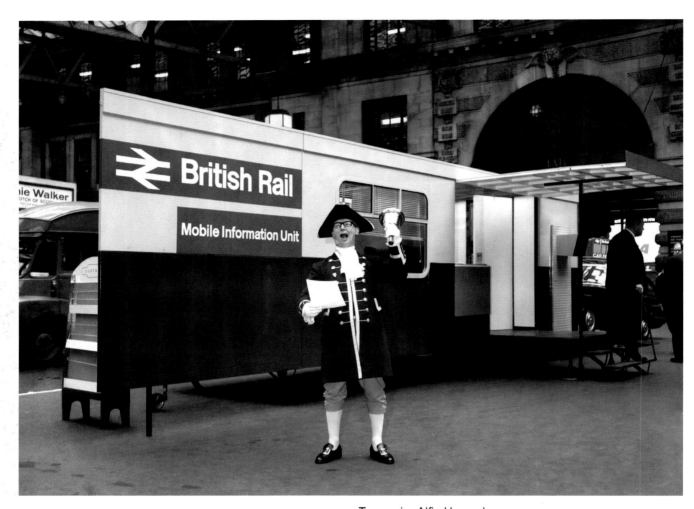

Town crier Alfie Howard
launches 'Rail Weeks', a British
Rail advertising campaign
at Waterloo station.
3rd June, 1965

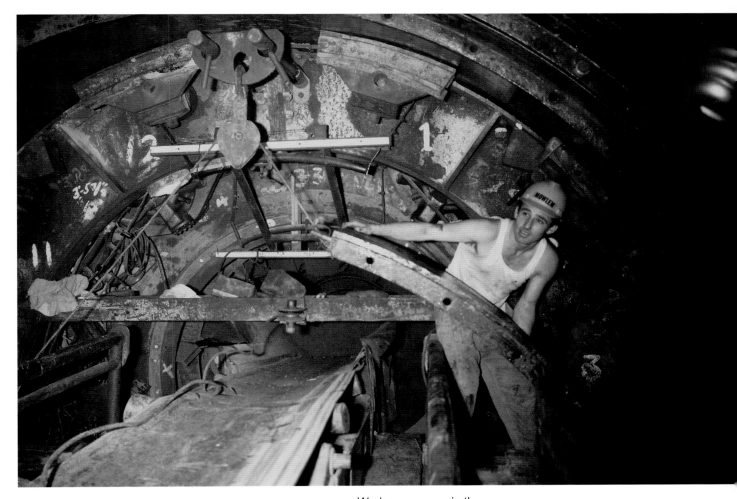

Work progresses in the
construction of the new
Victoria Line beneath the
streets of central London.
27th July, 1965

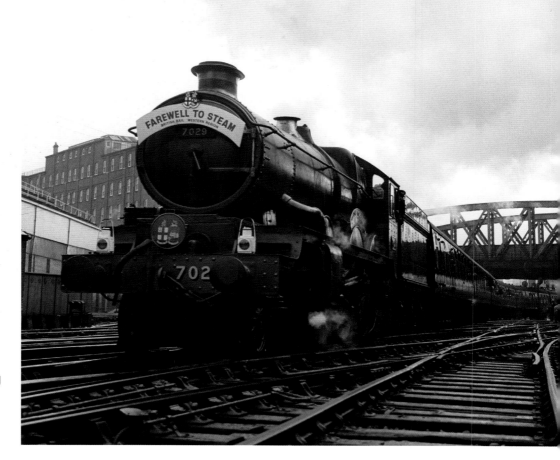

Great Western Railway steam locomotive Castle Class 4-6-0 No 7029 *Clun Castle* pulls out of Paddington station, London at the start of a special round trip run entitled 'Farewell to Steam', marking the beginning of the total dieselization on British Railway's Western Region.
27th November, 1965

Driver Bill Jones from Upminster, Essex, at the controls of one of the most powerful locomotives on British railways. With the speedometer touching 100mph he passes a steam train during a preview run of British Rail Midland Region's crack electrified services between London and the North West.
January, 1966

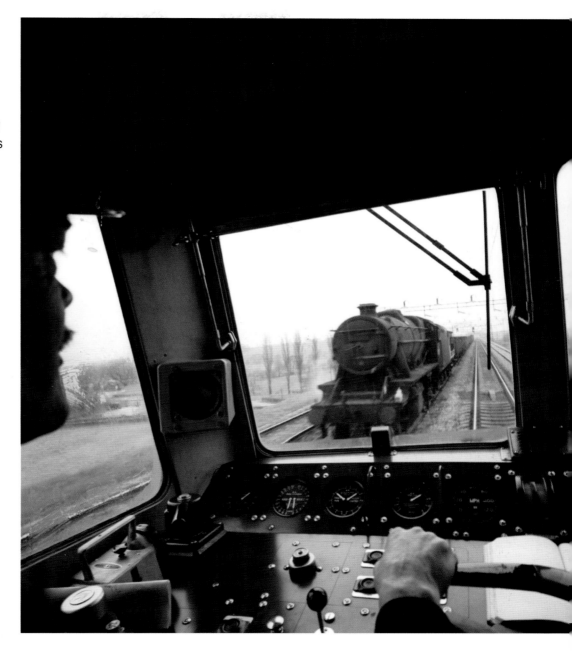

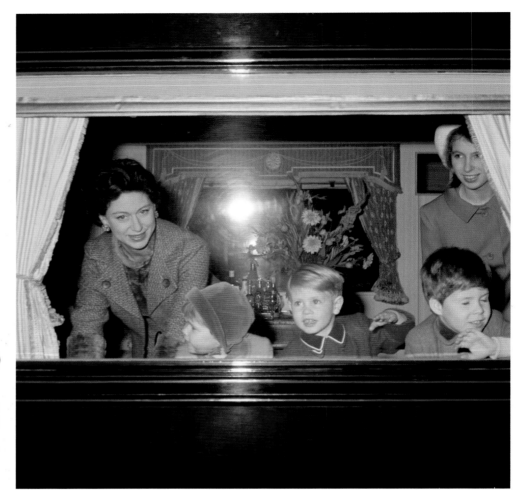

Princess Margaret with (L–R)
Lady Sarah Armstrong-
Jones, Prince Edward,
Viscount Linley and Princess
Anne as they leave Liverpool
Street station, London,
for Sandringham on board
the Royal Train.
30th December, 1966

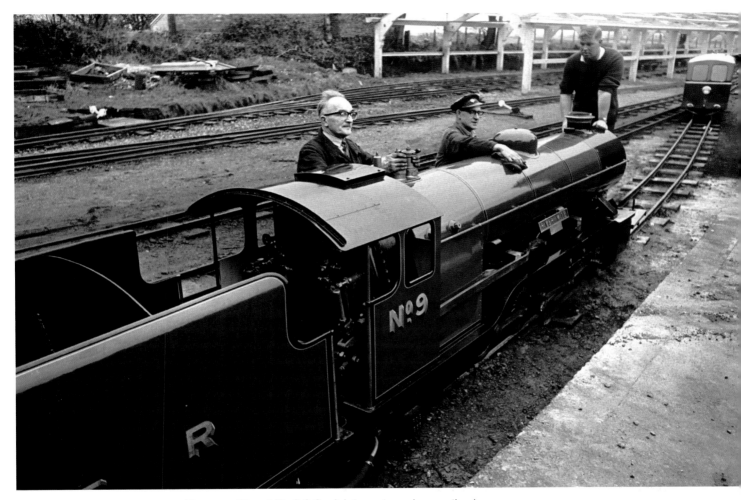

The new *River Mite* 2-8-2 miniature steam locomotive is prepared for work on the Ravenglass & Eskdale Railway. The original 3ft gauge railway opened in 1875 to haul hematite iron ore from the local mines, but the present 15in narrow gauge line now transports only passengers on its seven mile run from Ravenglass to Dalegarth station, near Boot in the valley of Eskdale, the Lake District.
2nd January, 1967

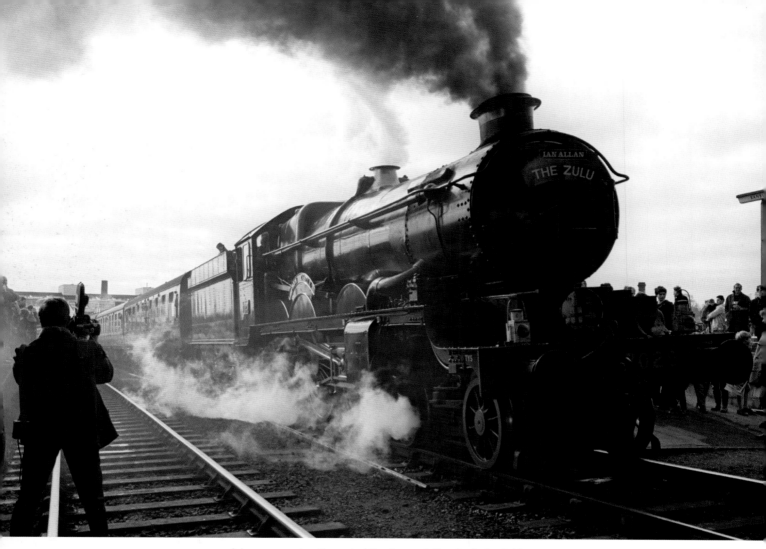

A large crowd gathered at Banbury station in Oxfordshire to see a fine lady steam out on her journey to Birkenhead, Cheshire, hauling the train *The Zulu* and marking the closure of the Great Western Railway route from London. She is the 40-year-old Castle Class No 7029 *Clun Castle*, 125-ton veteran, withdrawn in 1965 and privately owned before passing to a preservation company.

4th March, 1967

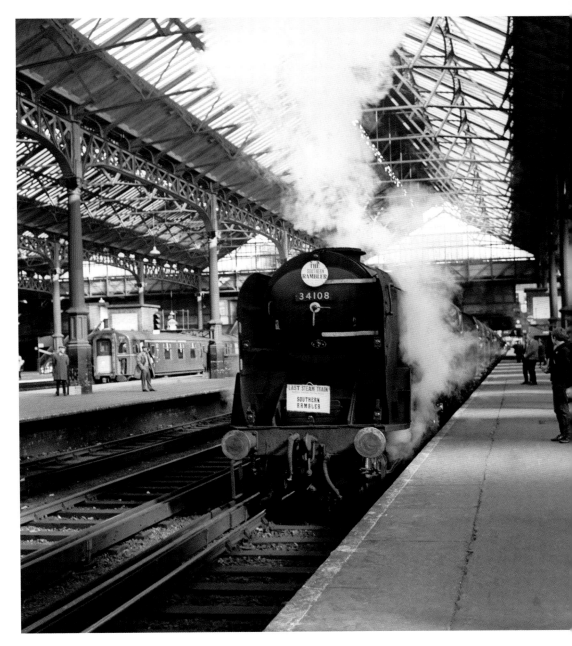

The SR Battle of Britain Class air-smoothed Light Pacific 4-6-2 locomotive No 34108 *Wincanton*, hauling the *Southern Rambler* train, makes an impressive departure as the last steam locomotive to leave Victoria station, London for Brighton and Eastbourne.

19th March, 1967

Freight trucks begin to move
again at the International
Freight Depot, Stratford,
east London as the rail
strike collapses.
6th July, 1967

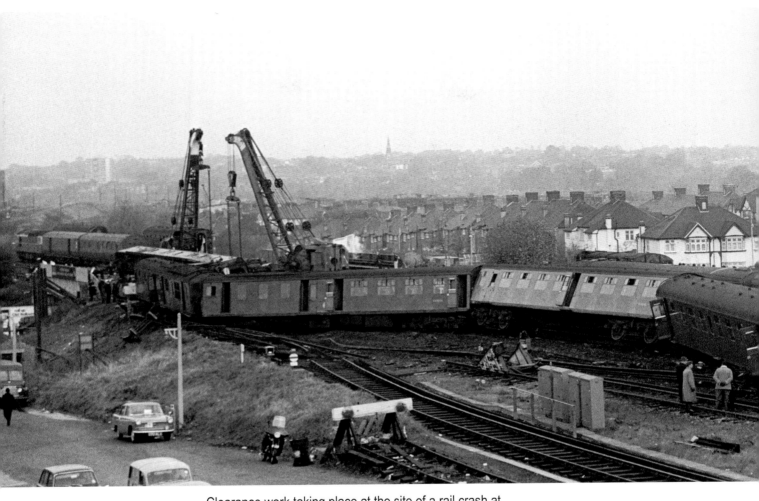

Clearance work taking place at the site of a rail crash at Hither Green, south London, in which 51 people died and 111 were injured. An evening express train of 12 coaches travelling from Hastings to London derailed at 70mph due to a broken rail. Most of the carriages overturned and the sides of two were ripped off.
6th November, 1967

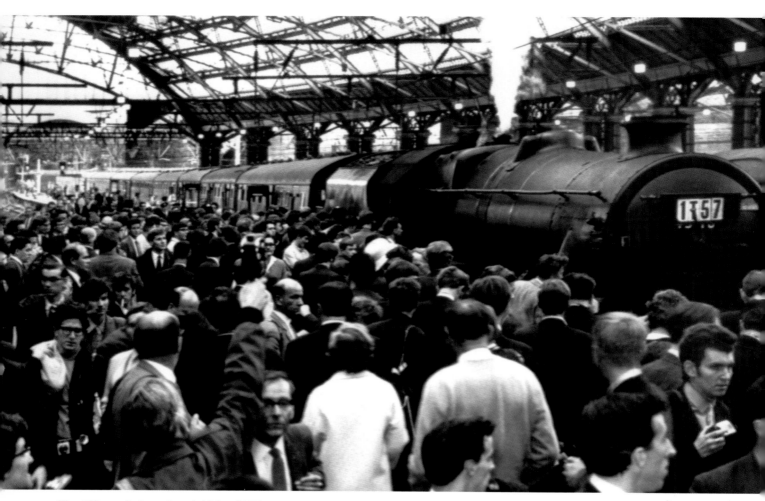

The *Fifteen Guinea Special* (aka 1T57), the last mainline passenger train hauled by steam, at Rainhill station, Merseyside, the day before the steam ban. The train left Liverpool hauled by LMS Stainer Class 5 No 45110 locomotive (shown), which was replaced with Britannia Class No 70013 *Oliver Cromwell* at Manchester for the onward journey to Carlisle. On the return leg, two Class 5s double-headed the train back to Manchester, where 45110 was replaced to complete the tour.

11th August, 1968

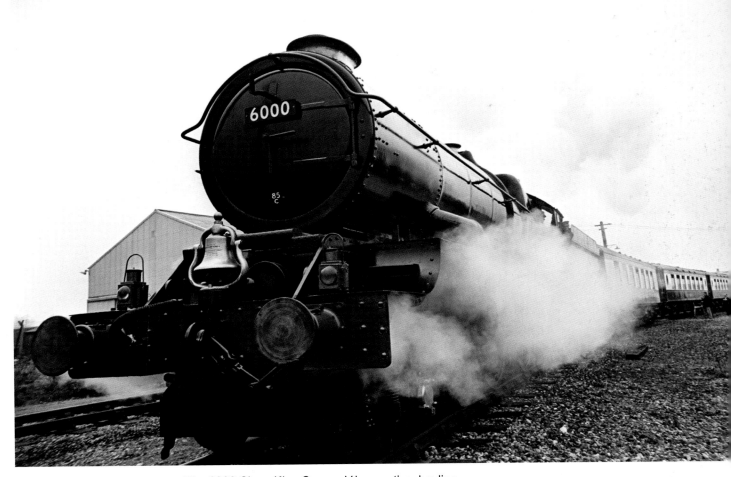

The 6000 Class *King George V* locomotive, hauling the *Bulmer's Cider* train on the remaining section of the Hereford, Hay & Brecon Railway. The historic locomotive, built in 1927, was restored and is preserved at Bulmer's Railway Centre in Hereford, Hertfordshire.

13th November, 1968

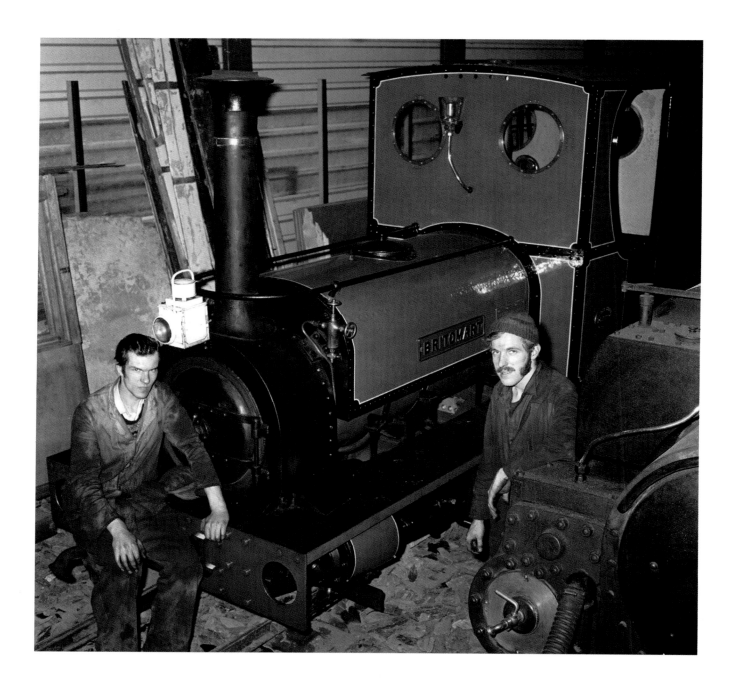

Facing page: After a working life at the Pen-yr-Orsedd Quarry in the Nantlle Vale in North Wales, the Hunslet 0-4-0ST steam locomotive *Britomart*, built in 1899, retired to the 24in narrow gauge Ffestiniog Railway in 1965. The little engine is being restored by enthusiasts at the railway's workshop at Portmadoc.
30th November, 1968

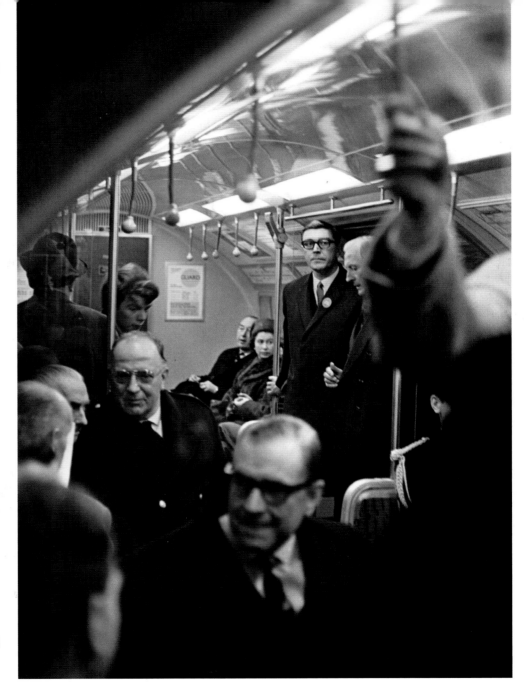

When the Queen opened the new Victoria Line, the occasion was the first time a reigning monarch had ridden on the underground.
7th March, 1969

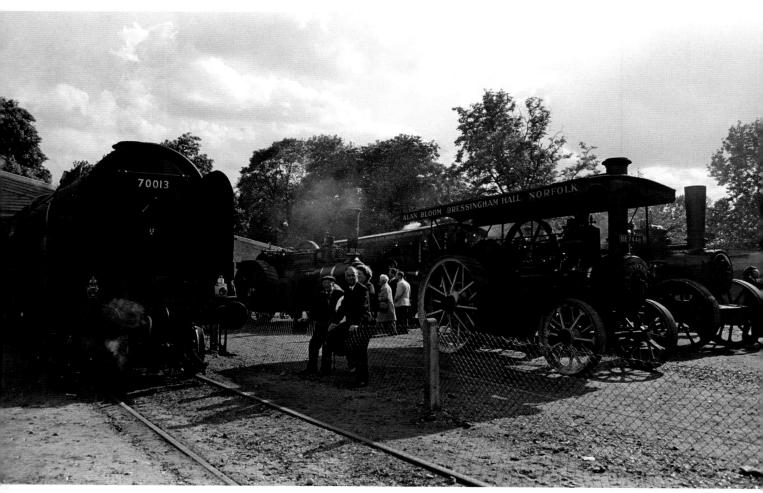

The gigantic Britannia
Class Pacific locomotive
No 70013 *Oliver Cromwell*
was on display with other
steam powered vehicles
at the Bressingham Steam
Museum, Diss in Norfolk.
7th July, 1969

Facing page: World famous steam train the *Flying Scotsman*
pulled by the eponymous LNER A3 Class Pacific locomotive
No 4472, designed by noted engineer Sir Nigel Gresley,
on returning from a promotional tour of the USA, where
the engine was fitted with a gleaming bell.
18th August, 1969

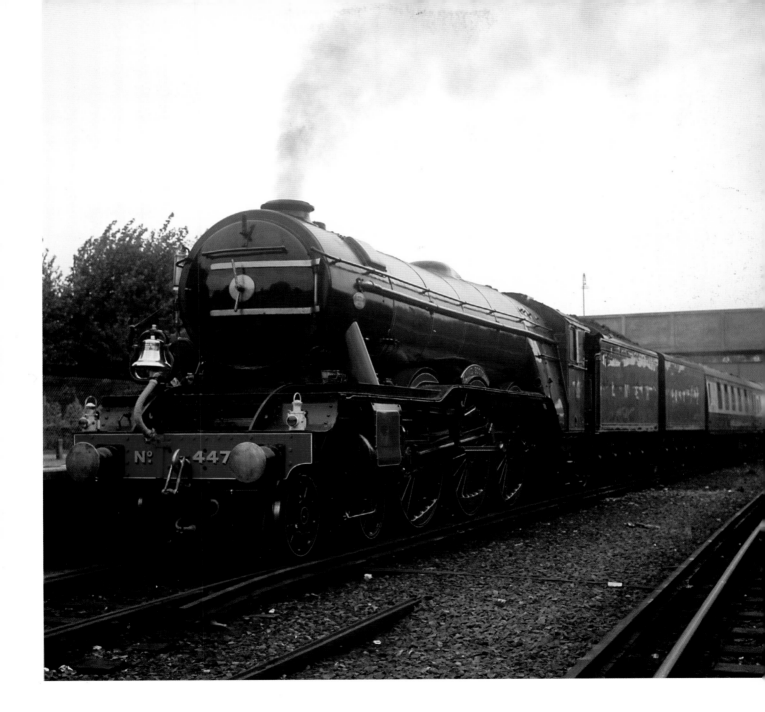

Broadcaster and horticulturalist Alan Bloom, of Bressingham Hall, Diss in Norfolk, rides the footplate of his steam locomotive, built in 1883, which he was displaying at the Bressingham Hall Steam Museum.
26th September, 1969

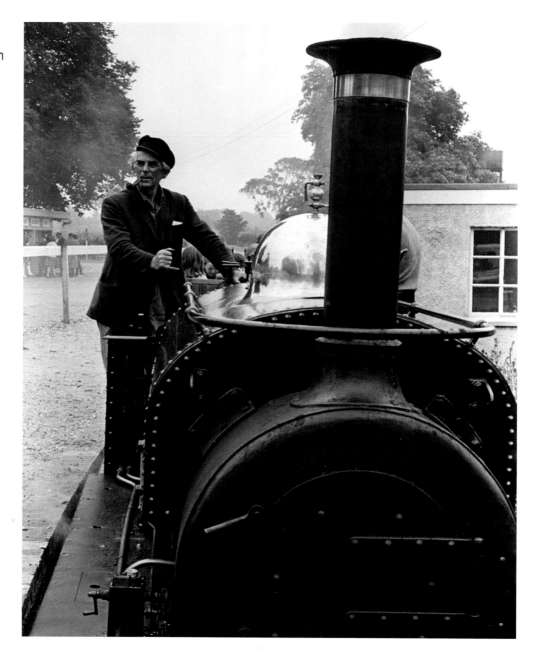

Arnos Grove Tube Station, designed by Charles Holden and opened in September, 1932, was originally the northernmost station of the Piccadilly Line extension until the opening of Oakwood and Cockfosters stations in 1933. The building, now Grade Two Listed, was built in a modern style from brick, glass and reinforced concrete, and includes a distinctive circular drum-like ticket hall rising from a low, single storey building.
3rd February, 1970

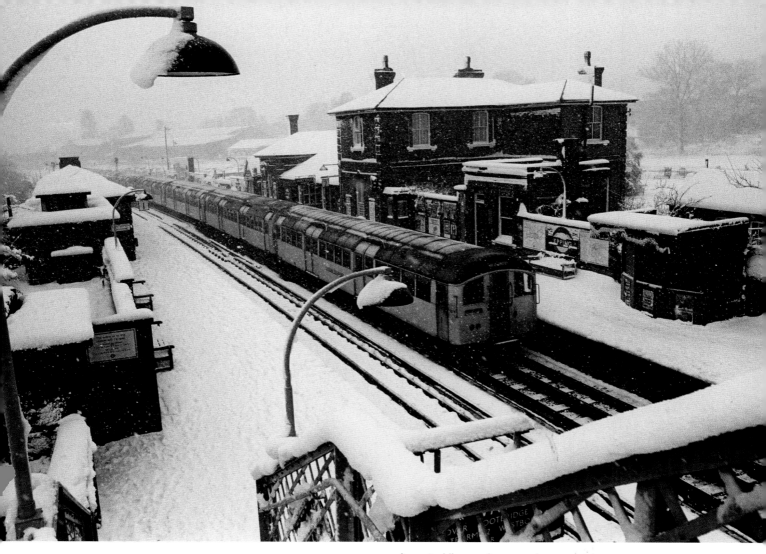

A central line underground train entering the overground Epping station, during its journey through the wintry snowscape.
4th March, 1970

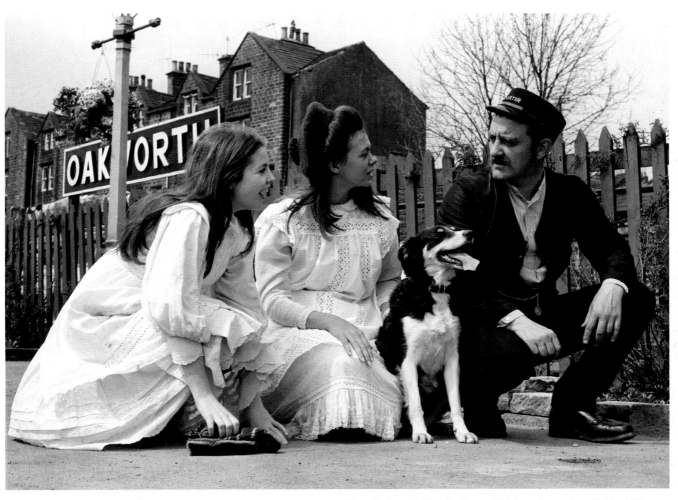

The filming of *The Railway Children*, based on E Nesbit's children's book, on location at Oakworth station in West Yorkshire, with actor Bernard Cribbens as station porter 'Albert Perks', and actresses Sally Thomsett (L) as 'Phyllis' and Jenny Agutter as 'Bobbie'.

2nd July, 1970

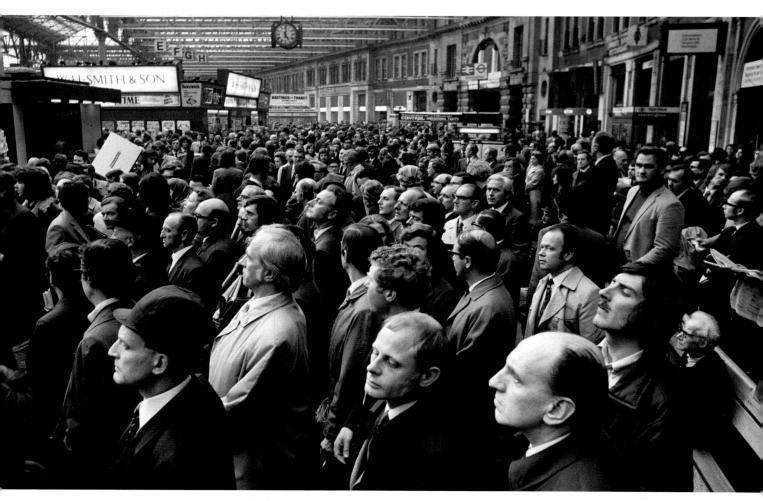

A grim but patient look
on the faces of would-be
passengers crowded into
the 880ft long concourse
at Waterloo station, as
they wait for trains home
during rush hour.
17th April, 1972

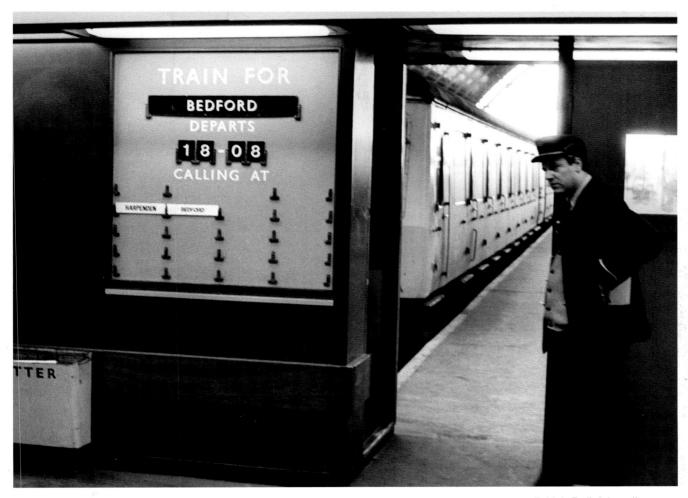

A British Rail ticket clipper waits for passengers to join the train to Bedford from St Pancras station.
1st May, 1973

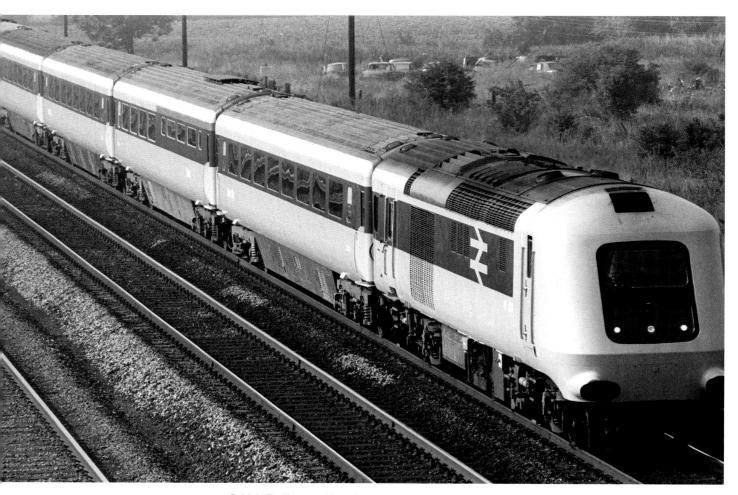

British Rail's new High Speed Train passes through Biggleswade on a trial run from London to Darlington. The 125mph train, which holds the world diesel train record of 143mph, is expected to operate on most Inter-City routes.
2nd August, 1973

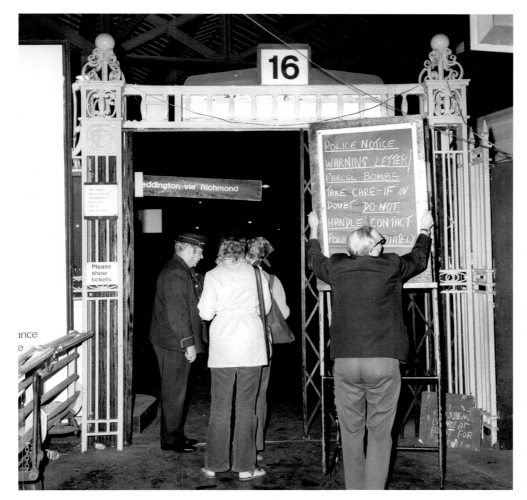

Commuters arriving at Waterloo station, London's busiest terminus, are greeted with hastily written notices warning them to be vigilant about letter bombs. A letter bomb, believed to have been sent by the IRA, had earlier exploded in the hands of Nora Murray, a secretary to the British military attaché in Washington, DC. The following day another letter bomb was discovered at the British embassy in Paris.
27th August, 1973

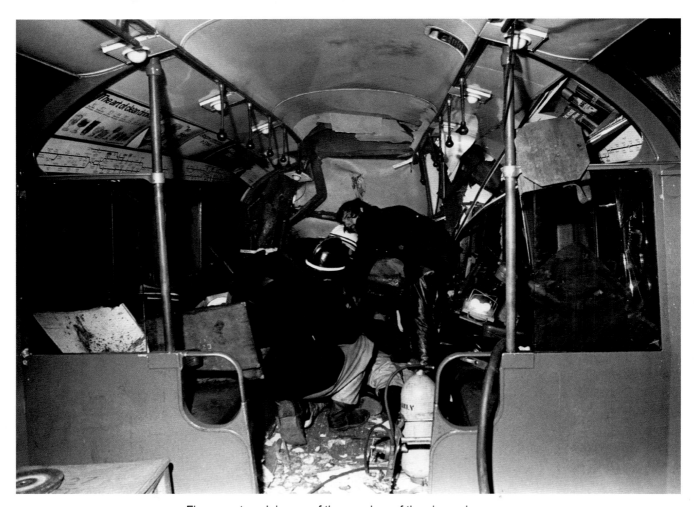

Firemen at work in one of the coaches of the six carriage London Underground train that overran the platform and entered a blind tunnel at Moorgate station on the Northern Line. Forty-three people were killed after the train crashed through buffers and into an end wall.
28th February, 1975

Face blackened, one of the people involved in the tube train crash at Moorgate station is helped from the station to an ambulance. In addition to the 43 deaths more than 50 people were injured and several more subsequently died from their injuries. The cause of the accident was never conclusively ascertained.
28th February, 1975

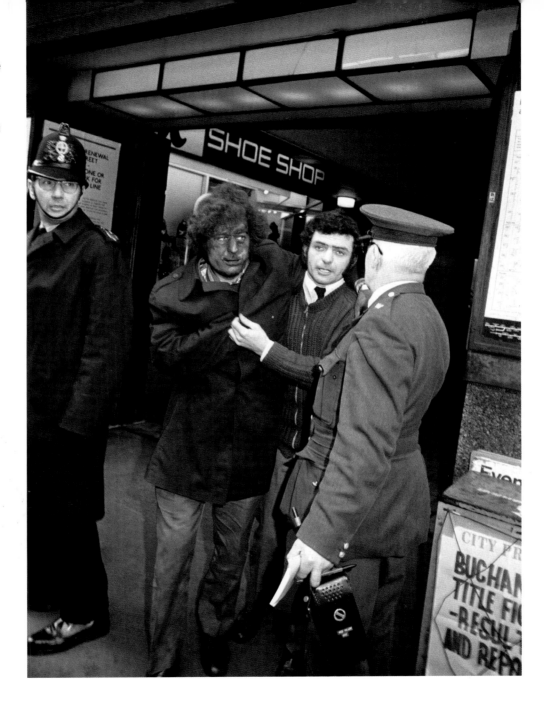

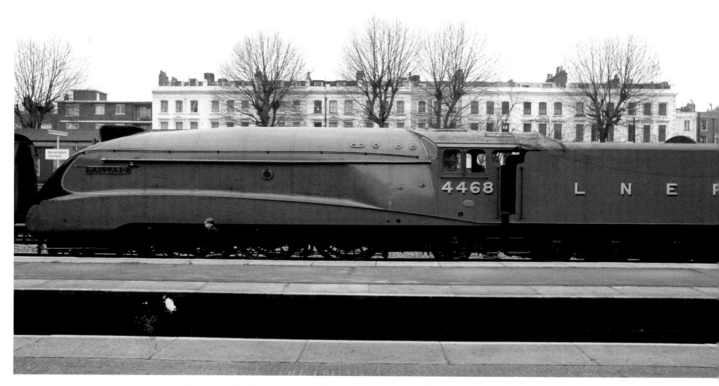

The world's fastest steam locomotive, the A4 Class 4-6-2 No 4468 *Mallard*, stands in Kensington Olympia station, London ready to make one more journey on the former LNER. The locomotive's unbroken record – 125.88mph – was achieved on the 3rd of July, 1938. It is unclear what the gentleman in the coat and hat, carrying a briefcase, is doing standing on the track at the side of the great locomotive.

12th April, 1975

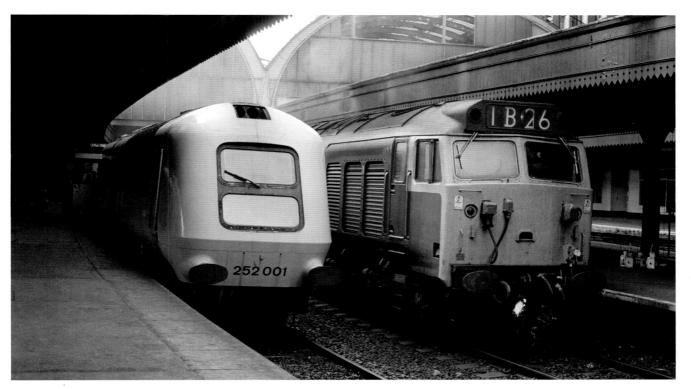

British Rail's prototype 252 Class High Speed Train No 001 (L) at Paddington station, alongside an older model Class 37 locomotive, after its first public passenger run from Bristol. The train was formed of two diesel-electric power cars at each end of a set of carriages. The HST was scheduled to make two trips each way on the route, from Monday to Friday. During trials the super train set a diesel world speed record of 143mph.

5th May, 1975

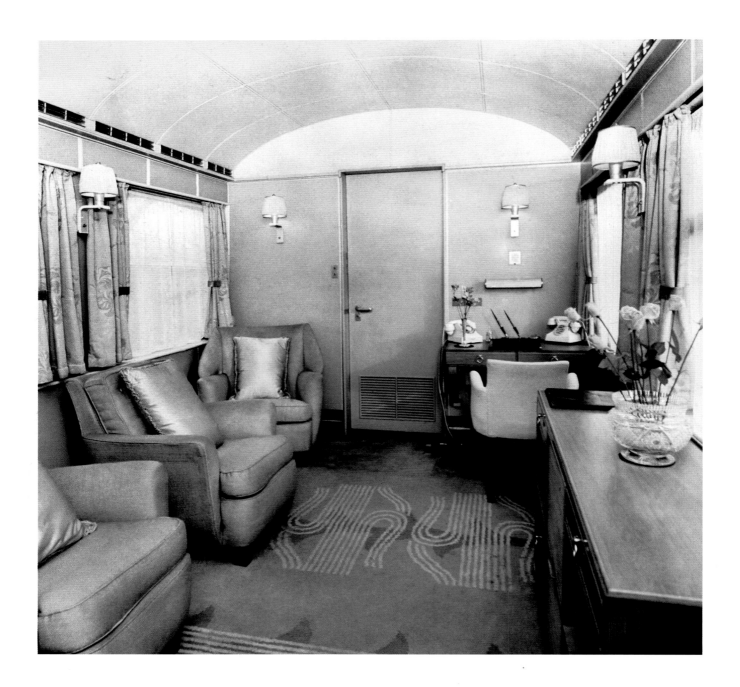

Facing page: The Queen's saloon aboard the Royal Train, during a visit with the Duke of Edinburgh to South Yorkshire, which included a tour of Doncaster's British Rail Engineering Works.
22nd July, 1975

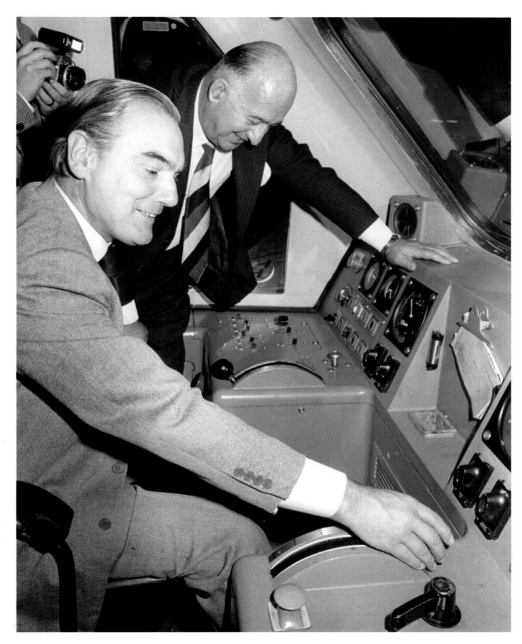

British Rail's chairman Peter Parker at the controls of a new High Speed Train (HST) at Paddington Station before it left for Cardiff on a press demonstration run.
30th September, 1976

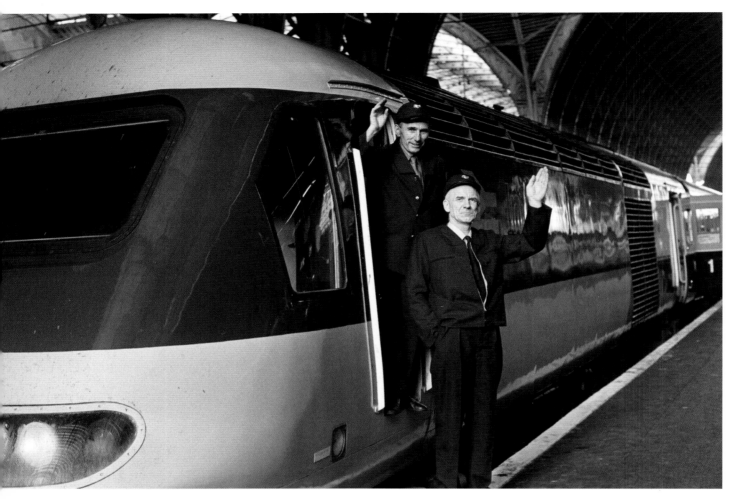

After bringing in Britain's new 125mph HST from Cardiff to London Paddington station, drivers Idris Jones (in cab) and Philip Lewis wave to onlookers. The Inter-City 125 is powered by two diesel motors and has recorded a top speed of over 140mph in trial runs, making it the fastest diesel-powered train in the world.
4th October, 1976

The Queen arriving at Heathrow Central station in London in the driver's cab of a tube train, when she officially opened the £30 million Piccadilly Line extension linking Heathrow Airport with London's underground railway system.
16th December, 1977

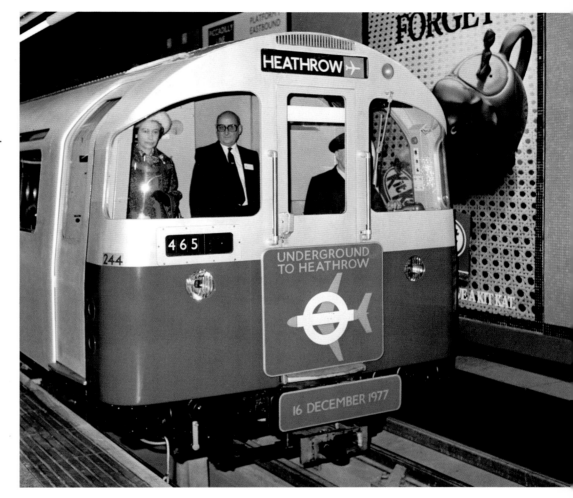

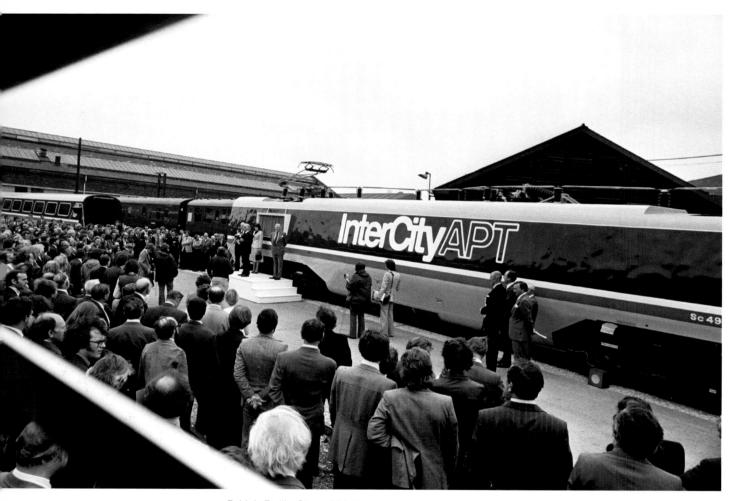

British Rail's Class 370 tilting train, the Inter-City APT-P (Advanced Passenger Train Prototype) is unveiled in Derby at a naming ceremony. *The City of Derby* is a sleek, £2m train powered by 25kV AC overhead electrification. Eleven years in development, the train is due to start high-speed trials on the main line between Glasgow and Crewe.

7th June, 1978

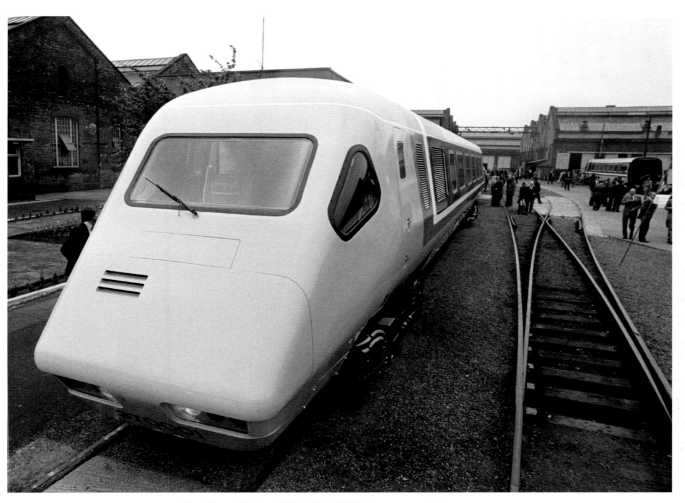

The City of Derby APT-P No 370001 was one of three prototypes designed to run at speeds up to 150mph on Britain's Inter-City network. Production problems, shortage of funds and lack of political support resulted in the proposed production series never being built, although the technology influenced the later InterCity 225 trainsets, and was sold to Fiat as the basis for their Pendolino trains.

7th June, 1978

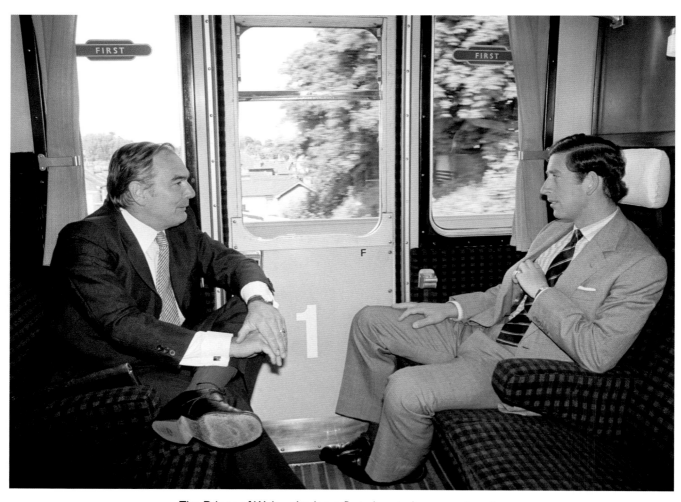

The Prince of Wales sharing a first-class train compartment with British Rail chairman Sir Peter Parker, who received a knighthood in 1978, on a journey from Victoria station, London, to Gatwick Airport.

9th June, 1978

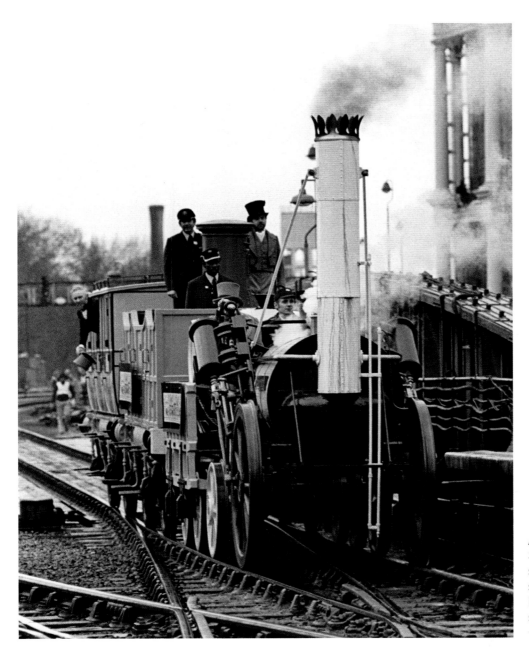

A working replica of George Stephenson's *Rocket* steamed into St Pancras station, London to mark the Post Office Special Train stamp issue.
10th March, 1980

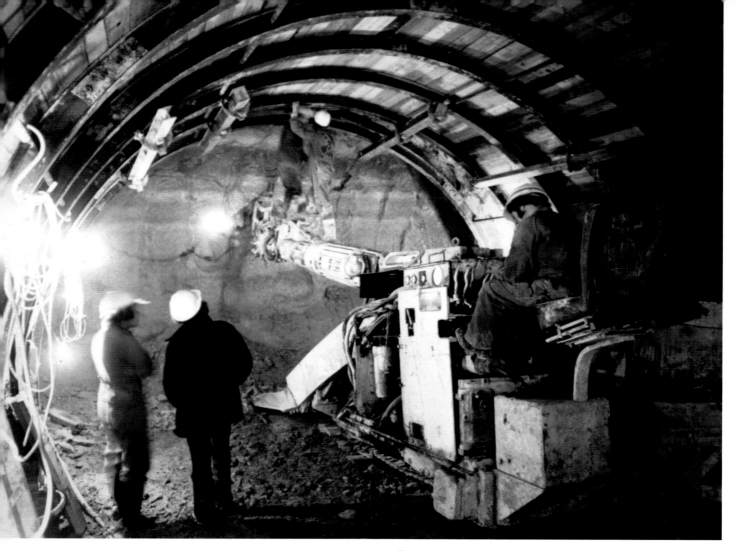

Engineers working on a section of the 32 mile long Channel Tunnel at Dover.

14th January, 1982

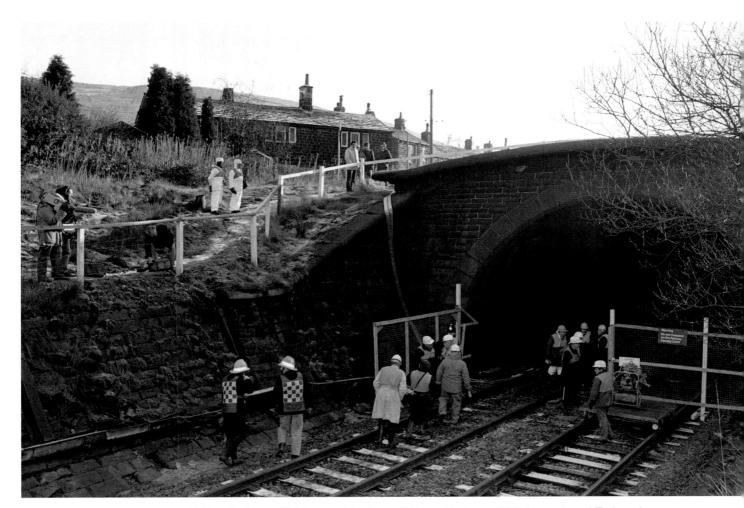

British Railway officials enter the Summit Tunnel between Littleborough and Todmorden to carry out a site inspection after a fuel train exploded in the tunnel on the 20th of December. No one was injured and the fire was contained by the tunnel and the co-ordinated efforts of the Greater Manchester and West Yorkshire Fire Brigades. The heat in the tunnel reached 1,530 degrees Fahrenheit, hot enough to melt some of the brickwork lining the tunnel roof.
27th December, 1984

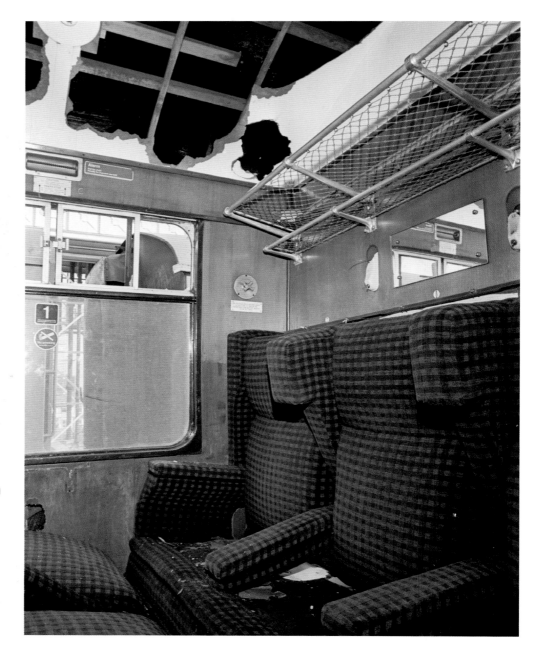

After one of the worst incidents of football hooliganism surrounding the FA Cup sixth round match between Luton Town and Millwall at Kenilworth Road stadium, Luton, on the 13th March, several train carriages of the 22.30 Luton–St Pancras football special train were wrecked by Millwall fans on their journey back to the capital.
14th March, 1985

Diana, Princess of Wales, steps from the driver's cab of an Inter-City 125 train, at Paddington station, after naming the locomotive *The Red Cross*, in honour of the 125th anniversary of the International Red Cross.
3rd May, 1988

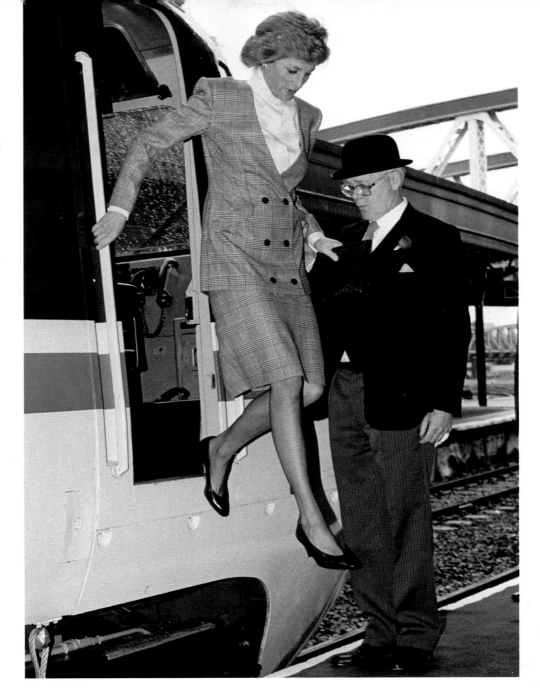

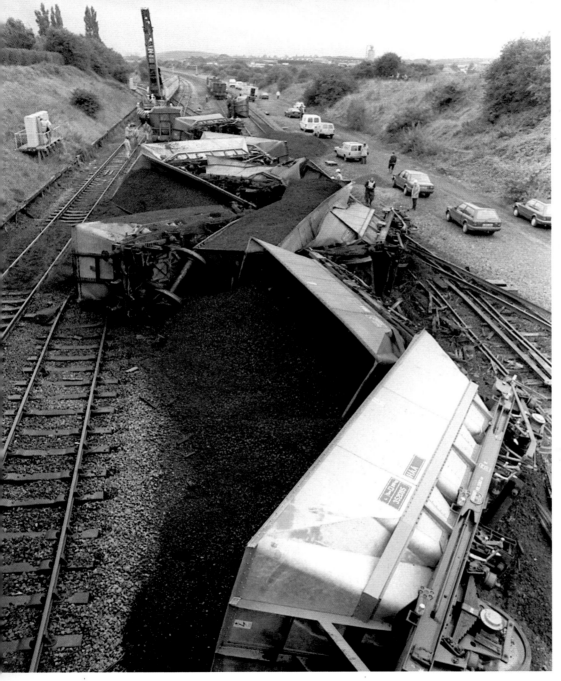

Overturned freight trucks spill their load across the tracks after a derailment at Trowell, Nottinghamshire.
1st September, 1988

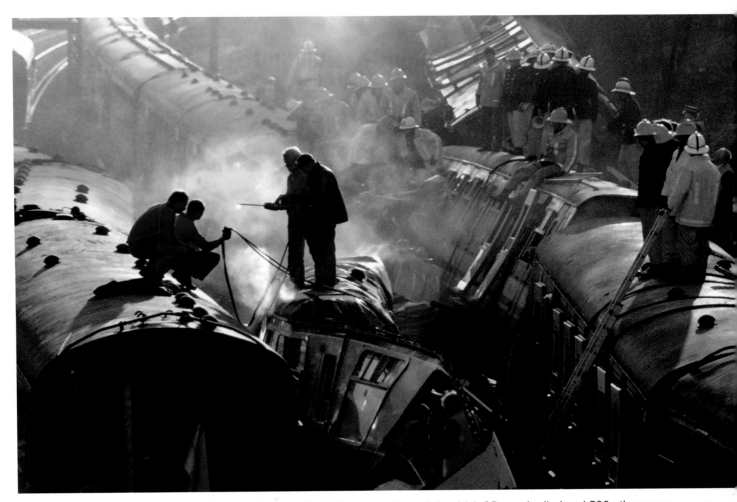

The scene of devastation following a rail crash in which 35 people died and 500 others were injured after two commuter trains carrying 1,300 passengers between them collided shortly after 8am at Clapham Junction, south London. Shortly afterwards a third empty train ran into the wreckage, killing some of the passengers who had survived the first crash. Faulty signal wiring, which caused a red light to show green, was partly to blame for the accident.
12th December, 1988

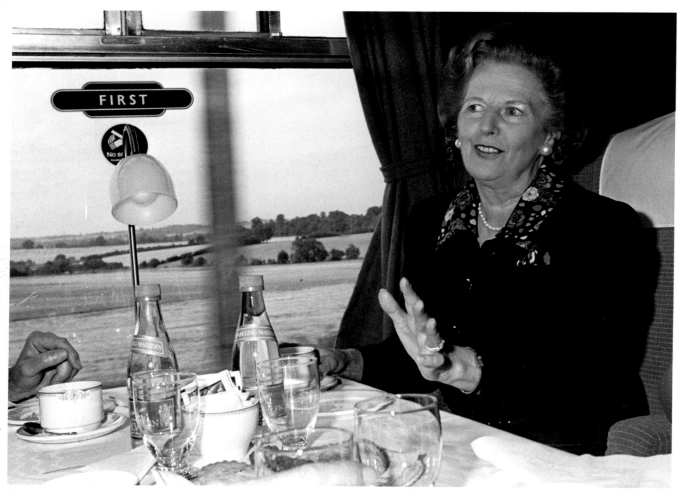

Prime Minister Margaret Thatcher making her first train
journey since the general election to Bedfordshire to visit
the headquarters of the Royal Society for the Protection
of Birds (RSPB) in Sandy.
31st August, 1989

Facing page: Tunnelling teams from Britain and France
celebrate the breaking through of the final underground
section of the Channel Tunnel, creating the first ground-
based connection to the continent since the Ice Age.
20th November, 1990

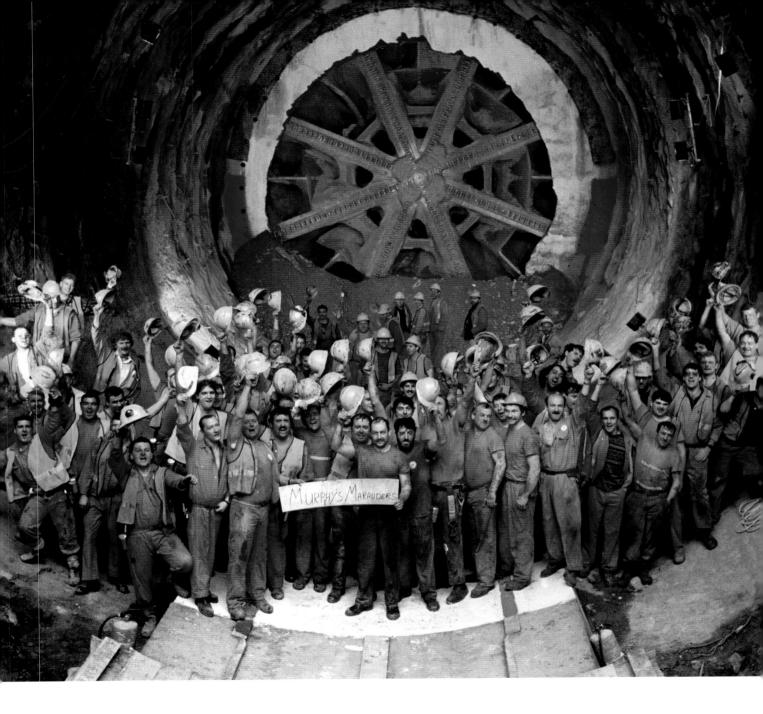

MURPHY'S MARAUDERS

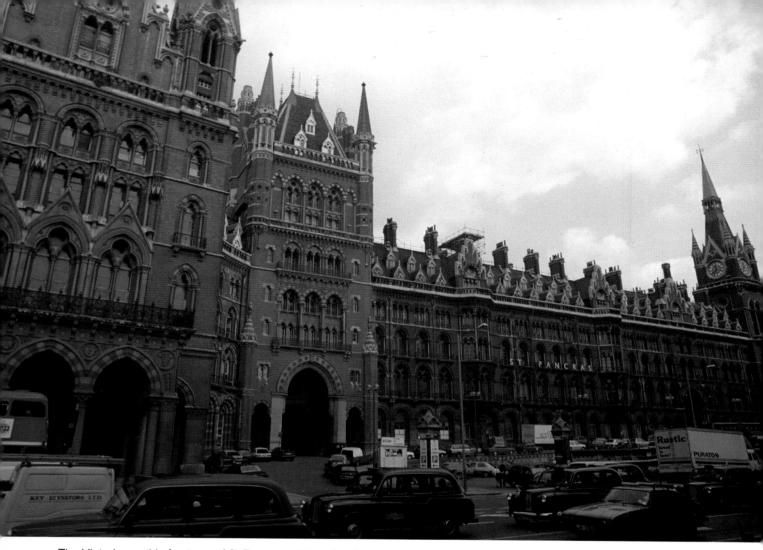

The Victorian gothic frontage of St Pancras station, London, was designed by Sir George Gilbert Scott as the Midland Grand Hotel, later becoming St Pancras Chambers. The hotel was the first in London to have lifts, called 'ascending rooms'.

22nd July, 1991

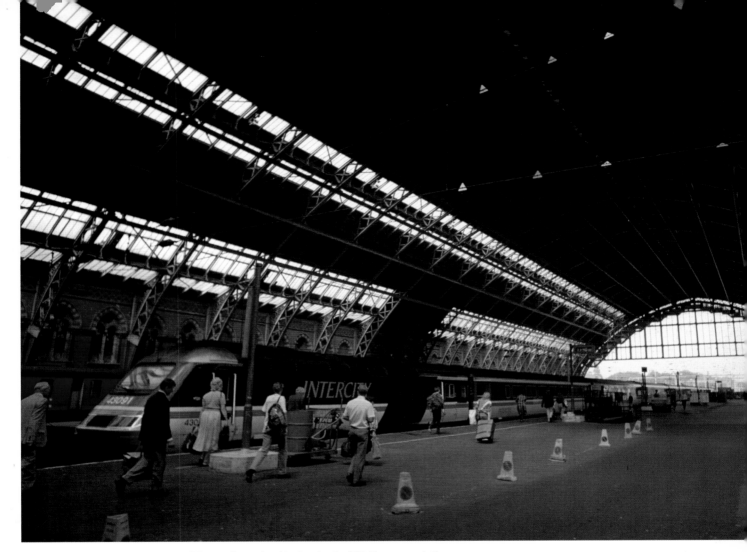

The main arched train shed of St Pancras station, constructed in 1868 by the engineer William Henry Barlow, was the largest single-span structure built at the time. The station complex was renovated and expanded in the 2000s to become St Pancras International, with a high-speed rail route via the Channel Tunnel to Continental Europe.
22nd July, 1991

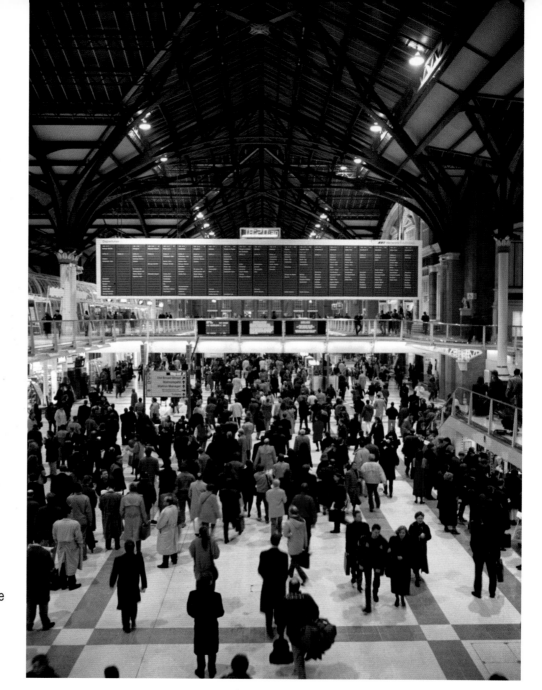

The two tiered concourse of Liverpool Street station in London, which was extensively modernized between 1985 and 1992, including the addition of a giant suspended 'flapper board' timetable. One of the last remaining mechanical displays at a UK station, it was replaced by an electronic board in 2007.
9th February, 1993

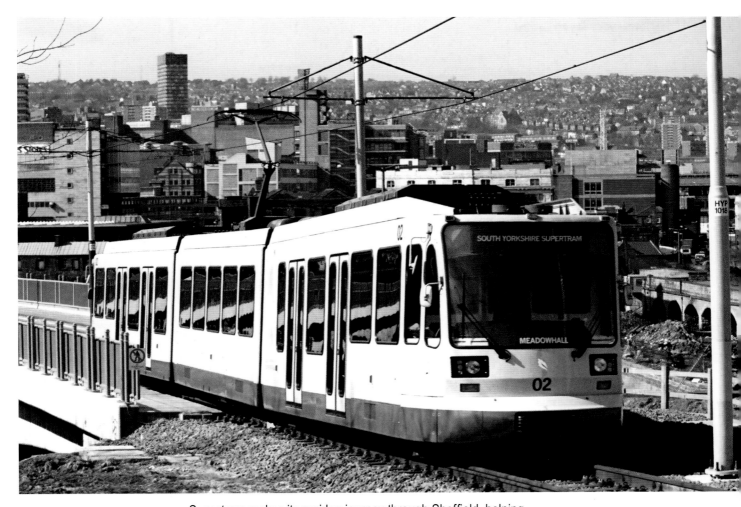

Supertram makes its maiden journey through Sheffield, helping to alleviate the congested streets. The £240m system consists of a mixture of on-street running, reserved right of way and former railway alignment, with a viaduct section.
21st March, 1994

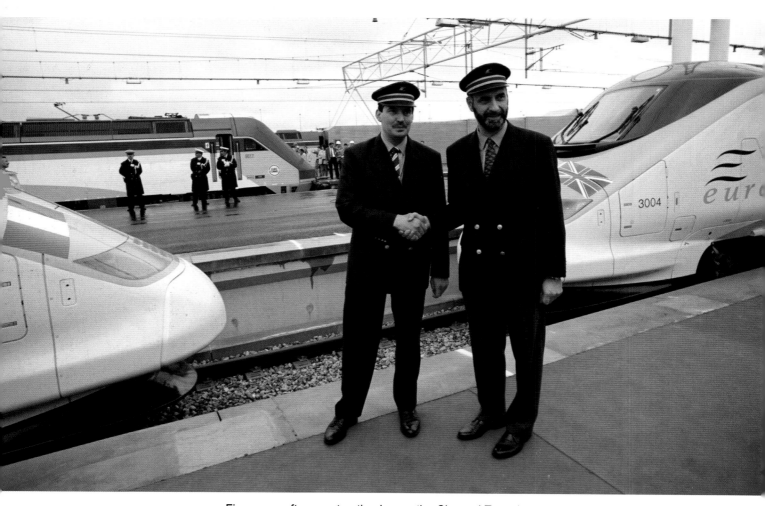

Five years after construction began the Channel Tunnel
was officially opened by the Queen and French President
François Mitterand. Eurostar drivers Nigel Brown (L) and
Francis Guilland shake hands at Coquelles in France after
Mr Brown had driven the Queen's train through the Tunnel to
meet nose to nose with President Mitterand's train driven by
Mr Guilland from Paris.
6th May, 1994

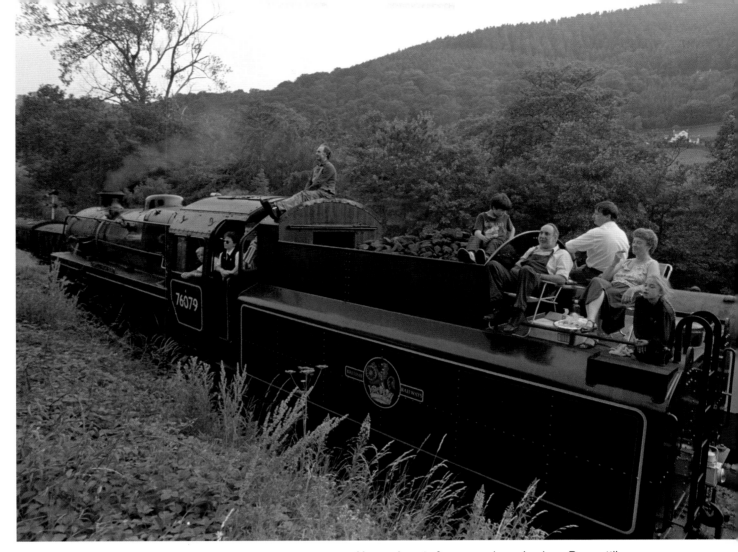

Unusual seats for opera singer Luciano Pavarotti's appearance at the Eisteddfod in Llangollen, Wales as BR 4MT Class 2-6-0 locomotive No 76079, built in 1957 and now owned by Riley & Son Ltd, stops to allow passengers to savour the dulcet tones of the maestro, on the town's famous railway line. The locomotive has a mainline certificate and makes guest appearances all over the national network.
9th July, 1995

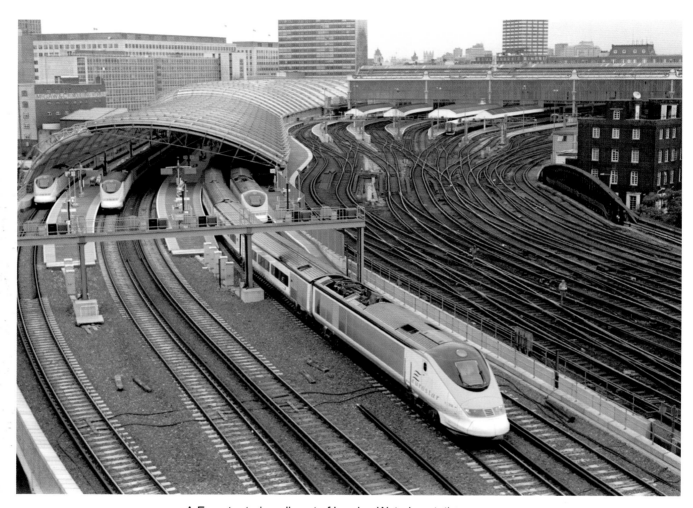

A Eurostar train pulls out of London Waterloo station on the second day of industrial action by members of the train drivers' union ASLEF. The international train, en route to Paris via the Channel Tunnel, is one of only a handful of services operating in Britain.

18th July, 1995

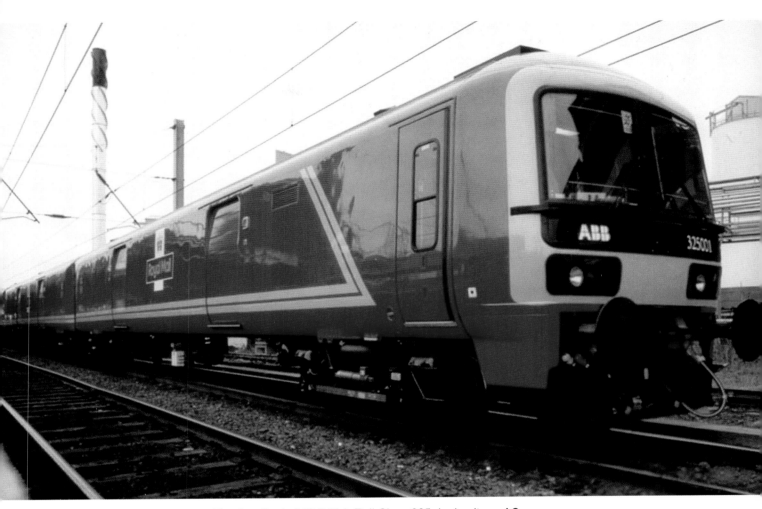

First in a fleet of 16 British Rail Class 325 dual-voltage AC
electric multiple unit trains used for postal services by
the Royal Mail, which employ Total Operations Processing
System (TOPS), a computer system for management
of locomotives and rolling stock.
30th July, 1995

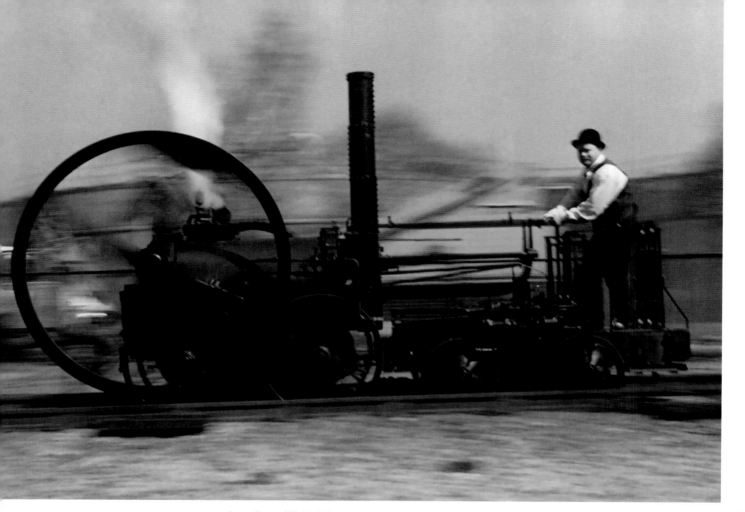

A replica of British inventor and mining engineer Richard Trevithick's 1802 steam engine, the world's first steam railway locomotive, runs on a track near the Ironbridge power station, Shropshire. The full scale locomotive was built at GKN Sankey in Telford by a team of nine apprentices, to Trevithick's original designs with some minor changes to meet current safety requirements.

4th April, 1996

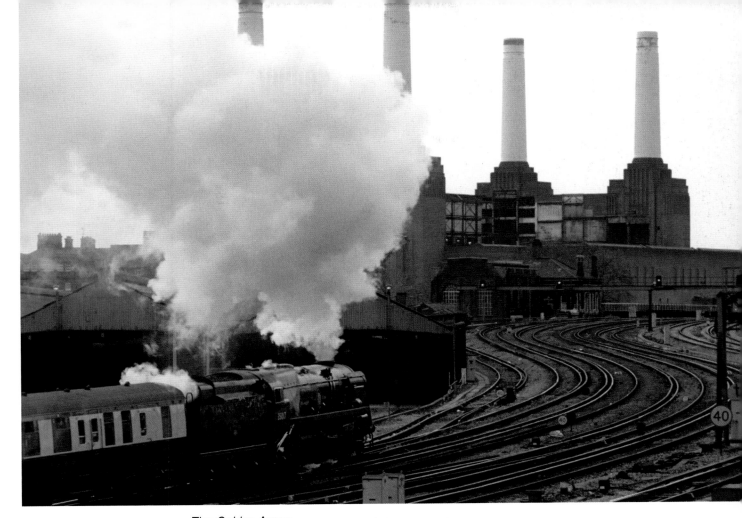

The *Golden Arrow* locomotive hauls the *Orient Express* train towards London's Battersea Power Station, the first time in 50 years a steam locomotive has been used to pull the luxury service.
28th April, 1996

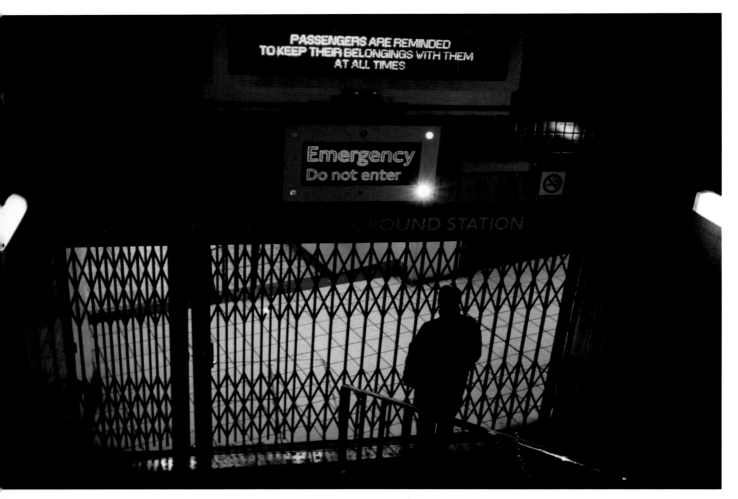

A lone person stands in front of locked gates at Victoria underground station in London after a system-wide power cut stranded 20,000 passengers on tube trains. The problem was traced to the failure of a control valve on one of the main gas boilers at the 91-year-old Lots Road power station in Fulham, which provides most of the electricity to the 11 lines and 248 stations of the network.

20th November, 1996

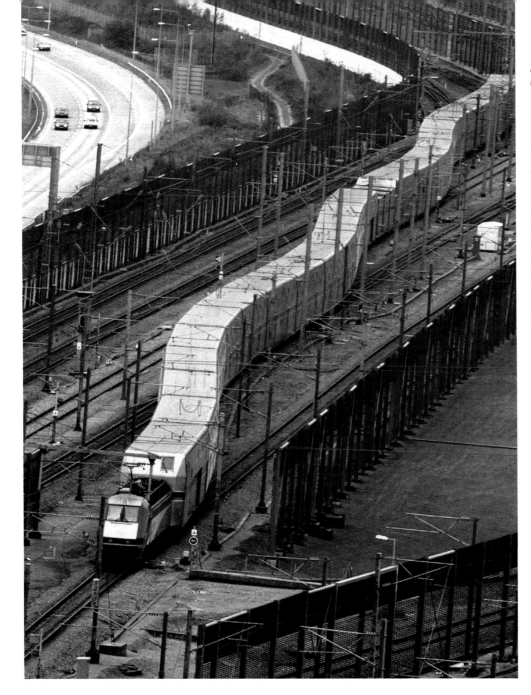

A *Le Shuttle* inspection train exits the Channel Tunnel at Folkestone following a fire in the tunnel on the 18th of November. Shuttle number 7539 carrying HGVs and their drivers from France to Great Britain caught fire prior to entering the tunnel. Passengers and crew evacuated to the adjacent service tunnel. No one was killed but several people suffered smoke inhalation. Services resumed over the following two months although refurbishment of the tunnel continued until May 1997.

20th November, 1996

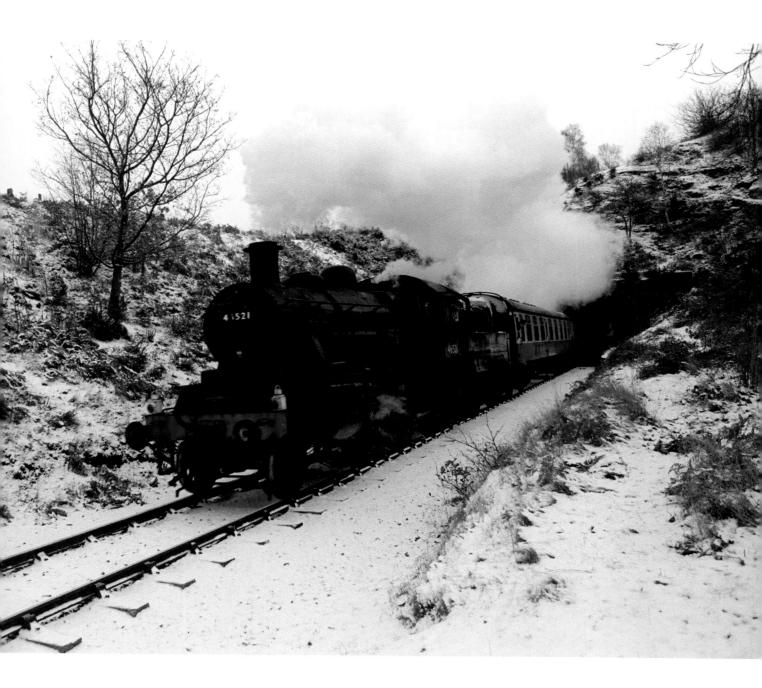

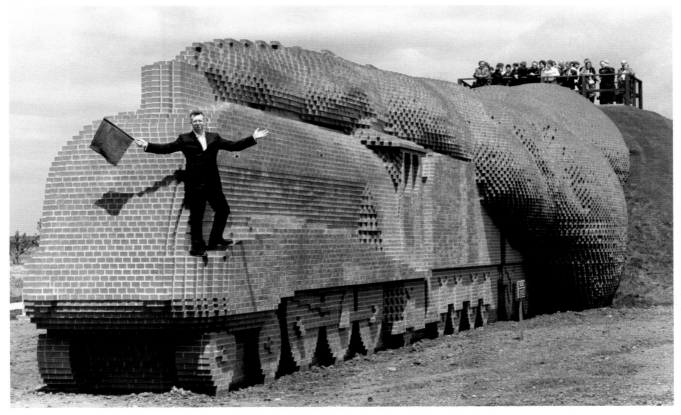

Facing page: Severn Valley Railway's LMS Ivatt Class 2 2-6-0 locomotive No 46521 emerges from the Bewdley Tunnel. The already scenic route was given the additional attraction of snow after an overnight fall. The locomotive, built in 1953, was used on branch and country lines but more recently played a starring role in the television comedy series *Oh, Doctor Beeching!* filmed at nearby Arley, for which she was re-christened *Blossom*.
31st December, 1996

Internationally renowned sculptor David Mach, 41, known for his large-scale works using everyday materials, stands on his latest creation *Train in Darlington*. The sculpture, unveiled in the birthplace of passenger railways, is made entirely of bricks and was built by 36 men who usually build houses. The £670,000 cost of the giant train was mainly covered by a Lottery Arts Fund grant.
23rd June, 1997

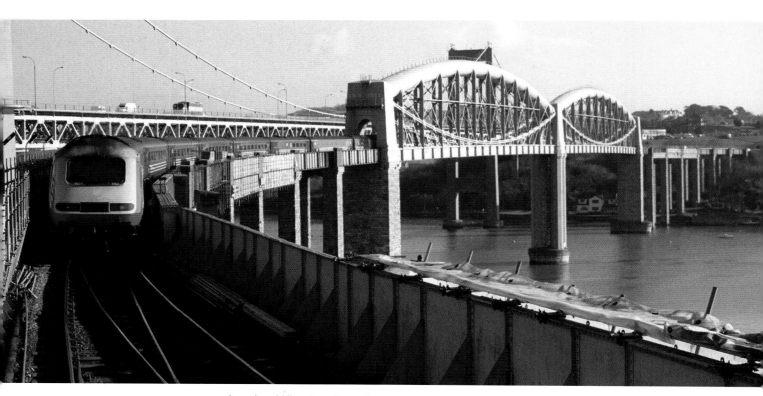

Isambard Kingdom Brunel's historic Royal Albert Bridge, which carries the Cornish Main Line railway that links Devon and Cornwall over the River Tamar at Plymouth. The unique design of the bridge features two 455ft lenticular iron trusses 100ft above the water with approach spans in a more conventional plate girder construction, and it has a total length of 2,287.5ft.
2nd February, 1998

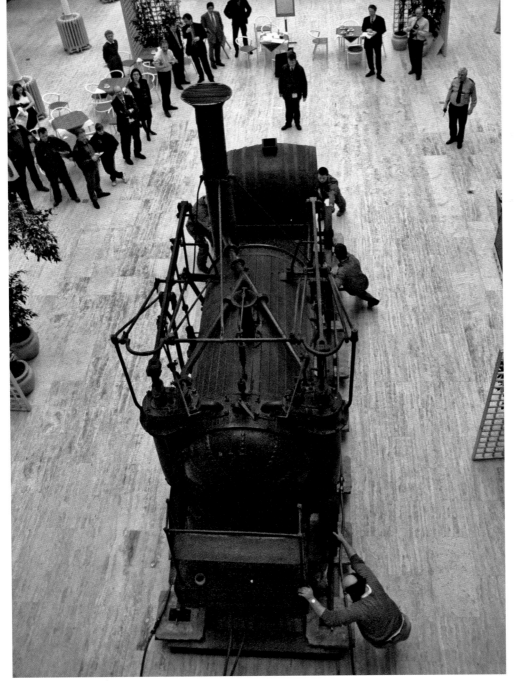

One of the two oldest surviving railway locomotives in the world, *Wylam Dilly*, built around 1815 by William Hedley and Timothy Hackworth to transport coal on the Wylam Waggonway, went on its first journey in four years – it was moved into the main hall of the Royal Museum in Edinburgh on a set of air-cushioned skates after being mothballed in March 1994.

4th March, 1998

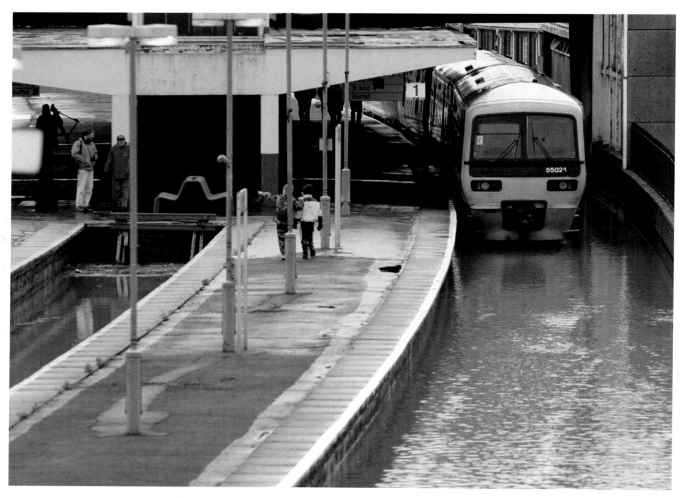

A train is marooned in waterlogged Banbury railway station. Thousands of people across Britain were left stranded over the Easter weekend following heavy rain, which flooded towns, roads and railways.
10th April, 1998

The new £1m multi-purpose Geismar Rail Cleaner, unveiled by Railtrack at London Waterloo station, is designed to deal not only with that bane of passengers' lives – leaves on the line – but also ice, weeds and fire. The first of 25 production models, DR98305 uses high pressure water jets to clear tracks and will come into service in August 1999.

8th May, 1998

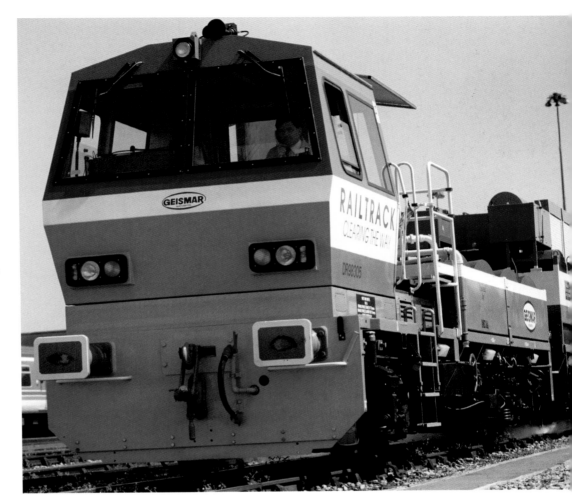

The high-pressure water jets that are designed to clear rail lines are put into action during a demonstration of Railtrack's new multi-purpose track machine.
8th May, 1998

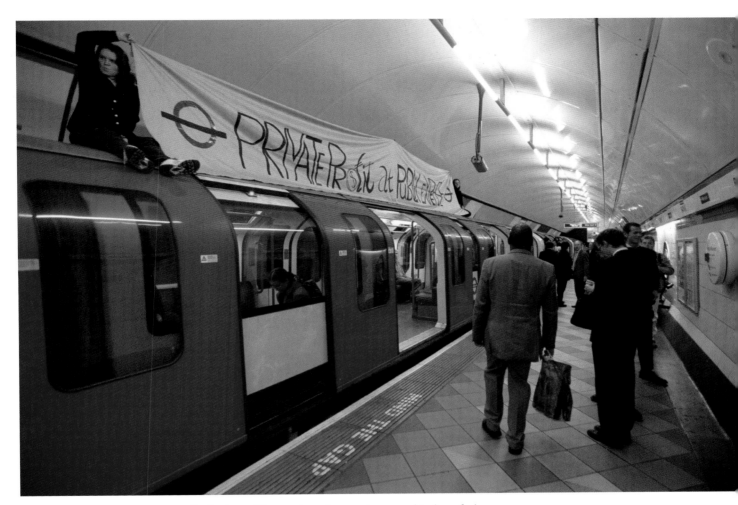

Protesters sitting on top of an underground train unfurl
a banner at Bank station, London after members of the
Reclaim the Streets direct action movement brought morning
rush hour trains on the Central Line platform to a standstill
for 30 minutes. The protest was in support of underground
workers striking to resist privatization.
13th July, 1998

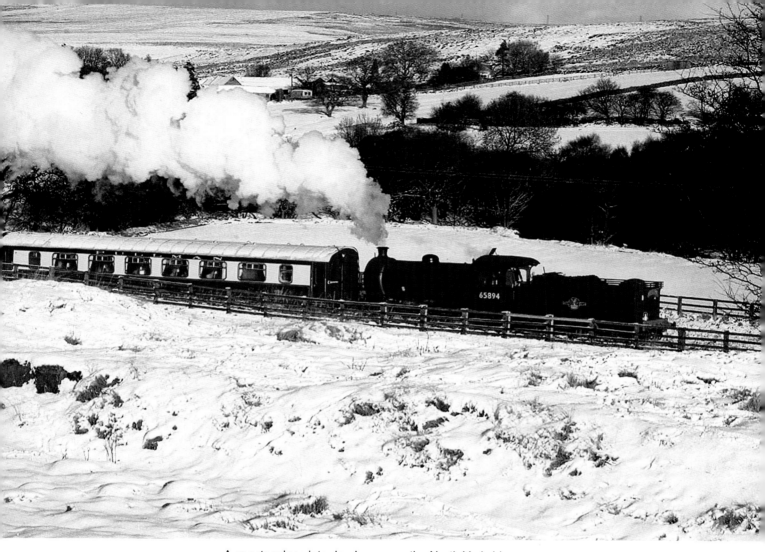

A spectacular winter landscape on the North Yorkshire Moors Railway near Goathland station as an NER P3 Class 0-6-0 locomotive hauls a train of Pullman coaches along the picturesque line.
6th December, 1998

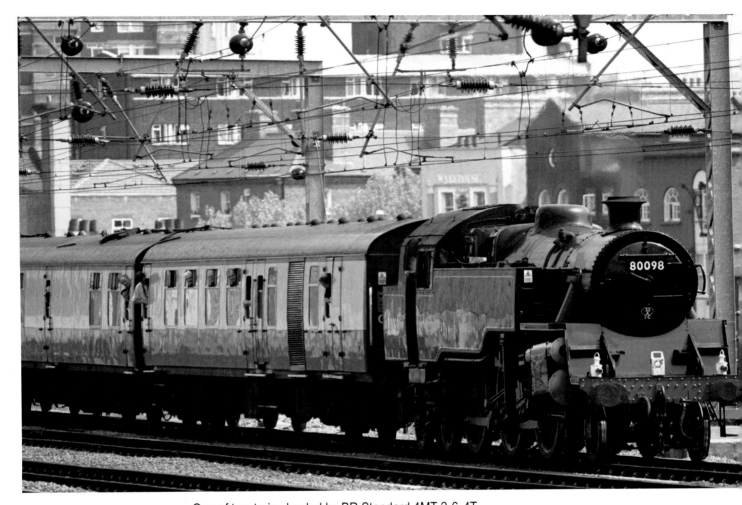

One of two trains hauled by BR Standard 4MT 2-6-4T locomotives leaves Fenchurch Street station, London on a special bank holiday weekend trip to Shoeburyness, near Southend-on-Sea, Essex, returning later in the day.
2nd May, 1999

Gerald Corbett, chief
executive of Railtrack,
the company that owns
and operates the railway
infrastructure, in London
to announce annual profits
of nearly £1.2m. Railtrack
said it needed to generate
profit in order to improve
the rail network.
27th May, 1999

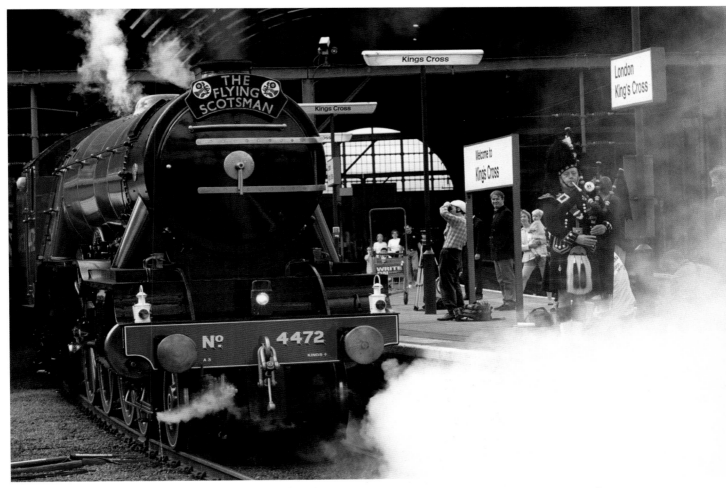

The Flying Scotsman, one of the world's most famous locomotives, steams triumphantly out of London King's Cross station, following three years of repairs costing £1m, including the rebuilding of the engine's leaky boiler.
4th July, 1999

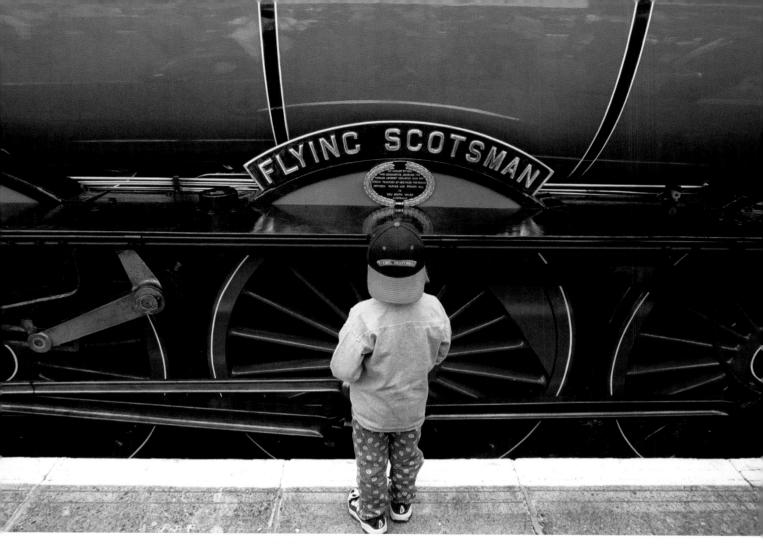

Hannah Styles, six, from the Peak District, takes a close look at *The Flying Scotsman* at King's Cross station. The 76-year-old locomotive left for York following three years of repairs.
4th July, 1999

Early locomotive consultant, author, lecturer and broadcaster Michael Bailey, standing on a replica of Stephenson's *Rocket* at the National Railway Museum in York, has been awarded the world's first Doctorate of Philosophy from the Institute of Railway Studies, York.
18th August, 1999

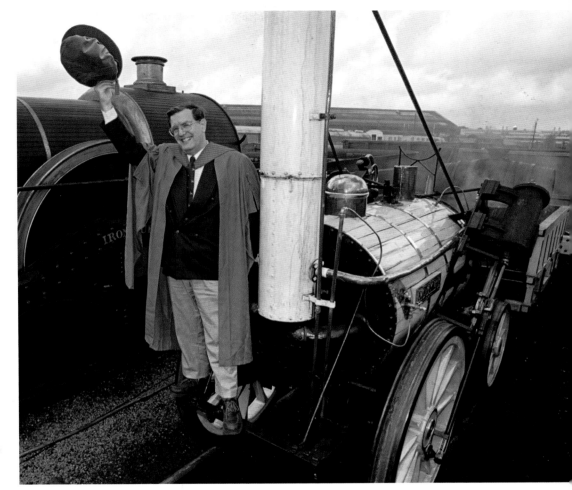

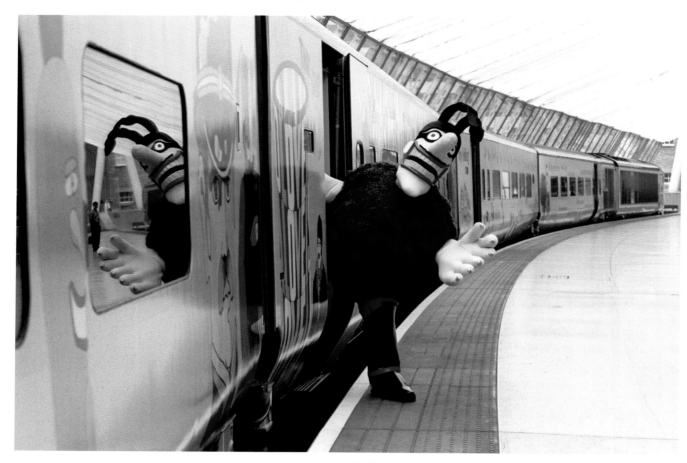

A *Blue Meanie* peers from a newly painted Eurostar train at Waterloo station. The train has been decorated with images from the revamped and re-released Beatles animated film *Yellow Submarine*, and renamed the *Beatles Express*.
8th September, 1999

Entrance ticket barriers at Canning Town tube station are a smart, high tech feature of the new London Underground Jubilee Line extension.

11th November, 1999

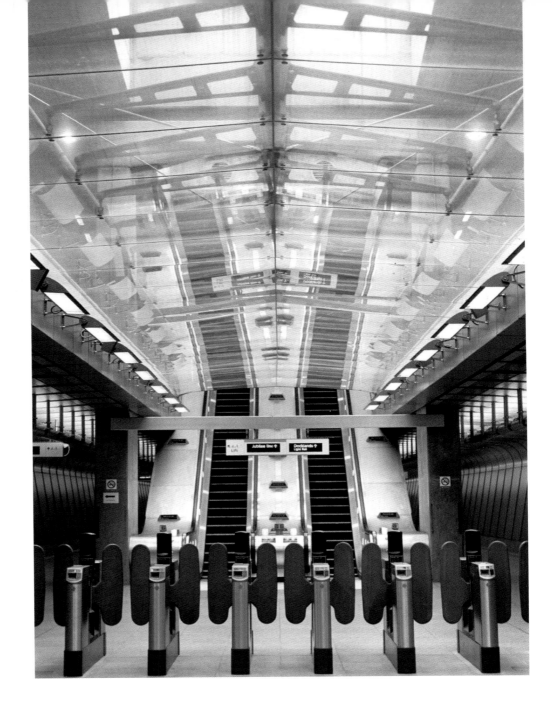

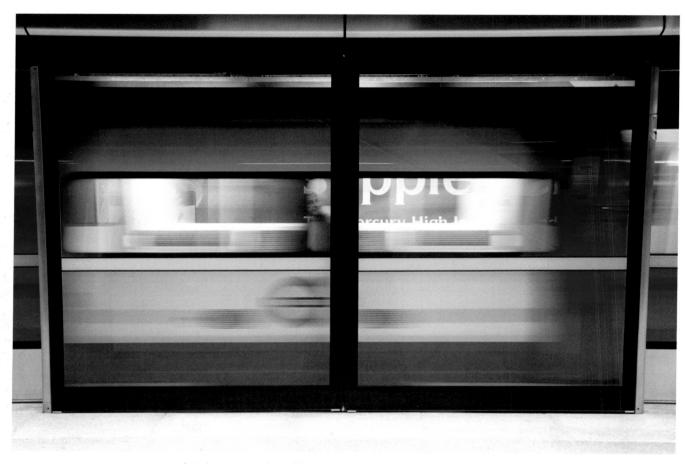

A train passes glazed barriers installed along the platforms at Canary Wharf tube station, pulling up so that its doors align with the platform edge doors. The innovation was designed to improve airflow at stations, while it also would prevent passengers from jumping or falling onto the line.
11th November, 1999

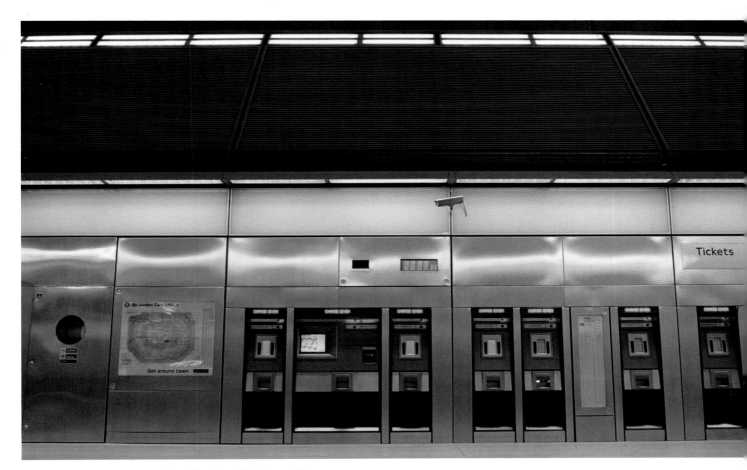

Banks of ticket machines
in grey and silver polished
metal give an ultra modern,
efficient appearance to
Canary Wharf tube station.
11th November, 1999

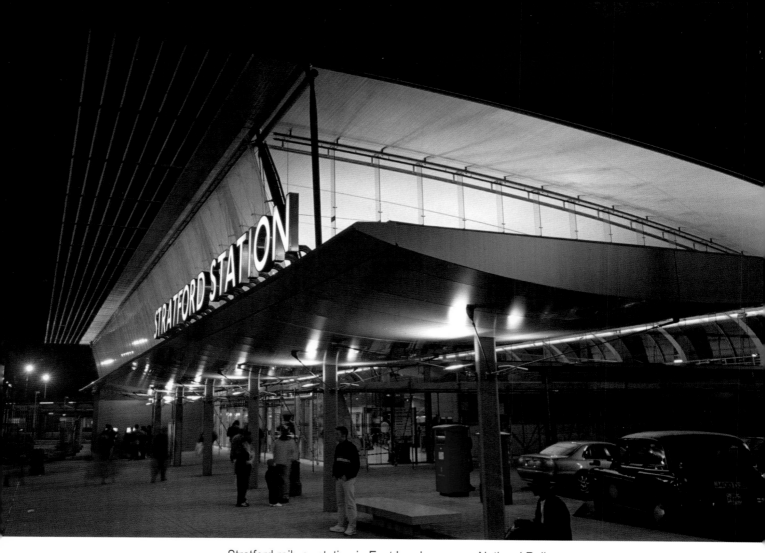

Stratford railway station in East London serves National Rail, London Underground, London Overground and Docklands Light Railway lines. The low level station was redeveloped as part of the London Underground Jubilee Line extension. The steel and glass entrance and new ticket hall were designed by Wilkinson Eyre architects.

12th November, 1999

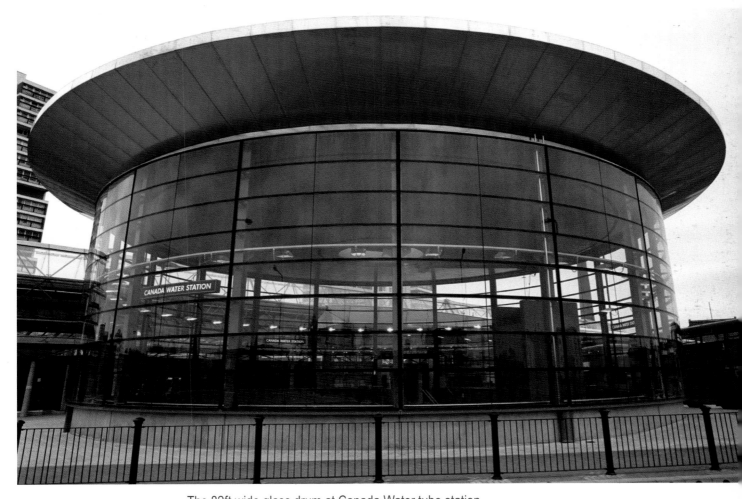

The 82ft wide glass drum at Canada Water tube station covers a deep opening that descends almost to the Jubilee Line platforms 72ft below the surface. It was designed by Buro Happold to admit natural light deep into the station.

12th November, 1999

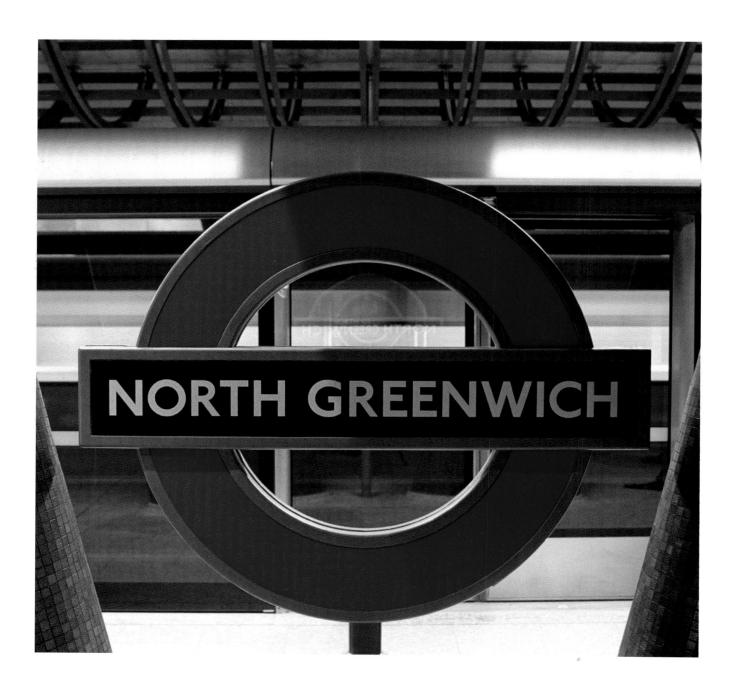

Facing page: Roundels have been used to denote London transport facilities since the 19th century, and the red circle with a blue name cross-bar was widely adopted in 1908 for underground stations. The logo is instantly recognizable not only to Londoners, but also to most Britons and many people worldwide.
25th November, 1999

The control room and some of the barriers at North Greenwich tube station. Located adjacent to the Millennium Dome, the station is one of the largest on the Jubilee Line and capable of handling about 20,000 passengers an hour.
25th November, 1999

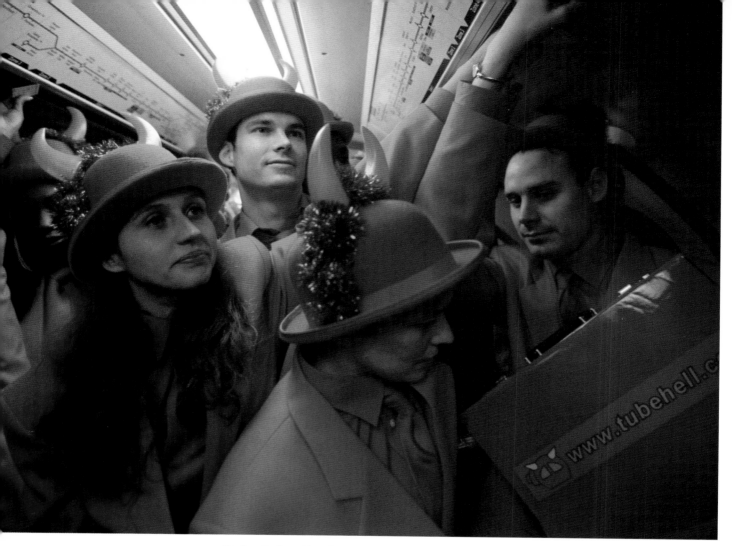

Red-suited and bowler-
hatted 'Commuters from
Hell' travel on a tube train
during the rush hour to
stage a protest at what they
regard as the current state
of London's underground.
8th December, 1999

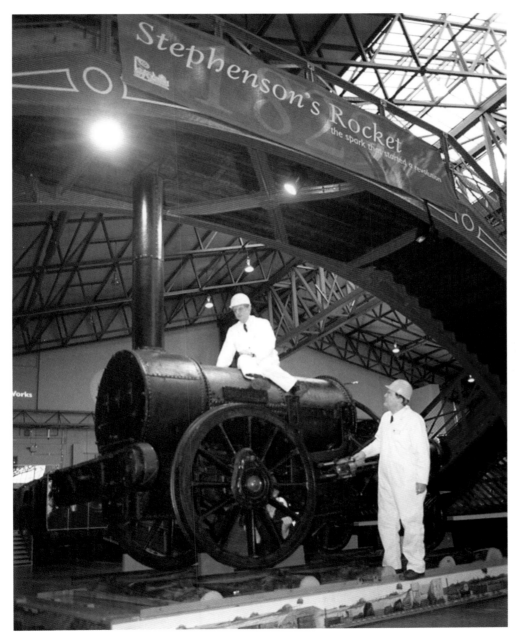

Early locomotive consultants John Glithero and Dr Michael Bailey (R) examine the original Stephenson's *Rocket*, which is preserved at the National Railway Museum in York.
14th December, 1999

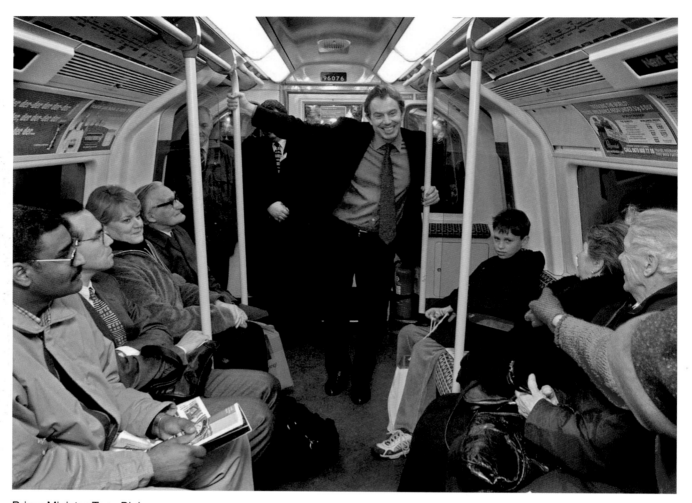

Prime Minister Tony Blair
travels on the newly built
Jubilee Line extension on
the London Underground
network, to the Millennium
Dome in Greenwich.
14th December, 1999

Facing page: A bank of
escalators at London Bridge
underground station, part
of the London Underground
Jubilee Line extension.
8th February, 2000

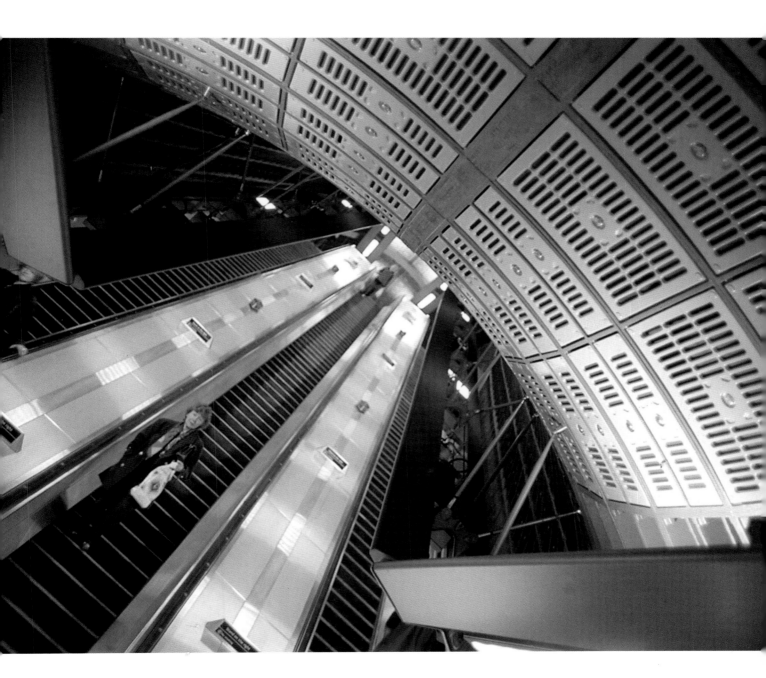

A train guard carries ticket machine boxes along the platform at Glasgow Central station, as guards in the Rail, Maritime & Transport union were being balloted over strike action in protest at changes to their responsibilities.

23rd February, 2000

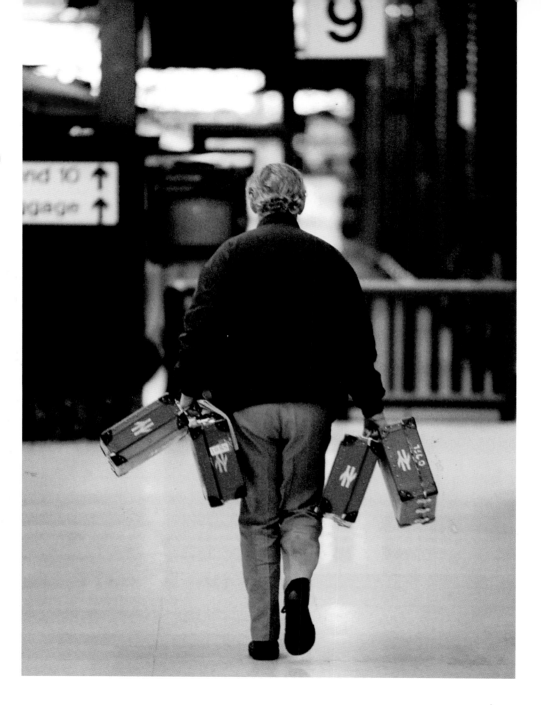

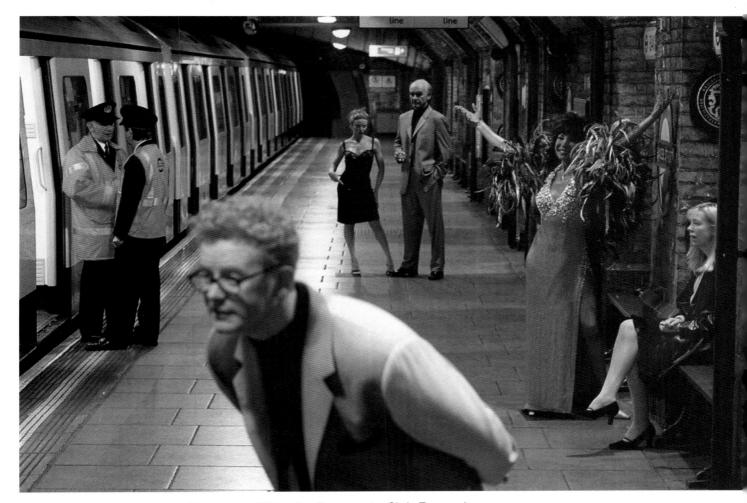

Waxworks of TV and radio presenter Chris Evans, singers Shirley Bassey and Kylie Minogue, and actor Sean Connery, from Madame Tussaud's, adorn the platform at London's Baker Street underground station as part of a publicity event.
16th March, 2000

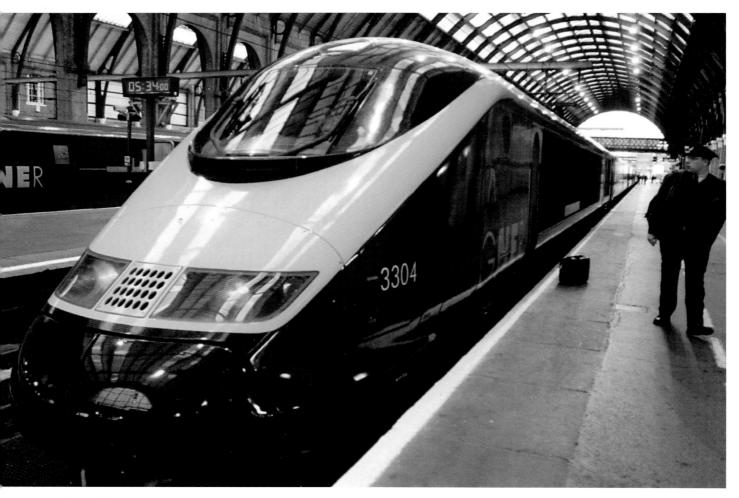

One of five BR Class 373 high-speed electric trainsets leased for five years from Eurostar by the Great North Eastern Railway for their new *White Rose* services between King's Cross and York. The trains were to integrate with GNER's new summer timetable to provide nine additional leisure services each weekday and six extra on Sundays, and to provide two million extra seats a year to reduce the overcrowding on GNER's Anglo-Scottish services.
30th May, 2000

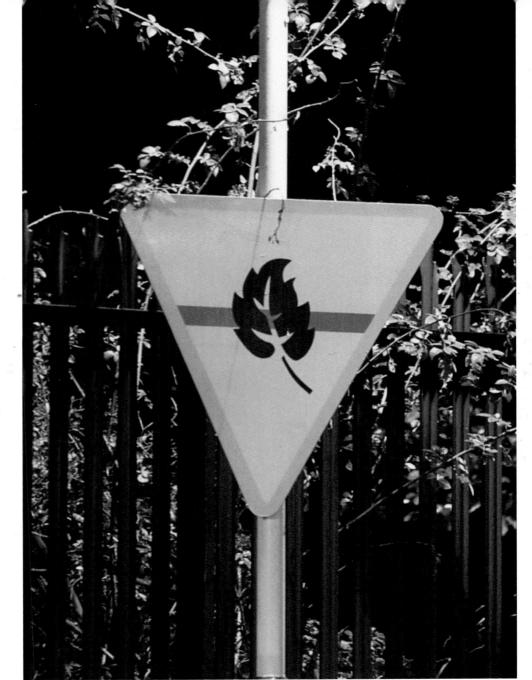

A sign at East Ewell railway station indicates to train drivers that they have passed a leaf fall area. Co-ordinator of Site Safety for Railtrack Chris Scott demonstrated some of the techniques used by the leaf teams to clear tracks of leaves at the station in Surrey.
17th October, 2000

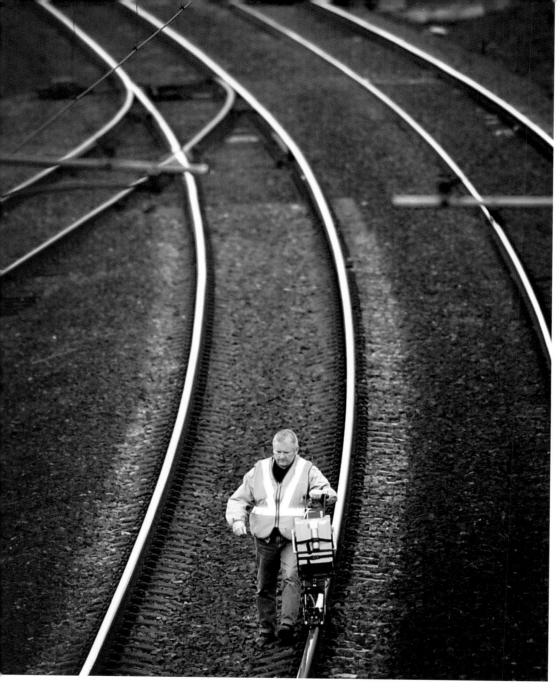

A railway engineer checks the track of the West Coast Main Line near Law in Lanarkshire, after the line between Gretna on the Scottish border and Law Junction, south of Glasgow, was closed for safety checks.
25th October, 2000

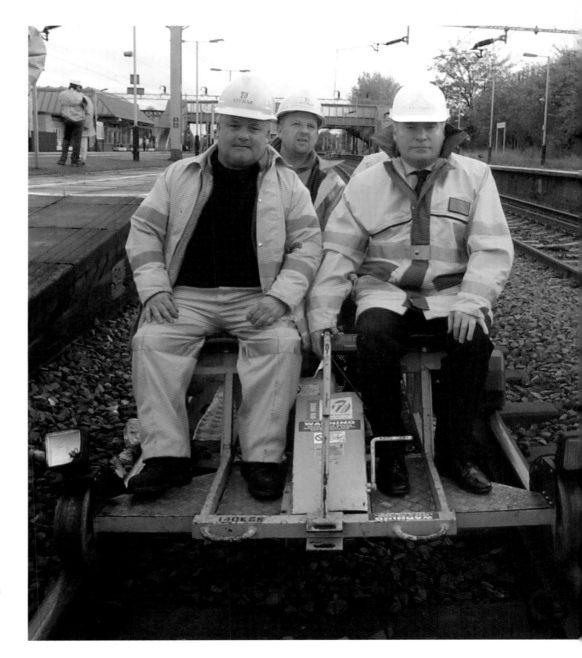

Railtrack chief executive
Gerald Corbett (R) rides
a motorized trolley on an
inspection of track that has
been re-railed at Leighton
Buzzard, Bedfordshire.
27th October, 2000

Track laying work at the scene of a train crash near Hatfield, Hertfordshire on the 17th of October, which killed four people and injured 70. The crash brought to light the shortcomings of Railtrack in maintaining the national railway infrastructure, and was a catalyst that resulted in its partial re-nationalization.

29th October, 2000

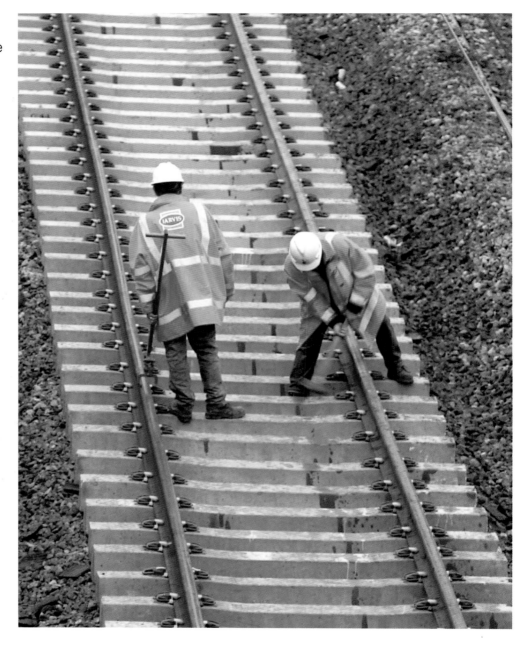

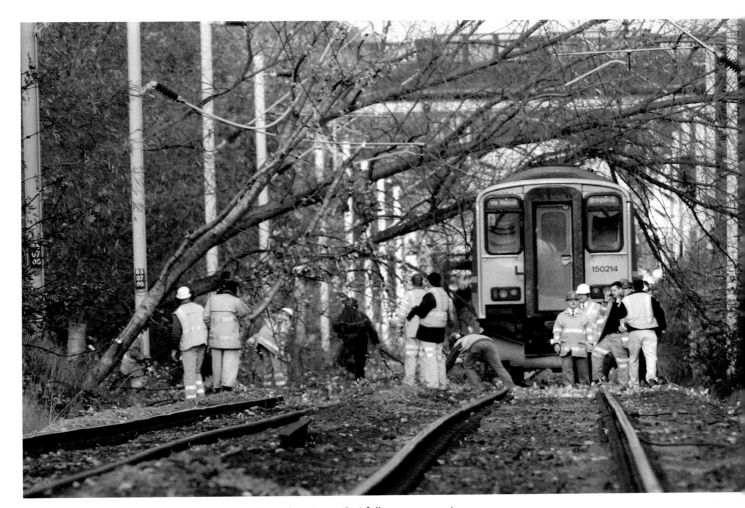

Railway workers clear trees that fell on a commuter
train near the Charlemont Estate, north of Birmingham.
Emergency services in some parts of the country warned
people to stay at home as they battled to deal with the debris
left by the worst weather to hit the south since the great
hurricane of 1987.
30th October, 2000

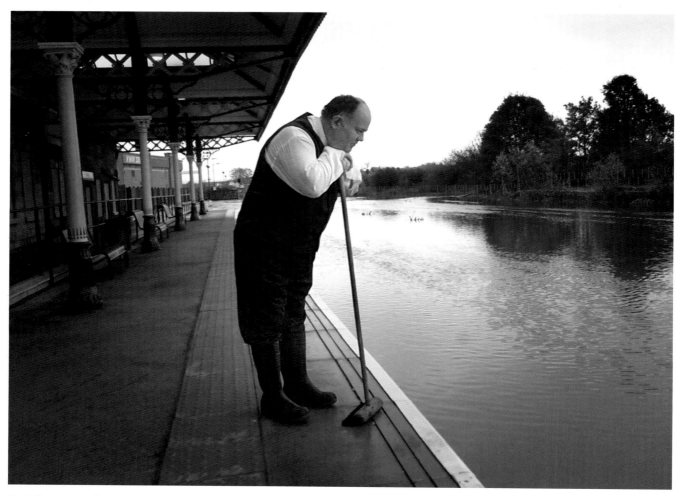

A station supervisor waits for the water level to drop on the flooded rail tracks at Malton station, North Yorkshire, following more than a week of heavy rain. The local council used a tractor and trailer as an impromptu bus service to ferry people between Malton and nearby Norton, which were cut off by deep floodwater after the River Derwent broke its banks.
6th November, 2000

Facing page: The first revenue earning steam hauled freight train for a third of a century runs over the Ribblehead Viaduct. Railtrack booked the engine to haul a 20-wagon ballast train over its Settle to Carlisle line in north west England to mark the final stages of a two year, £50m upgrade of the route.
19th December, 2000

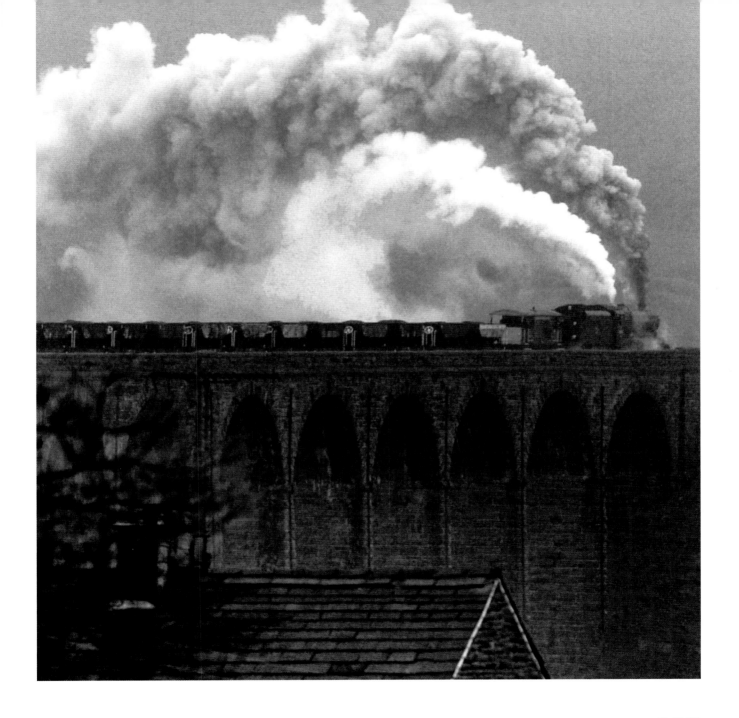

A quiet start at London King's Cross, but the festive getaway is expected to cause rail misery for many later. Trains on some routes were fully booked and many rail services were reduced due to speed restrictions.

23rd December, 2000

Railtrack worker Darren Smith checks the control panels of the new Wembley control centre, which is part of the modernization of the West Coast route.
28th December, 2000

A snow covered train yard in Birmingham. Arctic weather wreaked further havoc on Britain's roads and railways, and at airports. More heavy snow showers blanketed north east and south west England and northern Scotland, while the rest of the country faced a big freeze, creating treacherous driving conditions.
29th December, 2000

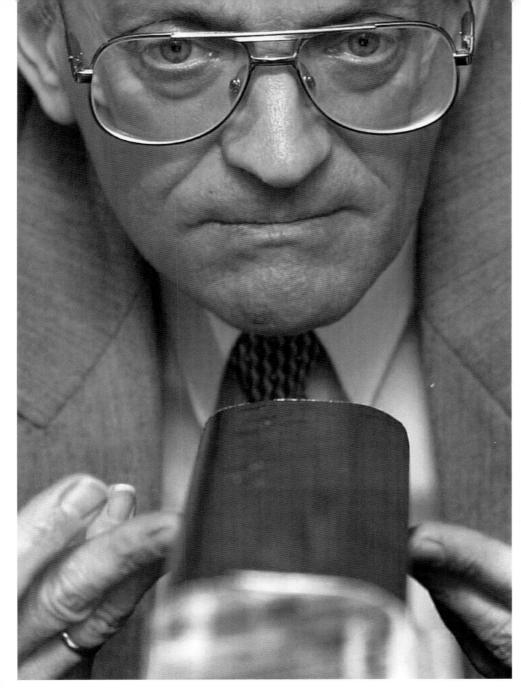

Vic Coleman, Chief Inspector of Railways, examining a section of railway line after the Health and Safety Executive presented its second interim report into the derailment of a train close to Hatfield in October 2000. The cause of the crash was identified as a fragmented rail: more than 300 critical cracks were discovered in rails at Hatfield.

23rd January, 2001

Britain's first electric tilting train since the 1980s, the BR 390 Class Pendolino, goes on trial at a track near Melton Mowbray, Leicestershire. The multiple units use Fiat's *pendolino* (pendulum) technology to enable the cars to tilt on curved stretches of track. The trains were built for Virgin Trains for operation on the West Coast Main Line.

14th February, 2001

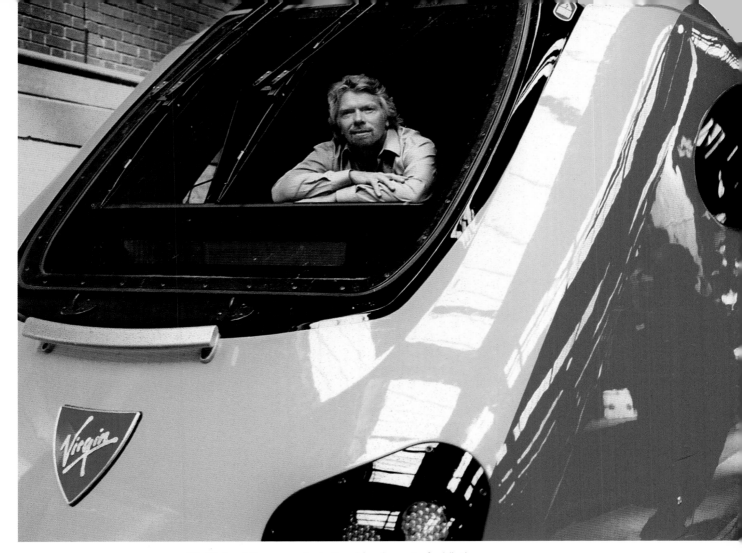

Sir Richard Branson sits in the driver's seat of a Virgin
Trains 220 Class *Voyager* diesel locomotive, part of
the new 125mph five-carriage sets he hopes will drastically
cut journey times on Virgin Rail's Cross-Country routes.
5th June, 2001

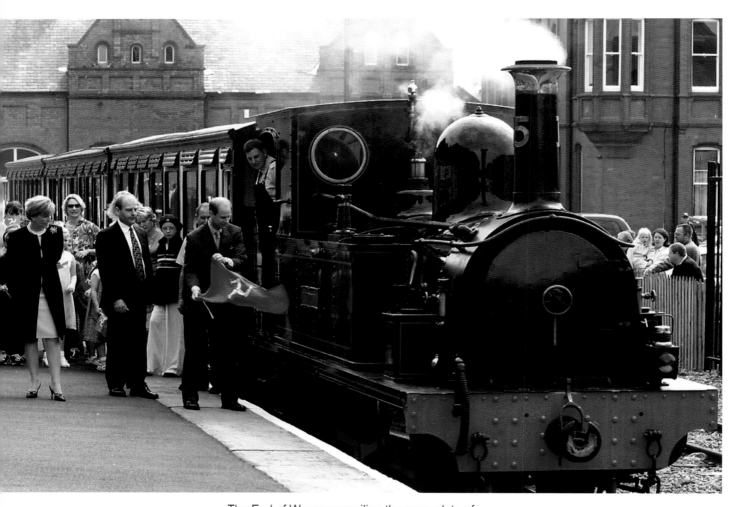

The Earl of Wessex unveiling the nameplate of
a 116-year-old re-commissioned steam locomotive,
the Isle of Man Railway's No 15 *Caledonia,* as he and
his wife Sophie, Countess of Wessex (L), continued
a two-day tour of the island. They took a trip on the train
hauled by *Caledonia* from Douglas to nearby Santon,
where they visited a traditional country fair.
7th July, 2001

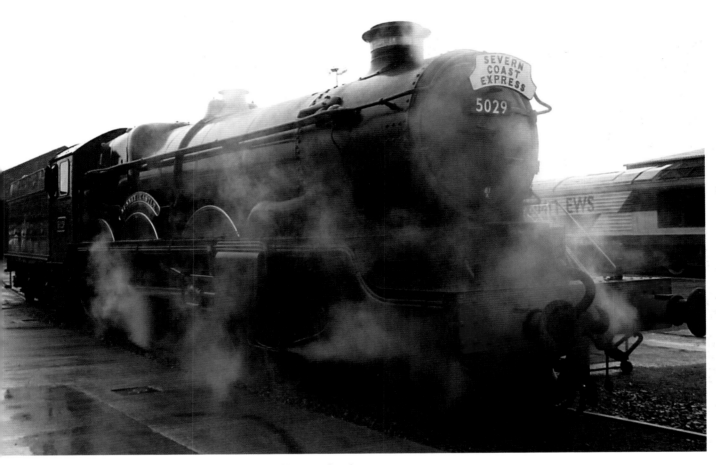

The GWR Castle Class locomotive No 5029 *Nunney Castle* under steam at the English, Welsh & Scottish Railway's Barton Hill depot in Bristol. The 1934 engine was to haul the *Severn Coast Express* during a week of regular passenger trains between Bristol, Gloucester and Newport.
9th July, 2001

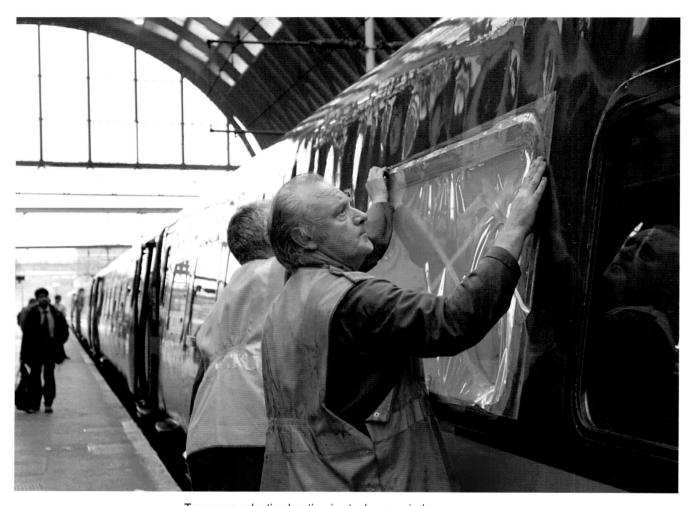

Temporary plastic sheeting is stuck over windows on a
GNER train, the 15.05 from Leeds, at King's Cross station
in London. The outer glass in five windows was smashed
by stones and bricks thrown at the train by vandals in the
Wakefield area.
13th July, 2001

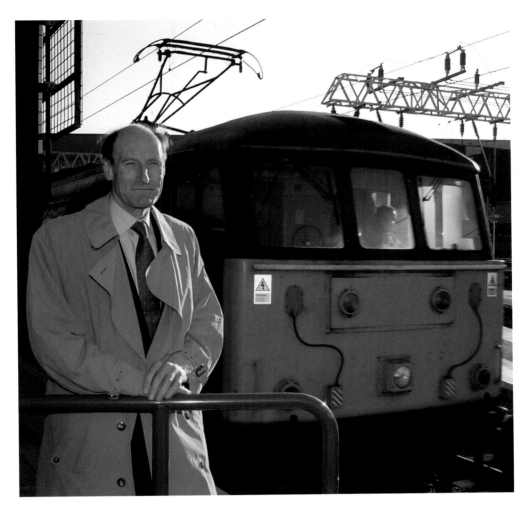

New Railtrack chief executive John Armitt at Euston station, London. The former construction company boss described his daunting task of presiding over a troubled national rail network as a responsibility and a privilege.

14th December, 2001

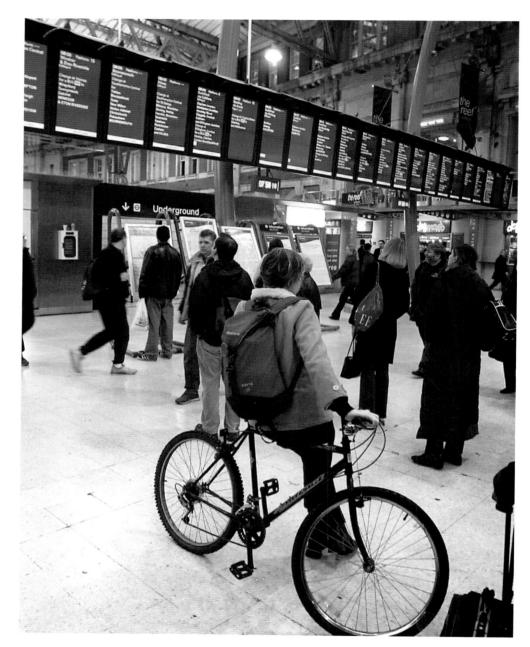

A woman traveller with her bike looks for train information at London Waterloo station at the start of a 48-hour rail dispute between the Rail, Maritime & Transport (RMT) union and South West Trains. Thousands of commuters faced travel misery as the union said it expected solid support for the latest walkouts against SWT in their long-running dispute over pay and disciplinary procedures.
28th January, 2002

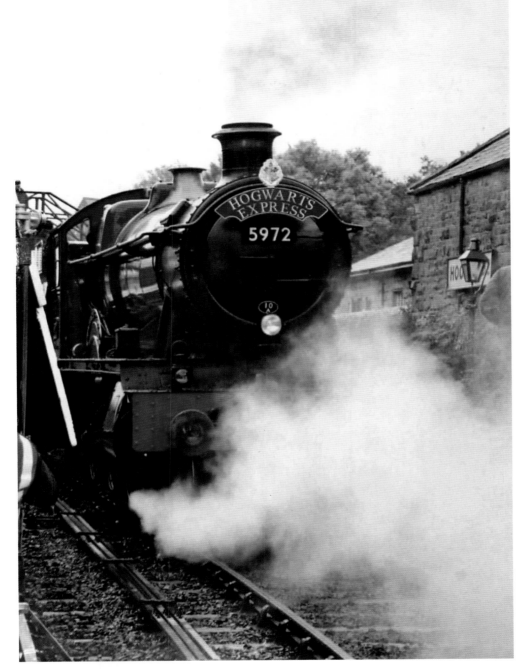

Filming of the new £100m film *Harry Potter and the Chamber of Secrets* involved scenes at the fictional Hogsmeade station and the magical *Hogwarts Express* train, which travelled from London King's Cross, Platform 9¾. The real station is Goathland on the North Yorkshire Moors Railway, and the steam engine used in the film is the GWR 4900 Class No 5972 *Olton Hall*.

20th February, 2002

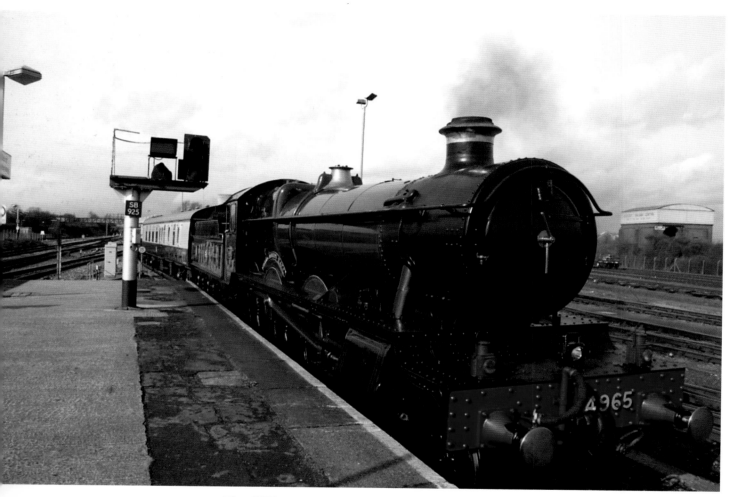

The GWR 4-6-0 Hall Class locomotive No 4965 *Rood Ashton Hall*, carrying a team of 20 Railtrack engineers and project managers, arrives at Didcot station after inspecting a stretch of track between Banbury and Oxford that is due to accommodate high speed tilting trains. Railtrack claimed that the old train's two Pullman-style coaches afforded passengers a better view of the track. The group enjoyed lunch on board before returning to the West Midlands.

27th February, 2002

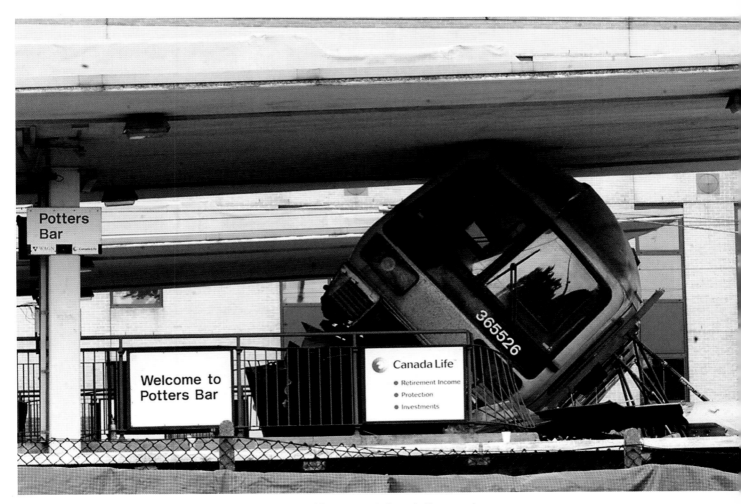

Part of a train is wedged between station platform and canopy after a crash at Potters Bar station, Hertfordshire, in which seven died and 81 were injured. Railtrack said it was not aware of problems on that particular stretch of track, after reports that both passengers and drivers had felt a bump when trains crossed the accident point. Poorly maintained points were blamed for the incident.

11th May, 2002

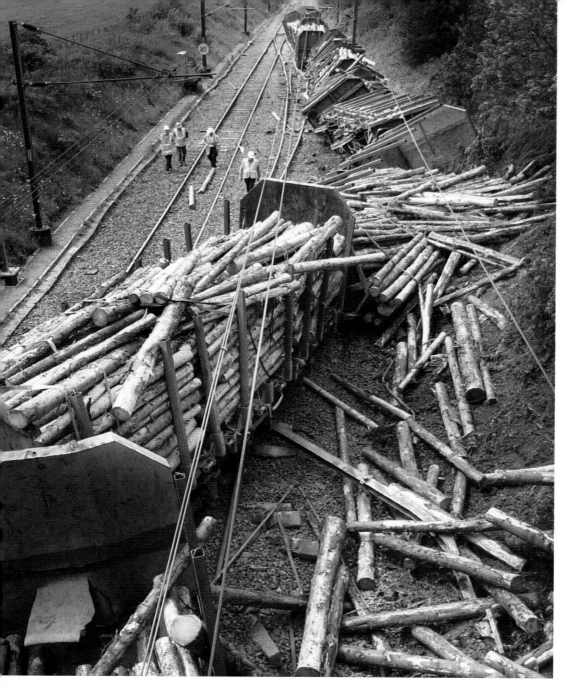

A view of the railway line where a freight train derailed at Quintinshill, between Gretna and Chapleknowe, Dumfries and Galloway. The train, comprising 14 wagons of timber, left the track at about 9.30am. The driver was not injured in the derailment and nobody else was on board the train at the time.
17th June, 2002

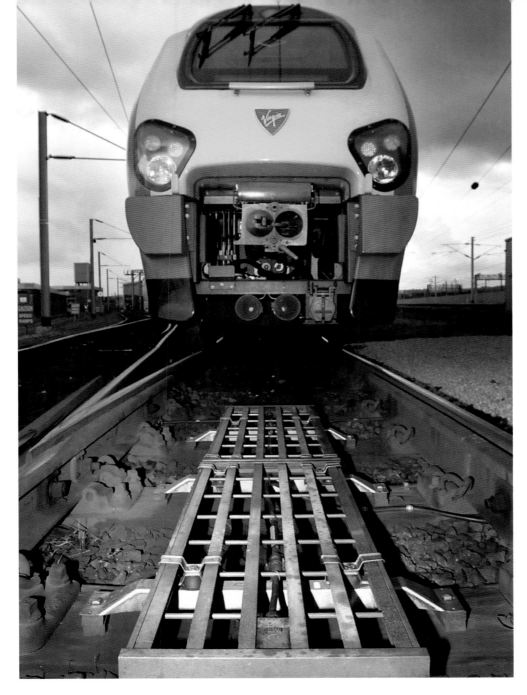

The Train Protection &
Warning System (TPWS)
equipment designed
to stop trains passing
signals at danger, or when
overspeeding, installed on
track in Glasgow, Scotland.
10th July, 2002

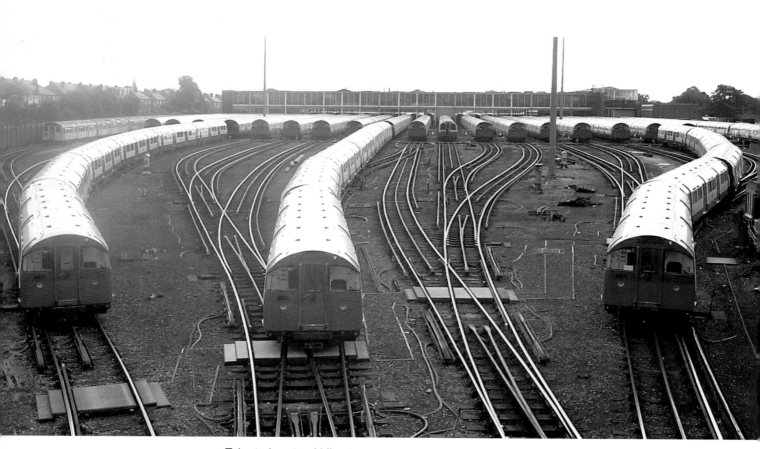

Tube trains stand idle at
a depot in west London
as drivers, station staff
and signallers on the
London Underground stage
a 24-hour walk-out in a row
over tube safety. Union
leaders claimed the planned
public/private partnership
of the underground might
put the lives of staff
and passengers at risk.
18th July, 2002

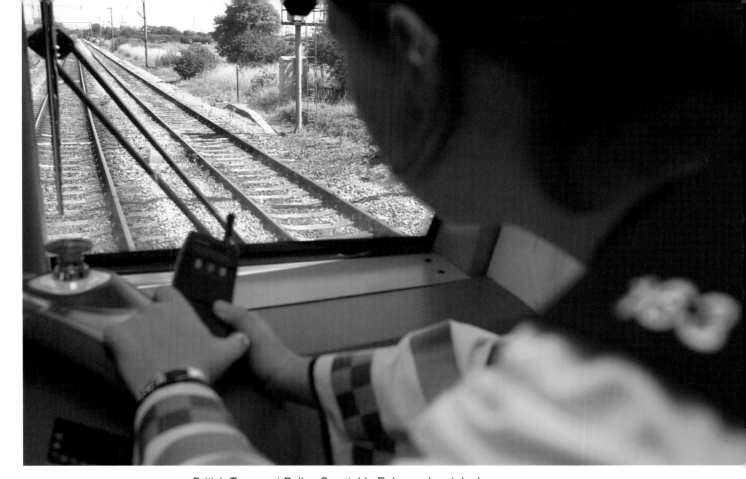

British Transport Police Constable Rebecca Lamb looks ahead onto the railway lines as she travels aboard a Q-Train between Barking and Leigh-on-Sea in Essex. Q-Trains are undercover trains, which run on Britain's railways in joint operations by British Transport Police and Railtrack. Slotted in between normal passenger services they patrol the rail network, concentrating on hotspots known to have a problem with trespass and vandalism.

13th August, 2002

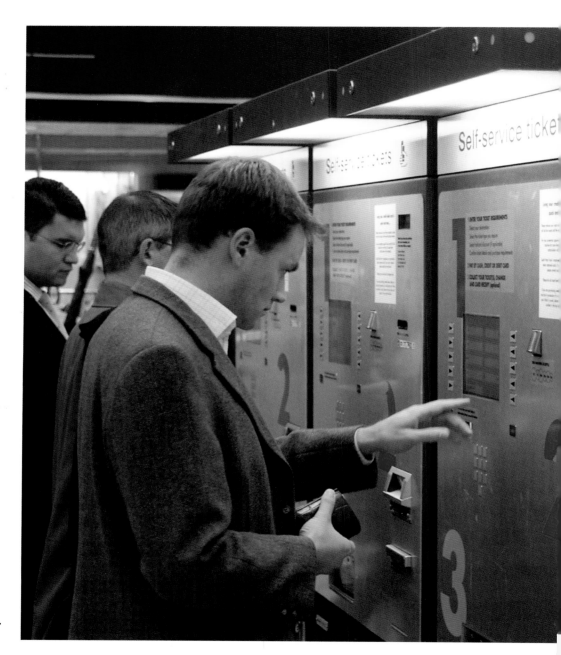

Rail passengers using the self-service ticket machines at Clapham Junction station.
29th October, 2002

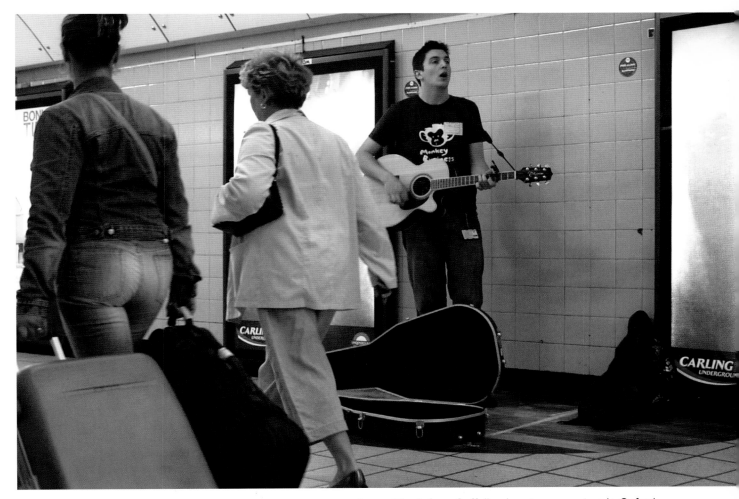

Aaron Short, from Suffolk, plays to commuters in Oxford Circus underground station, as buskers are given permission to perform in allocated areas on the tube for the first time. The bylaw banning buskers was changed after 80 per cent of passengers questioned by London Underground said they liked live music as they waited for their trains.
19th May, 2003

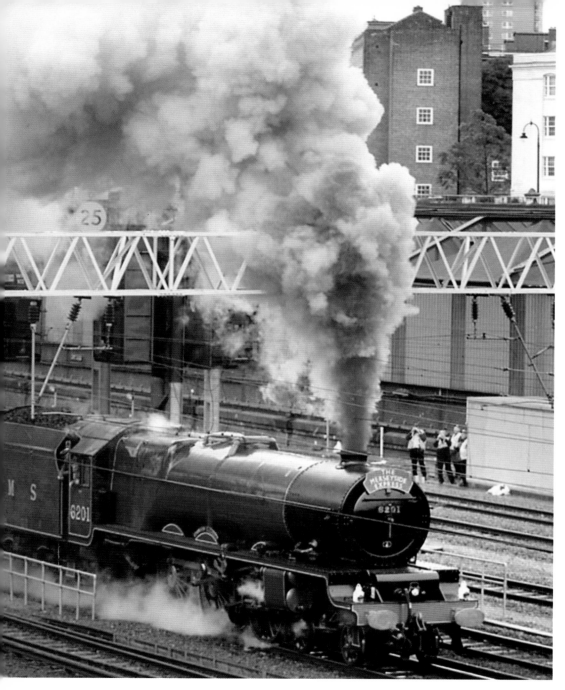

The *Princess Elizabeth* steam locomotive leaves London Euston station on its return to Merseyside, after a trip to the capital. The LMS Princess Royal Class 4-6-2 locomotive became part of the service that ran between London to Liverpool in the 1930s and for many years was based at Edge Hill depot in Liverpool.
6th June, 2003

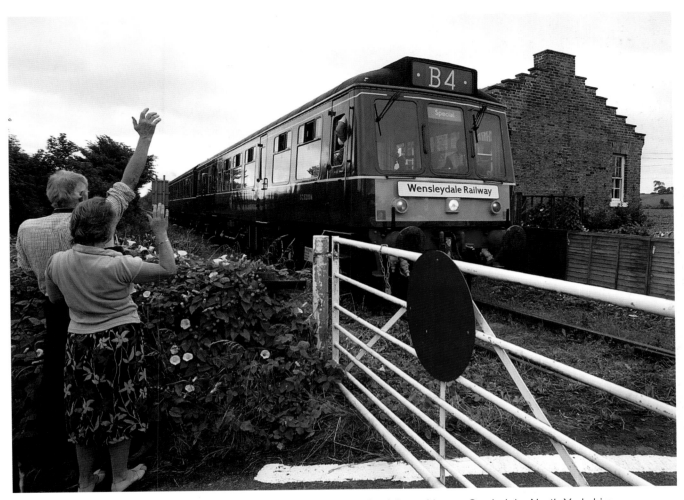

The Wensleydale Railway, in Wensleydale and Lower Swaledale, North Yorkshire, is reopened by Wensleydale Railway plc (WRC). The line, which had not been used for 50 years, began to run services between Leeming Bar and Leyburn after the Rail Regulator granted licences to WRC, covering management of 22 miles of track and infrastructure between Northallerton and Redmire, operation of stations, passenger trains, freight trains and train maintenance.
4th July, 2003

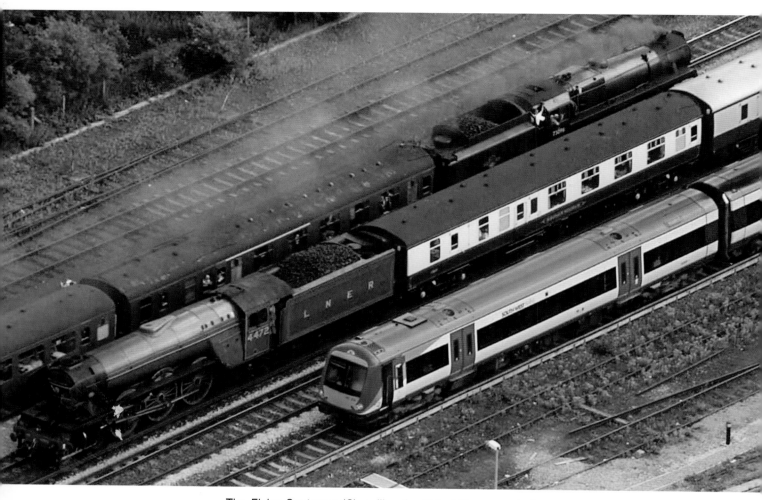

The *Flying Scotsman* (C), pulling the *Orient Express* out of London towards Bath, passes the *Cathedrals Express* (L) pulled by the unnamed 1955 Standard Class 5 locomotive No 73096 in Basingstoke. They met alongside a modern South West Trains service as they marked the anniversary of the end of stream train travel in British Rail's Southern Region on the 9th of July, 1967.
9th July, 2003

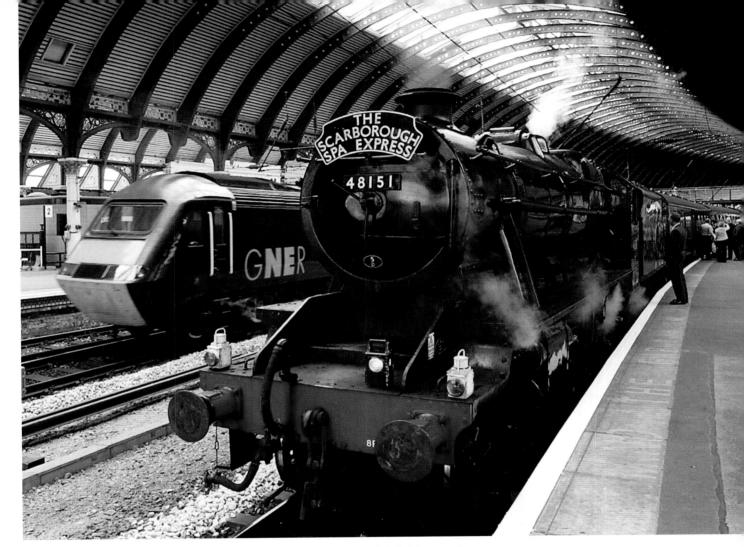

The restored LMS Stanier Class 8F 2-8-0 locomotive, originally a freight hauler, picks up passengers on *The Scarborough Spa Express*, which runs for the summer holidays to the East Coast resort, as a regular mainline diesel engine (L) travels through York station.

29th July, 2003

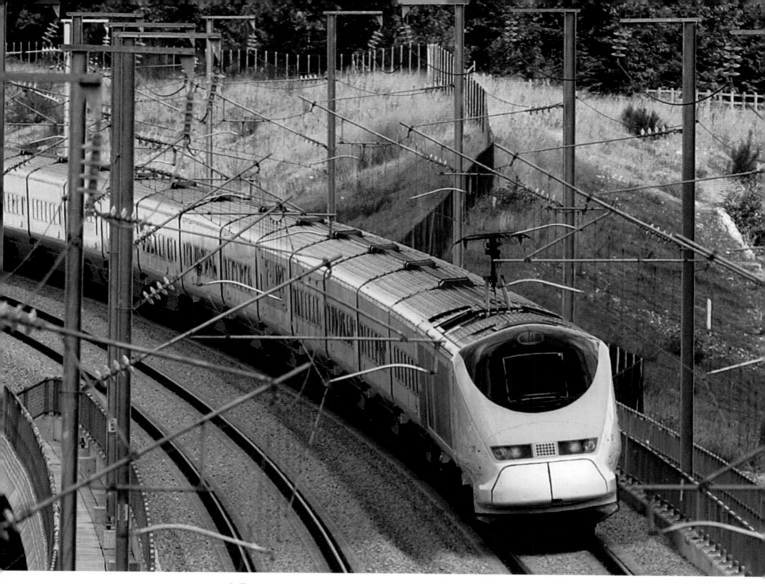

A Eurostar train breaks the UK rail speed record through the Kent countryside. The 14-carriage, 600-ton train was travelling on a test run on the £1.9bn first section of the Channel Tunnel Rail Link, which will open for passenger service in September. The train beat the previous record of 162.2mph that was set by British Rail's ill-fated tilting Advanced Passenger Train in December 1979.

30th July, 2003

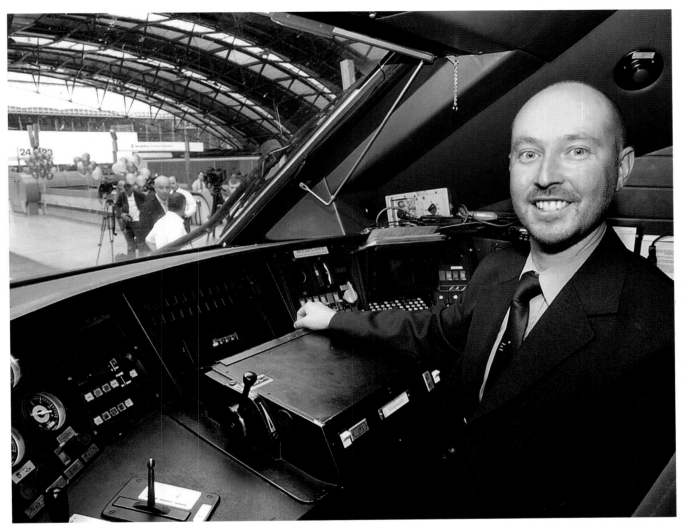

Happy Eurostar driver Alan Pears inside his train at Waterloo station, London, after breaking the British rail speed record. The train reached 208mph as it travelled through Kent. Mr Pears, 35, from Staplehurst, Kent spoke afterwards of his great thrill at making history.
30th July, 2003

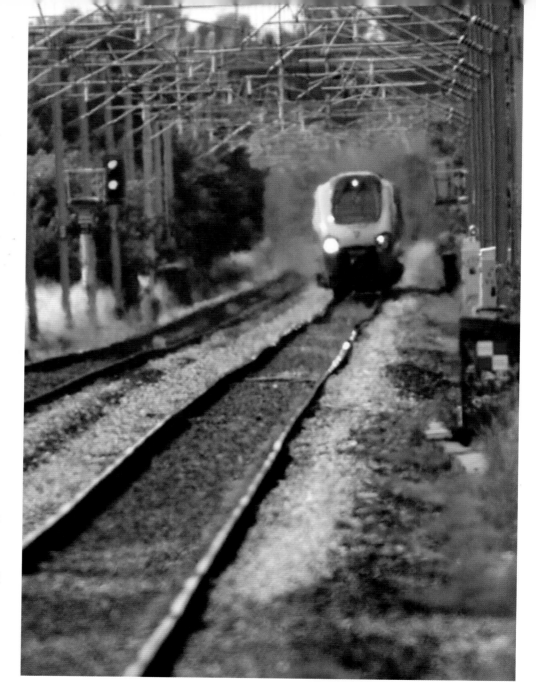

A Virgin train approaches Marston Green Station, Birmingham. Speed restrictions were imposed on some of Britain's busiest rail routes as temperatures across the country soared towards the highest on record. The track-related measures were introduced as forecasters predicted the possibility of figures reaching an all-time high of 37.2 degrees celsius.

4th August, 2003

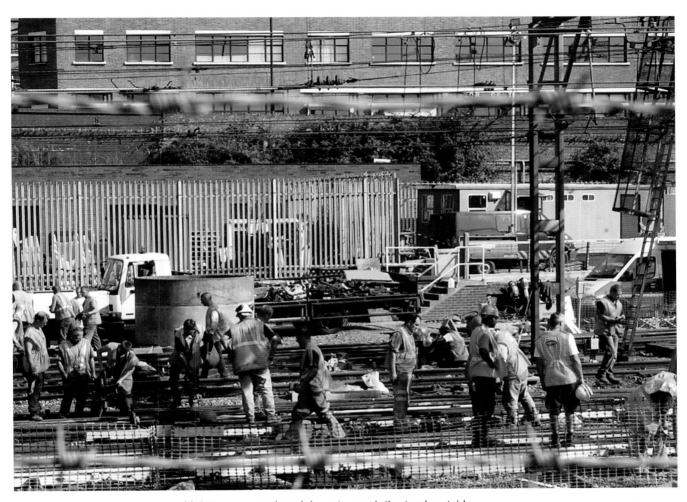

Maintenance workers labour to repair the track outside King's Cross station, London, after the derailment of a passenger train earlier in the week, which closed six platforms of the busy station. No one was hurt in the incident. Engineering firm Jarvis admitted that its faulty maintenance work was to blame.
17th September, 2003

Margaret Barton, who played the character of tea room assistant Beryl Walters in the 1945 film adaptation of Noël Coward's *Brief Encounter*, which starred Celia Johnson and Trevor Howard, enjoys a cup of tea in the refurbished refreshment bar at Carnforth station, Lancashire, where scenes where shot.
17th October, 2003

Passengers make their way to the platform at Carnforth station, after the official re-opening following the station's refurbishment. Both the station and the clock were immortalized in the 1945 film *Brief Encounter*.

17th October, 2003

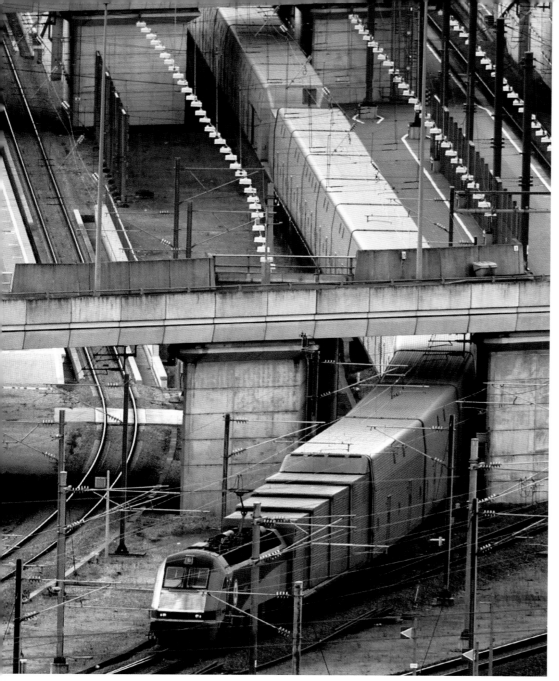

Facing page: The 90 tonne Class 67 diesel locomotive No 67005 *Queen's Messenger*, brought into service to pull the Royal Train, was unveiled at the English, Welsh & Scottish Railway depot at Toton, near Nottingham.
18th February, 2004

A shuttle train leaves for France at the Channel Tunnel Terminal in Folkestone, Kent, as Eurotunnel announces plans to slash access rates for train operators in a bid to increase traffic growth and reverse heavy losses. Eurotunnel said the cuts would allow high-speed train operator Eurostar to boost traffic to Paris and Brussels, and potentially launch new destinations such as Amsterdam.
9th February, 2004

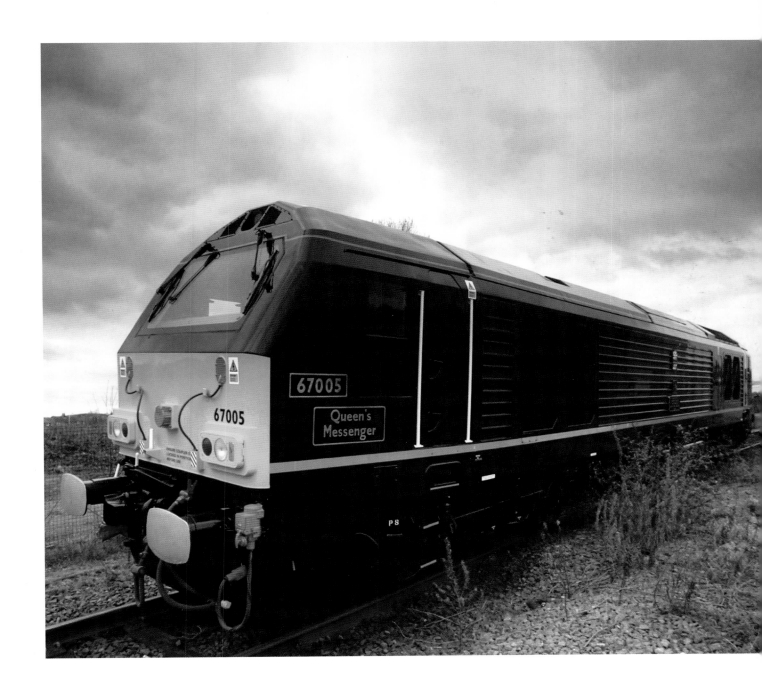

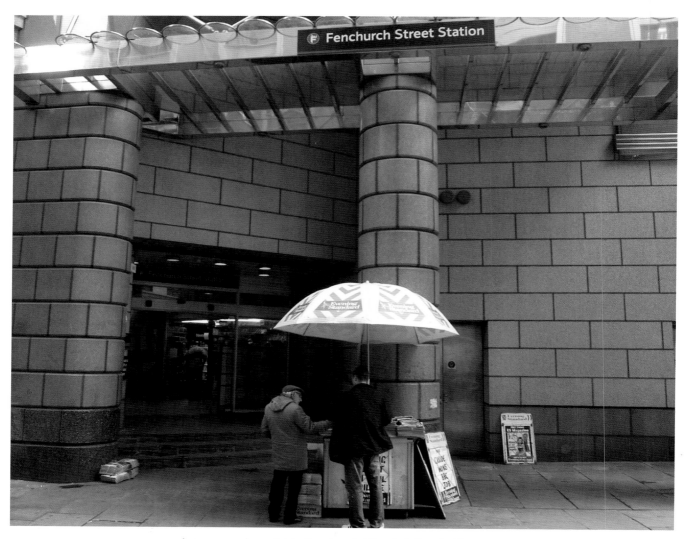

A news vendor outside Fenchurch Street station, built between 1853 and 1854 to serve the London, Tilbury & Southend Railway (LT&S) and the Eastern Counties Railway, later the Great Eastern. Today Fenchurch Street still serves east London and south Essex.
2nd April, 2004

Liverpool Street station, which opened in 1874 and was built for the Great Eastern Railway to serve east London, Essex and East Anglia, also had a connection to the Metropolitan Railway, the world's first underground railway. A major facelift in the 1980s transformed the station yet retained its striking architecture.
2nd April, 2004

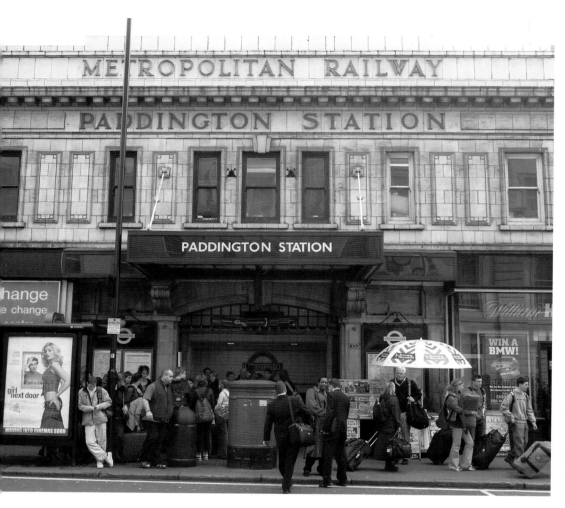

Designed by Isambard Kingdom Brunel and Digby Wyatt, Paddington station was built as the terminus of the Great Western Railway in 1850–54. A famous literary character made the station's name known throughout the world: a statue dedicated to *Paddington*, the Peruvian bear, can be seen on the concourse, as well as one of its architect, Brunel.
2nd April, 2004

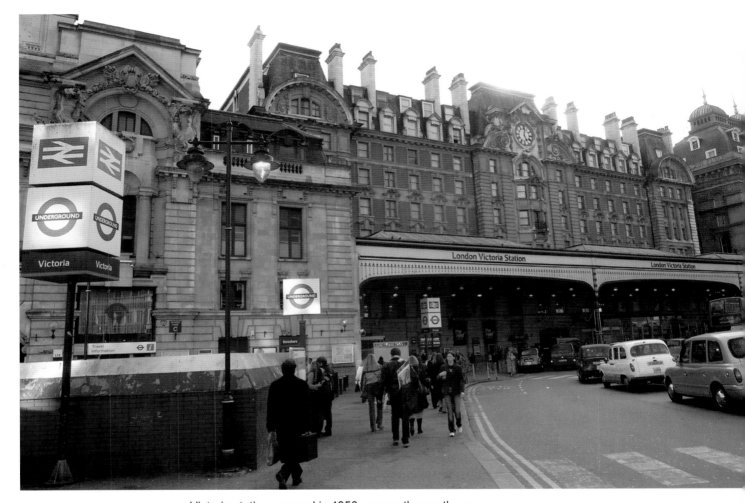

Victoria station, opened in 1858, serves the southern
commuter belt, Kent and the South Coast. Victoria was
originally two separate stations, which were connected
by a small access in 1924 although not amalgamated
until a 1980s redevelopment.
2nd April, 2004

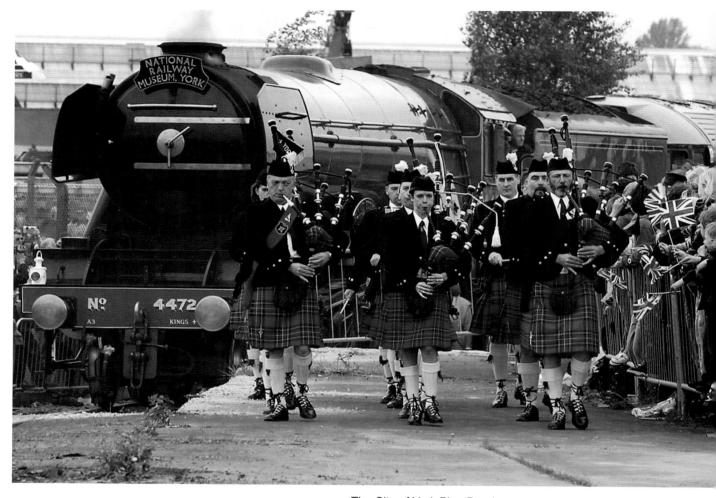

The City of York Pipe Band welcomes *The Flying Scotsman* as the locomotive arrives for *RailFest 2004* at the National Railway Museum, York.
29th May, 2004

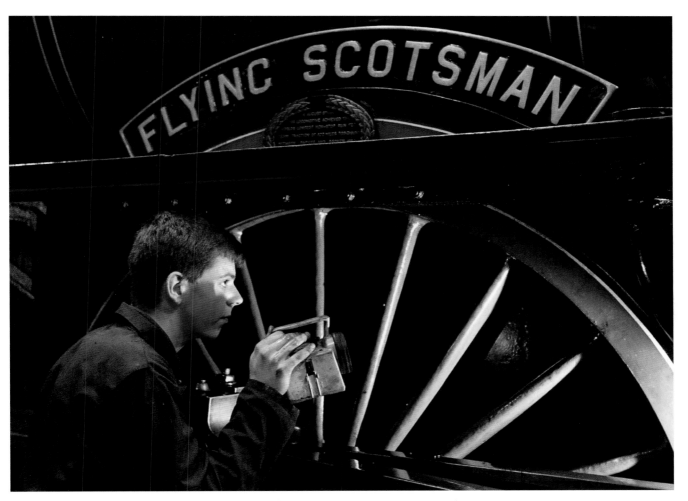

David Wright, an apprentice engineer at the National Railway Museum in York, checks over the *Flying Scotsman* locomotive in preparation for its summer services between York and Scarborough.
15th June, 2004

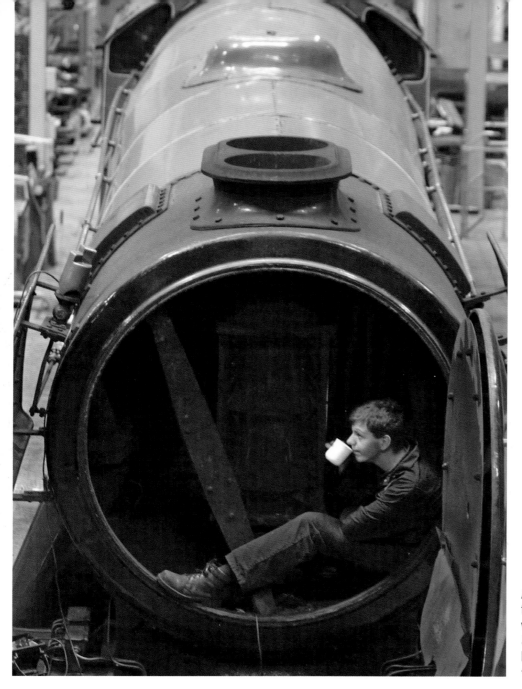

Apprentice engineer Wright takes a tea break while working on the *Flying Scotsman* at the National Railway Museum, York.
15th June, 2004

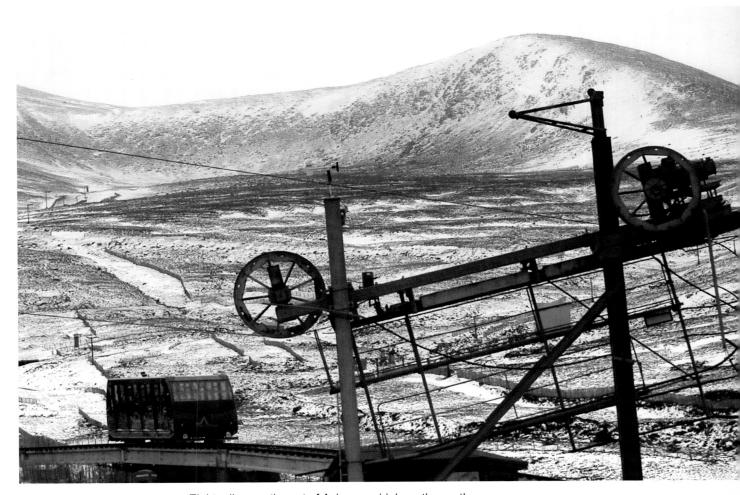

Eight miles south east of Aviemore, high on the northern flank of Cairngorm, a funicular railway runs for almost two miles through the popular ski area. The CairnGorm Mountain Railway, built between 1999 and 2001, is the country's highest and fastest mountain railway. It terminates at a restaurant 400ft below the summit of the mountain.
30th January, 2005

The National Railway Museum is preparing for a month of celebrations to mark the 60th anniversary of *Thomas the Tank Engine*, the fictional anthropomorphic steam locomotive created by the Reverend W V Audrey in *The Railway Series* books.

3rd February, 2005

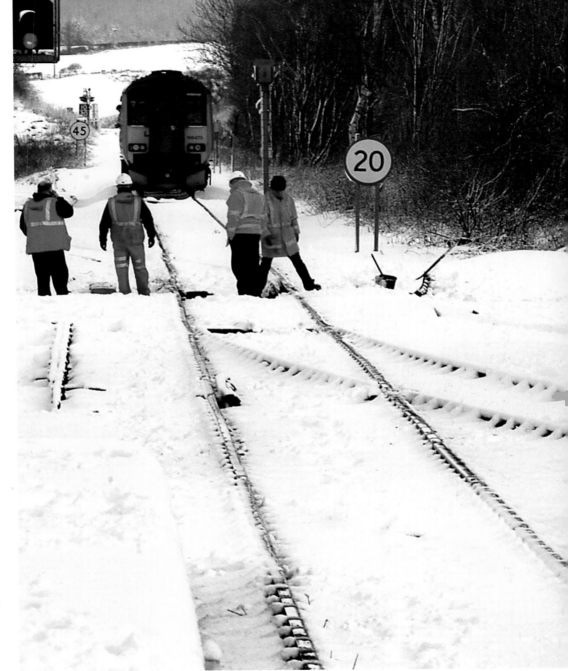

Heavy snowfalls caused disruption on rail tracks in the north of England, forcing crews to clear points of snow and ice to allow trains to continue running.

21st February, 2005

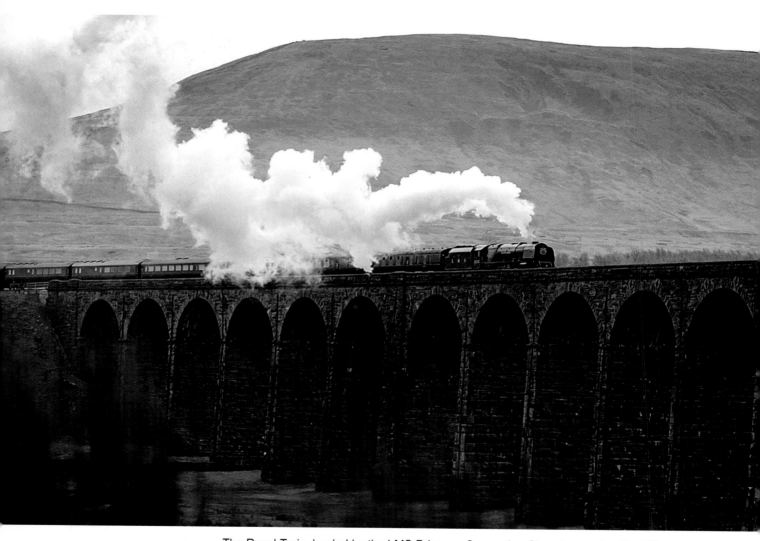

The Royal Train, hauled by the LMS Princess Coronation Class locomotive No 623 *Duchess of Sutherland,* crosses the viaduct at Ribbleshead with the Prince of Wales on board. The prince was to travel along the Settle–Carlisle Railway in Cumbria to mark the 25th anniversary of the formation of the Friends of the Settle and Carlisle pressure group.
22nd March, 2005

Leicester Square underground station is closed for the rush hour in Central London, as a newsstand reports a terrorist attack on London transport. A series of co-ordinated suicide attacks was carried out on three underground trains and a double-decker bus by four British Muslim men protesting about Britain's involvement in the Iraq War.
7th July, 2005

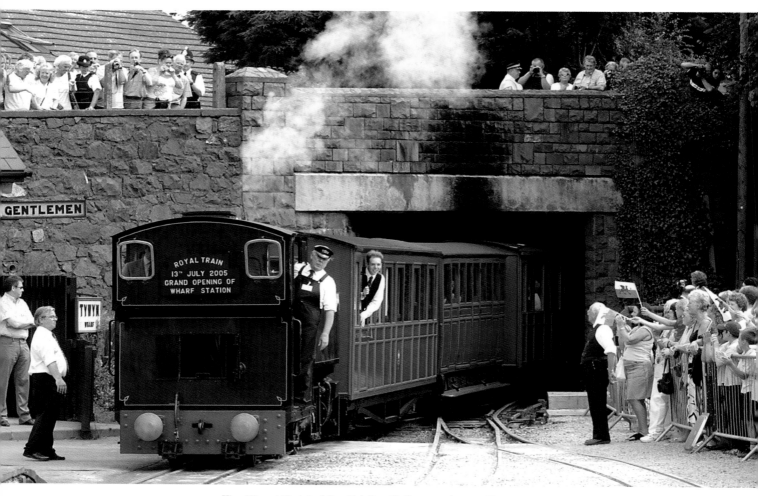

The 'Royal Train' of the Talyllyn Railway arrives at Tywyn Wharf Station, Gwynedd, with the Prince of Wales partially visible in the left window of locomotive No 7 *Tom Rolt*, which was driven by railway volunteer Phil Guest, from Birmingham. The station recently received a £1m redevelopment to enhance the facilities on the historic narrow gauge railway.
13th July, 2005

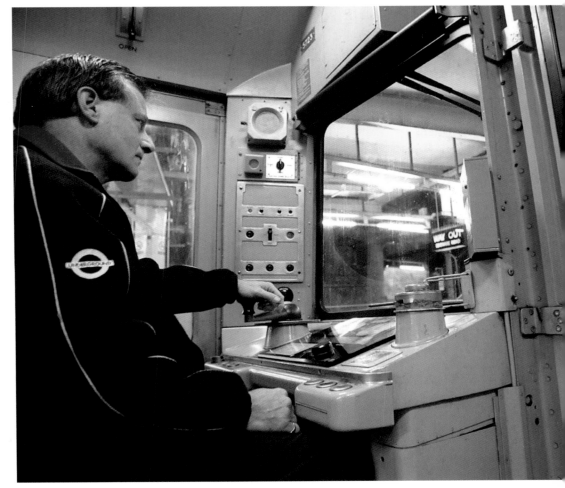

Tube train driver Brian Ingleton at the controls of the second train to leave Edgware Road station, London, after the District Line reopened through the station for the first time since the bomb attacks of the 7th of July. Seven people died in the blast on a Circle Line train, one of four explosions across the capital that day.
29th July, 2005

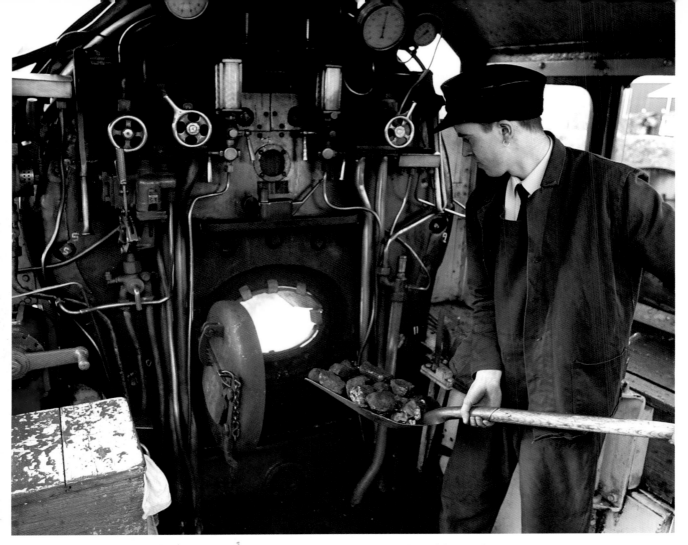

Fireman Lee Sutherland tops up the coal aboard the newly overhauled LNER D49 Class 4-4-0 No 246 steam engine *Morayshire* on the Bo'ness & Kinneil Railway line, operated by the Scottish Railway Preservation Society, where it is due to haul its first passenger train.

20th October, 2005

A South West Trains Class 458 Electric Multiple Unit train on the line between London and Staines.
24th March, 2006

A First Capital Connect Train at Royston railway station, Cambridgeshire. The operating company began on the National Rail network on the 1st of April, 2006. In early 2007 FCC produced a study on options for increasing capacity of services to Peterborough and Cambridge, which would involve lengthening peak trains from eight to 12 carriages from 2009.
5th March, 2007

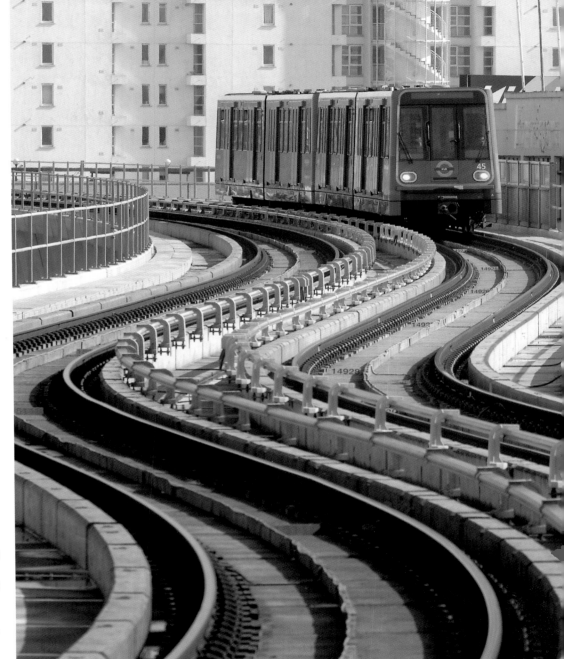

The Docklands Light Railway, east London. The light metro system opened on the 31st of August, 1987 to serve the redeveloped Docklands area. It operates high-floor, single-articulated, bi-directional electric multiple unit cars, with two cars per train. There is no driver's cab since trains are automated, although a small console allows for driver operation if necessary.

10th March, 2007

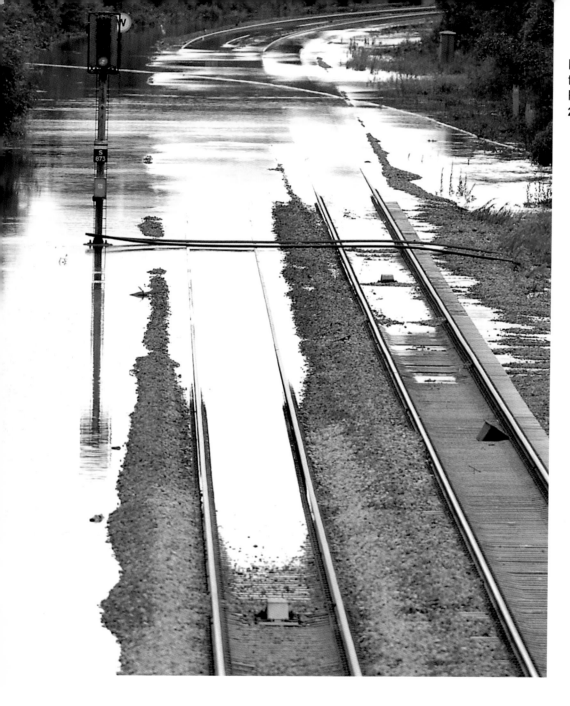

Flooding on the railway tracks at Mexborough near Rotherham, South Yorkshire.
26th June, 2007

A freight train passes an
industrial plant on Teesside.
13th July, 2007

A freight train operated by the English, Welsh & Scottish Railway passes Coalbrookdale, Shropshire, after leaving the Ironbridge Power Station. It is hauled by EWS 66 Class diesel electric locomotive.

11th September, 2007

Facing page: Eurostar trains in the station after the Queen officially opened St Pancras International station, Euston Road, London. Her Majesty not only opened the new home to Eurostar, but also launched the finally completed £5.8bn Channel Tunnel Rail Link, High Speed 1.

6th November, 2007

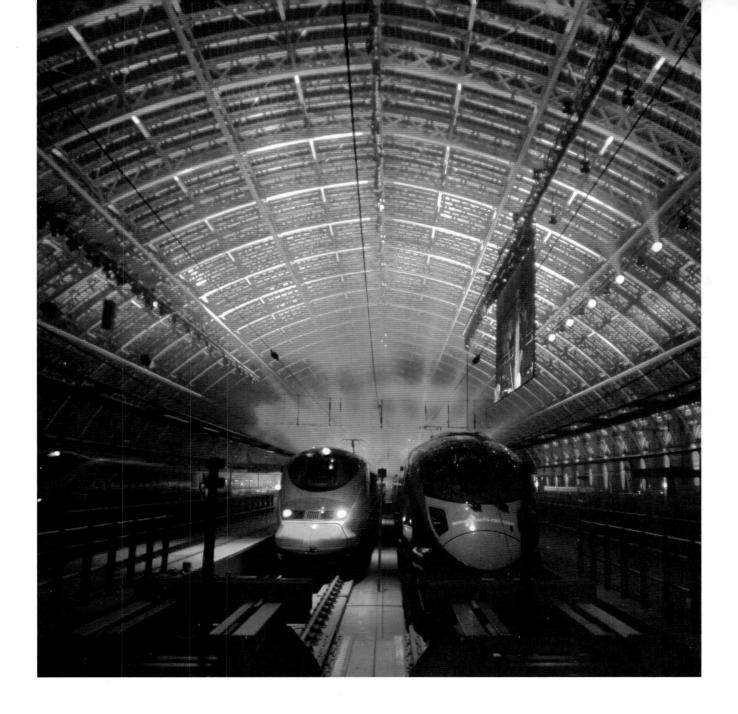

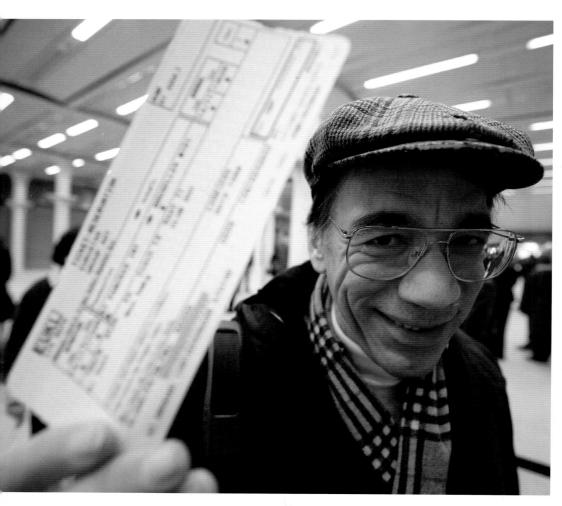

Roger Kemp from north London was the first passenger aboard the first Eurostar train to depart from London Waterloo at 8.23am on the 14th of November, 1994, and he was also first with his ticket at the new terminal at St Pancras station.
14th November, 2007

E-Ticket machines at
the new Eurostar terminal
at St Pancras station.
14th November, 2007

One of the world's first Personal Rapid Transit (PRT) System vehicles, to be deployed across Terminal 5 at Heathrow Airport. The innovative system will revolutionize the way passengers are transported around the airport. The low energy, battery powered driverless vehicles can carry four passengers and their luggage, and travel along a dedicated guide way.
17th December, 2007

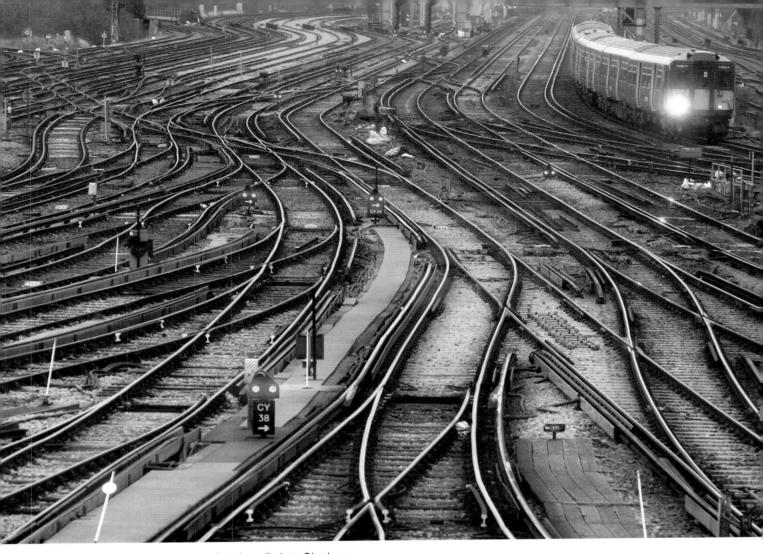

A train pulls into Clapham Junction station in south west London, one of the busiest railway stations in Europe, determined by the number of trains using it.

7th January, 2008

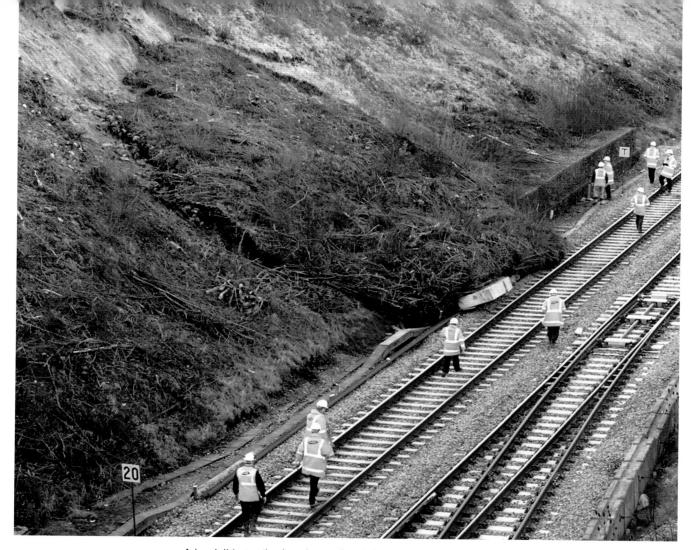

A landslide on the London to South Wales train line, at Chipping Sodbury, South Gloucestershire. Railway engineers inspect the landslide on the railway, which will remain closed for several days.

24th January, 2008

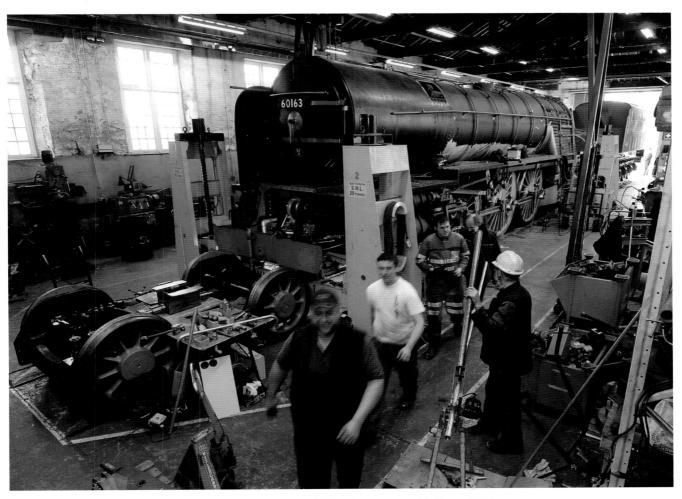

Engineers at work on the LNER Peppercorn A1 Class 4-6-2
No 60163 *Tornado*, the first mainline-ready steam locomotive
to be built in Britain since 1960, which is under construction
at a workshop in Darlington.
6th February, 2008

The elegant façade of
Sheffield railway station,
South Yorkshire, which
was designed by architect
Charles Trubshaw and
opened in 1870 by the
Midland Railway.
20th March, 2008

A couple wait for a train to pass at a rail foot crossing near Moor Lane between Staines and Wraysbury in Middlesex, where Theresa Mansell, 66, was killed by a train after her foot became trapped in the rails.

16th April, 2008

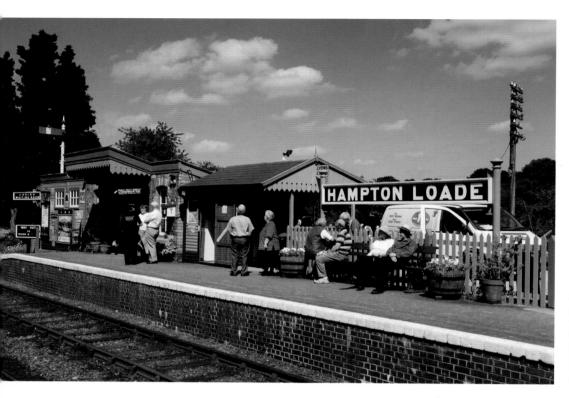

The quintessentially British Hampton Loade railway station on the picturesque Severn Valley Railway heritage line in Shropshire.
10th June, 2008

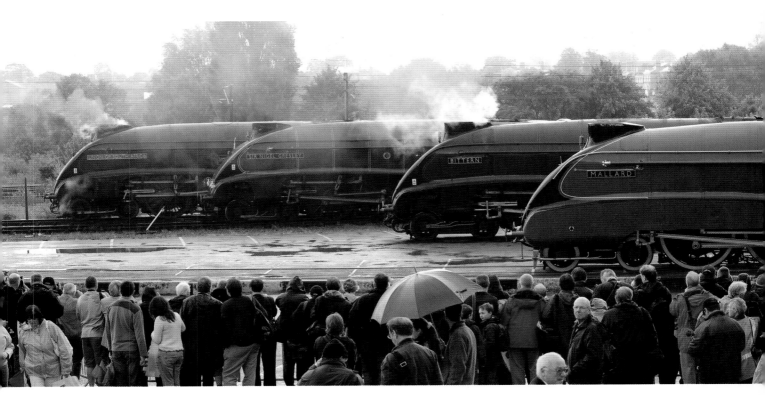

Crowds gather despite the rain to see the 'Great Reunion' of four UK-based streamlined A4 steam locomotives (L–R) *Union of South Africa*, *Sir Nigel Gresley*, *Bittern* and *Mallard*, at The National Railway Museum, York. The event was held to celebrate the 70th anniversary of *Mallard's* world speed record breaking run.
5th July, 2008

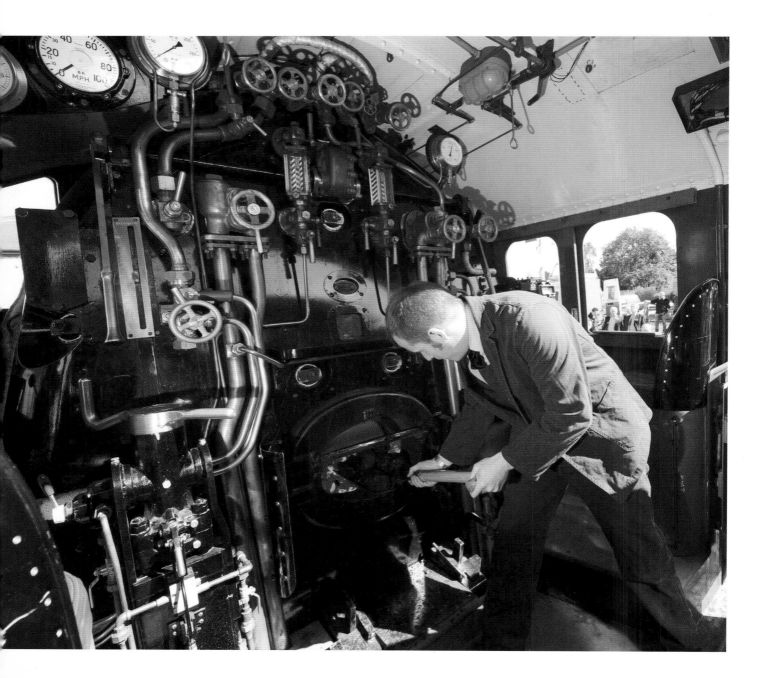

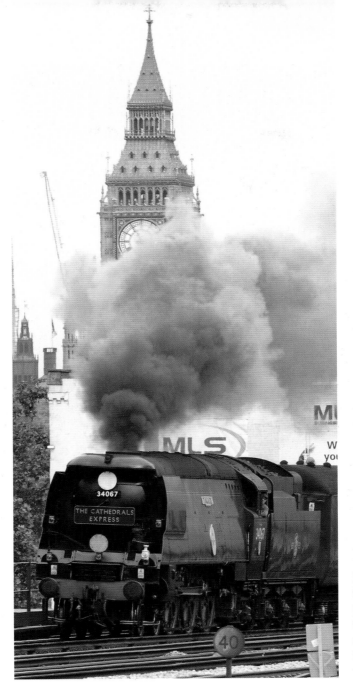

Facing page: Graeme Bunker shovels coal into the firebox on board the Peppercorn A1 Class Pacific 60163 *Tornado* as it prepares for its first test run in Darlington.
1st August, 2008

The Cathedrals Express, hauled by the Battle of Britain Class locomotive No 34067 *Tangmere*, passes through Vauxhall station on its way from Waterloo to Salisbury on a day trip.
7th August, 2008

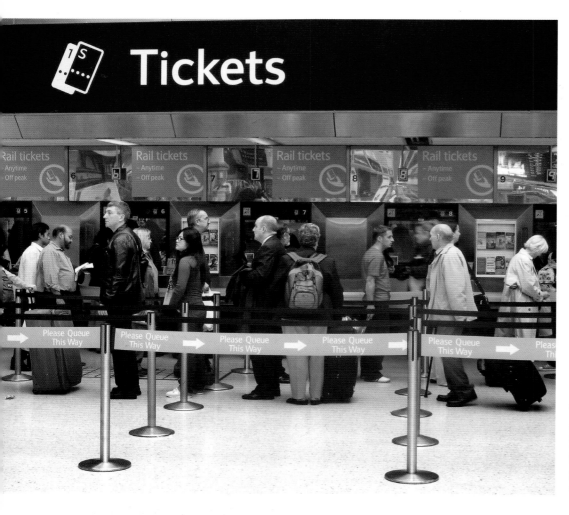

The bane of train passengers' lives, the zig-zag queue for train tickets at Victoria station, London.
10th September, 2008

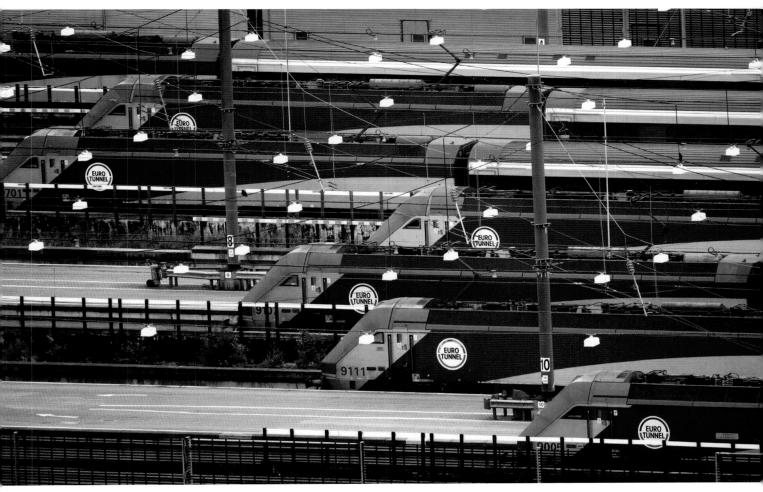

Eurotunnel trains at the Eurotunnel Terminal in Folkestone, Kent, following suspension of services due to a fire in the tunnel. A chemical lorry on the France-bound Shuttle carrying HGVs and their drivers caught fire and the blaze lasted for 16 hours. Fourteen of the 32 people on board the train suffered minor injuries.

11th September, 2008

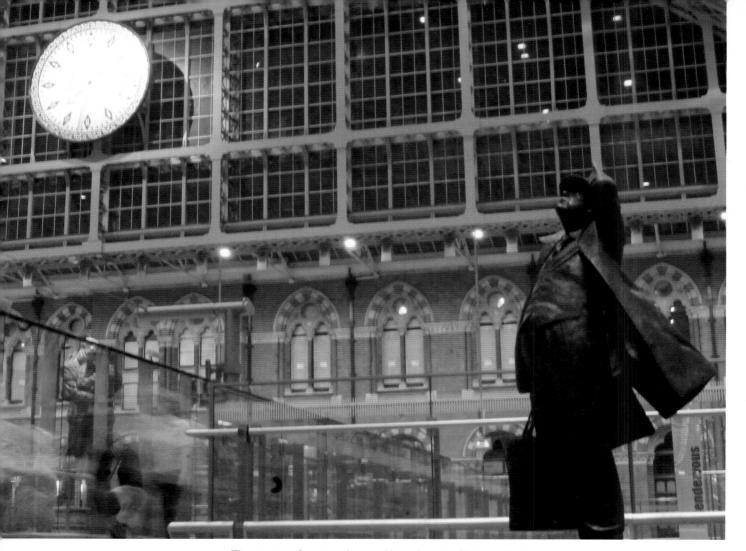

The statue of poet, writer and broadcaster Sir John Betjeman inside St Pancras International station, gazing up at the lofty Barlow roof. The statue commemorates Betjeman's campaign during the 1970s to save the station's façade.
20th September, 2008

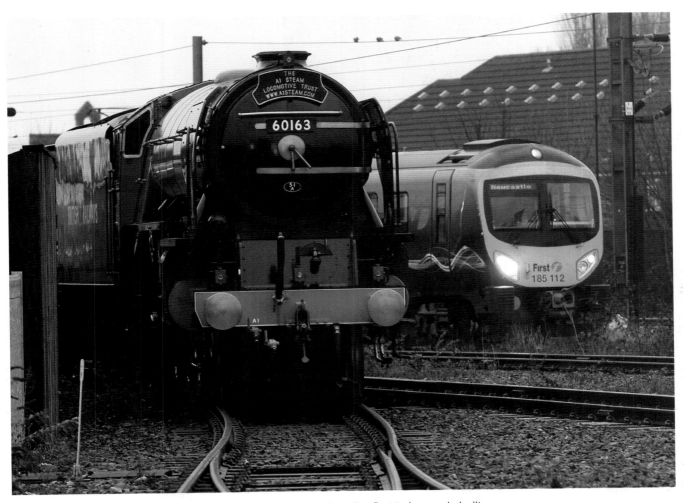

The *Tornado* steam locomotive, the first to be newly built
for 50 years, passes a modern passenger train after
it was unveiled at the National Railway Museum in York.
The magnificent engine sports the newly applied traditional
green livery and markings.
13th December, 2008

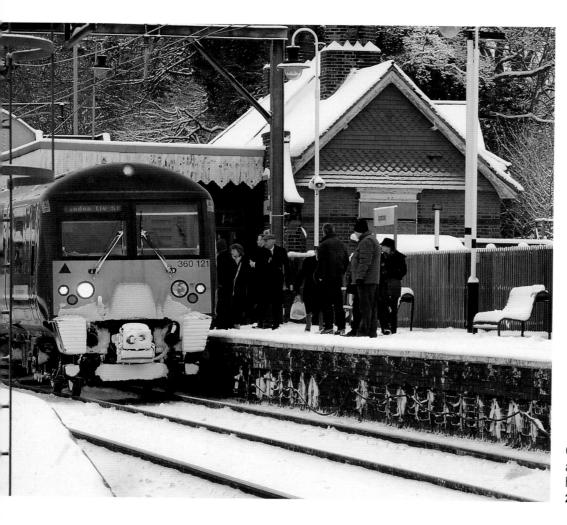

Commuters wait for a train at Ingatestone, Essex, after heavy overnight snowfall.
2nd February, 2009

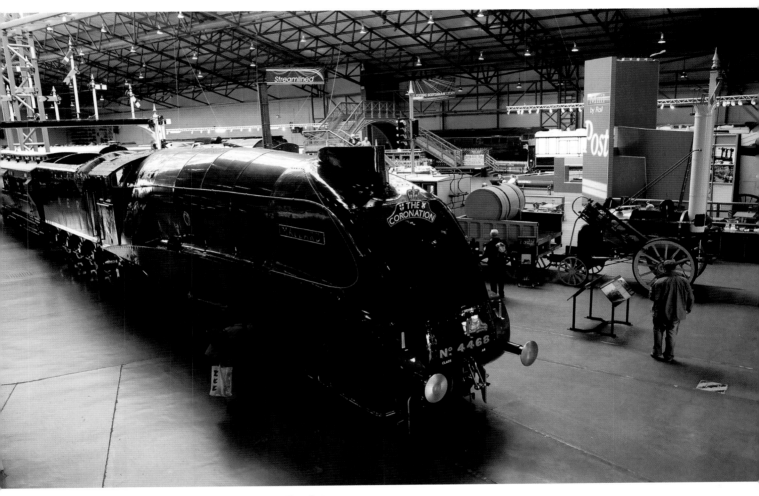

The A1 streamlined steam locomotive *Mallard* stands in all its glory in the Great Hall of the National Railway Museum, alongside a working replica of George Stephenson's *Rocket*.

13th May, 2009

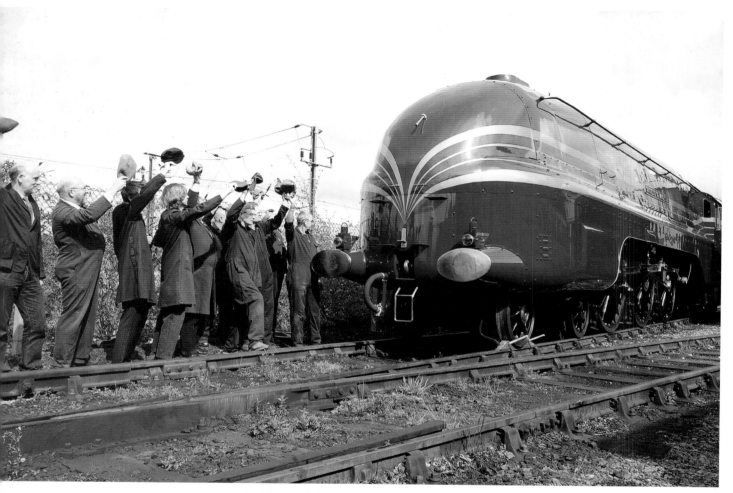

Staff at the workshops of the National Railway Museum recreate the scene from 1937 when workers waved off the first of the luxurious Princess Coronation Class streamliners as it left the Crewe Works. The newly 're-streamlined' LMS 4-6-2 locomotive No 6229 *Duchess of Hamilton*, which has been restored to its 1938 glory, was the centrepiece of a new free exhibition *Streamlined: Styling An Era* at the museum.
19th May, 2009

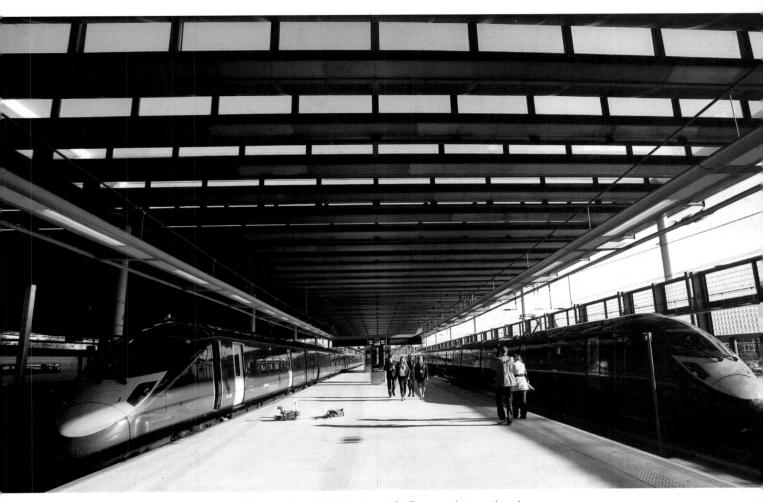

Two 140mph Hitachi 395 trains at St Pancras International station for a preview of the UK's new high-speed train service. The dual voltage electric multiple units are to be brought into service by Southeastern for use on High Speed 1, the Channel Tunnel Rail Link. It is planned that the trains will also provide the *Javelin* shuttle service for visitors to the 2012 Olympic Games venue in Stratford.
18th June, 2009

The Publishers gratefully acknowledge Press Association Images, from whose extensive archive the photographs in this book have been selected. Personal copies of the photographs in this book, and many others, may be ordered online at www.prints.paphotos.com

PRESS
ASSOCIATION
Images

AMMONITE
PRESS

For more information, please contact:

Ammonite Press

AE Publications Ltd. 166 High Street, Lewes, East Sussex, BN7 1XU, United Kingdom
Tel: + 44 (0)1273 488006 Fax: + 44 (0)1273 472418
www.ammonitepress.com